Iconoclasm

vs.

Art and Drama

Early Drama, Art, and Music
Monograph Series, 11

Iconoclasm

vs.

Art and Drama

Edited by

Clifford Davidson & Ann Eljenholm Nichols

Early Drama, Art, and Music
Monograph Series, 11

MEDIEVAL INSTITUTE PUBLICATIONS
Western Michigan University
Kalamazoo, Michigan--1989

ISBN 0-918720-97-4
ISBN 0-918720-98-2 (paperback)

Printed in the United States of America

Contents

List of Illustrations

Preface

The suppression of religious art--devotional images, wall paintings, and in many instances stained or painted glass--and the laying aside of the religious drama that had been so important previously in the civic life of many cities in England were not unrelated events. Like a considerable amount of the ritual and even the vestments of the medieval Church, these visible displays came under increasing attack in the sixteenth century, and ultimately during the revolutionary period following 1642 they would be subjected to even greater hostility, which also would close down the secular stage for nearly two decades. While writers such as John Rainolds criticized especially "the profane and wicked toyes of Passion-playes" which he regarded as worse than the wickednesses of the secular stage, the "Masse-game" of traditional worship also came in for severe censure, since "instead of preaching the word, they caused it to be played . . ." (*Th' Overthrow of Stage Playes* [1599], as quoted in Jonas Barish, *The Anti-Theatrical Prejudice* [1981], pp. 162-63). And, along with the alleged insincerity of the Mass with its supposedly theatrical (and therefore false) display of vestments and ceremonial, the images that represented the saints, apostles, and Christ himself were seen as "idols" to be put down.

In 1637, Archbishop Laud noted in his diary that

his chaplain had paid for the finishing of the south porch of the Church of St. Mary at Oxford. At his trial in 1644, one of the charges against him involved the statue of the Blessed Virgin included in this construction. And his accuser on this score was none other than that great enemy of stage plays, William Prynne. At this time, of course, political power resided with individuals who reacted with phobic antagonism both to religious image or picture in the visual arts and to the stage image. The one was to be destroyed, the other was to be forbidden by law, in this instance by the First Ordinance of the Long Parliament against Stage-Plays and Interludes of 2 September 1642. The iconoclasts' response to visual displays with religious content and also to the stage was passionate and angry, and may be conveniently seen as not so very different from the reaction in the 1890's of a Norwegian immigrant, the grandmother of one of the editors, who, seeing two of her sons entertaining themselves with playing cards, snatched the cards away from the boys and consigned the pack to the fire with the words "The devil is in the cards."

Even the cross itself was anathema to the most radical of the iconoclasts. A Puritan who claimed to have visited the "Arminian nunnery" of Nicholas Ferrar at Little Gidding was thus apparently horrified at the cross on the font cover and at other evidences of Anglo-Catholicism such as candles and the manner of conducting religious rites, which suggested to him that here the practice of religion was polluted (*The Arminian Nunnery*, quoted in *Anglicanism*, ed. Paul Elmer More and F. L. Cross [1935], pp. 737-38). In this instance, the Puritan

writer was anxious to affirm the desacralization of space, for he insisted that no place was to be seen as more holy than another. In other words, communication with transcendent Being must for this writer-- and for other iconoclastic Protestants of the sixteenth and seventeenth centuries--be detached from all worldly or material things, and especially from "images and crucifixes," for veneration of such objects among Roman Catholics opens them to the charge of idolatry.

In England the Reformation meant the triumph of attitudes that to be sure had been infected by continental Reformed Protestant iconoclasm, but the carrying out of an iconoclastic program in England also meant acceptance in official quarters of earlier Wycliffite objections to the religious image and the religious drama. The Wycliffite treatise A *Tretise of Miraclis Pleyinge* insisted that, in contrast to holiness which "is in ful ernest," religious plays are illegitimate and scornful of the truth. So too in a Wycliffite treatise of images and pilgrimages, religious statues and paintings are said to appeal to the senses, while indeed God instead "dwellis by grace in gode mennus soulis, and withoute comparesound bettere than all ymages made of man in erthe . . ." (*English Wycliffite Writings*, ed. Anne Hudson [1978], pp. 84, 99).

When the Reformers reached out for arguments to defend and sustain their iconoclasm, they had to contend with the orthodox Western justification of images and visual depictions of sacred scenes inherited from St. Gregory the Great, whose role in the conversion of England was legendary. Gregory, faced with an incident of iconoclasm instigated by a

bishop, had supported the use of images so "that thay . . . that cunneth no letterue scholde rede in walles thate that they mowe nought in bokes," to cite a Lollard translation. Gregory's books-for-laymen justification persisted through the 1530's anomalously alongside the official destruction of images, but by the 1540's Gregory had been discredited to a role second only to the wicked Empress Irene. To reach this position the English Reformers borrowed heavily from the more radical continental Reformers who had themselves seen in the Byzantine iconoclastic controversy an historical antecedent for their own struggle. As Anthony Ugolnik indicates in his article in the present book, there was a concerted effort to link the official attitudes of the early part of Elizabeth's reign with Carolingian condemnation of image theology in the *Libri Carolini*, which in turn had been produced in reaction to the affirmation of images at the Second Nicene Council. Furthermore, argues Ugolnik, the epistemology of the Caroline Books evinces the same anti-visual prejudice demonstrated by the Reformers. Curiously, as Clifford Davidson demonstrates in his article on "The Anti-Visual Prejudice," the understanding of the sense of sight which had served as underpinning to image theology might be retained in order to turn on its head the previous veneration of sacred pictures and images. Thus scenes in religious drama that had once been seen as edifying and useful for devotion were also before very long regarded as sacriligious and even dangerous by some.

Margaret Aston in her essay illustrates how iconoclastic acts were utilized by the Reformers to drive the process of "reform." Acts of vandalism

were at times found to be useful to the country's rulers, who were thus able to reduce sensitivity to the destruction of sacred objects and to give encouragement to the progress of Reformation ideas and practices. Even the beloved Cheapside Cross in London would eventually fall to the fury of the iconoclasts. Destruction of examples of the visual arts was in fact seen by the reformers as a cleansing of the English Church and nation, for images, identified as "idols," were strongly associated with dirt and infection rather than with holiness. Davidson's "'The Devil's Guts': Allegations of Superstition and Fraud in Religious Drama and Art During the Reformation" takes up this aspect of Reformation iconoclasm which emphasizes the defilement associated with the "idolatry" directed to images. A psycho-historical interpretation of the aggressiveness of the Protestant reformers is tempting, for their projection of dirtiness onto the holiest objects venerated by their parent generation suggests a collective disorder. Others may wish to compare the actions of the iconoclasts with the those of the young men and women who recently constituted the driving force of the Cultural Revolution in China or with the extremism of so-called "Islamic fundamentalism." For the Reformation iconoclasts it was not enough to challenge the use of images for communicating with the realm of transcendence, but rather the Reformers had to destroy them with all the vigor of which they were capable. Hence when they were confronted with something like a seven-sacrament font that depicted sacraments for which there was, they felt, no authorization in scripture, they hammered away the offending imagery. Such indeed was the case at

Cratfield, where parish iconoclasm was sanctioned by the incumbents and systematically carried out. Iconoclasm in this parish in Suffolk is surveyed by Ann Eljenholm Nichols in her contribution to this volume.

Ceremonies, including those involving the Easter sepulchre on Good Friday and Easter, were likewise frowned upon. There was no longer to be any veneration of the cross, no quasi-dramatic *Depositio* or *Elevatio*--and certainly no dramatic *Visitatio sepulchri*. Pamela Sheingorn's "'No Sepulchre on Good Friday': The Impact of the Reformation on the Easter Rites in England" provides an outline of the kind of information we are able to glean from the sepulchre records of the period in which they were suppressed. Her study focuses on the middle of the sixteenth century when the first phase of the anti-ritualist reform swept over the country, but it provides a useful example of the official attitude toward highly popular ceremonies which had both devotional and didactic functions. But the Easter sepulchre itself was often an artistically elaborate structure built into the north wall of the chancel of the church, and the record of destruction of such church art as part of the campaign against the ceremonies makes depressing reading. As Bishop Hooper, one of the more radical members of the hierarchy in his time, had insisted in his Articles and Injunctions for the Gloucester and Worcester dioceses in 1551-52, no one was to "maintain . . . sepulchres pascal"; further, clergy were told to "exhort your parishioners and such as be under your cure and charge for the ministry of the church, to take down and remove out of their churches and chapels, all places, tabernacles,

tombs, sepulchres, tables, footstools, rood-lofts, and other monuments, signs, tokens, relics, leavings, and remembrances, where such superstition, idols, images, or other provocation of idolatry have been used" (quoted by Pamela Sheingorn, *The Easter Sepulchre in England* [1987], p. 154).

It may be asked why another book on iconoclasm, especially when the last two years have seen the publication of three major books on the subject-- Carlos Eire's *War Against the Idols* (Cambridge University Press, 1986), the first volume of Margaret Aston's *England's Iconoclasts* (Clarendon Press, 1988), and *Bilder und Bildersturm im 16. Jahrhundert*, ed. Bob Scribner (Wolfenbüttel Forschungen, forthcoming). Our collection of essays took root in 1986 at a session on iconoclasm sponsored by the Society for Reformation Research at the annual International Congress on Medieval Studies in Kalamazoo. We believed then that much remained to be said about iconoclasm. Two years later we believe that the need still exists--because of (rather than in spite of) the recent publications, for they have provided fertile ground for new insights and expanded research. We hope that this collection of essays will also suggest new directions and challenge scholars in a variety of disciplines to pursue the study of iconoclasm in a number of relatively unexplored areas.

The loss of textiles is one such area. Sheingorn mentions the red silk coat for a Resurrection statue, Aston the coat for the Dovercourt rood, Nichols the hoods for the Marian statue at Cratfield. Of special interest are imaged textiles. The famous Henry VII cope is a particularly good example with its orphrey

embroidered with ten saints, including St. Bartholo-
mew with his knife, St. Thomas with a spear, St.
Andrew with his cross, and St. Dorothy with a basket
of flowers. Part of an elaborate set of vestments for
priests, deacons, and subdeacons, this cope is the
only one to have survived of twenty-nine copes,
described in full in the will of Henry VII as being "of
the same cloth and work." By 1563 the twenty-nine
copes had been reduced to twenty-four, to eleven by
1608, these being burned in 1643 (Christa C.
Mayer-Thurman, *Raiment for the Lord's Service* [Art
Institute of Chicago, 1975], pp. 112-15). When not
converted to secular service, fabric proved singularly
susceptible to destruction by fire (see Aston's
example, below, of the pyx cloth at Rickmansworth).

Although most of the imaged textiles have
disappeared, the Edwardian inventories provide
ample evidence for the wealth of vestments at the
parish level, even in the simpler churches. Concise
parish inventories leave us only a teasing glimpse of
items like "stayned aulter clothes," but detailed
inventories marshal an array of saints and biblical
scenes embroidered on orphreys: St. Thomas of
Canterbury, apostles and prophets on matching sets
of copes and chasubles, apostles, virgins, and diverse
martyrs emblazoned on copes (St. Peter Mancroft,
Norwich); the espousals of Mary and Joseph, St.
Edmund, St. Nicholas, the Assumption and Corona-
tion of Mary, narrative sequences--the Annunciation,
Visitation, Nativity, and Baptism of Christ, biblical
schemata--apostles and prophets (College of Stoke-
by-Clare, Suffolk). What of the twelve vestments
and seventeen copes at the magnificent marshland
church of Walsoken, Norfolk, meticulously listed by

color and fabric? It is hard to believe that some, if not many, were similarly decorated with imaged orphreys.

However, we need more than a master inventory of imaged textiles that were destroyed or lost. We also need a rationale for the use of such images on ecclesiastical textiles and within the church fabric. The Reformers' objections to the saints are well known, such objections exacerbating their hostility to vestments. Strangely, Church historians have, by and large, agreed with the Reformers about the role of the saints in the devotional life of the late Middle Ages, with the result that even revisionists who have argued for a vital pre-Reformation piety grant that this piety was subjective, overly materialist, verging on the magical. Such assessments may in part reflect the bias of liturgical theologians, beginning at the turn of this century with the work at Maria Laach, who have singled out the late Middle Ages as the period in which the understanding of the liturgy was lost--the period when the *cultus divorum* replaced the *cultus divinus*. We would like to suggest that a different rationale is needed for the proper understanding of the cult of the saints--i.e., the approach suggested by Ugolnik when he refers to the place of the icon in the East, where it is not an independent cult object but rather is integrated into the liturgy. One has only to think of the procession of saints in the iconographic plans of churches like S. Apollinare Nuovo at Ravenna, the Pantocrator surrounded by Old Testament prophets as at Daphne, or the ranks of apostles in the narthex at Osios Loukas in Greece to appreciate the role of the saint's image in the liturgy celebrated in those

buildings. These saints do not "deck" (much less pollute) the atmosphere; they sacralize space and unite past with present, the earthly liturgy with that of heaven. If, from this Eastern rationale, we view the East Anglian parish church with its seried ranks of saints upon the rood screen, its life of Christ carved in roof boss or on font bowl, its prophets and apostles with their promise and fulfillment embroidered on the priest's vestments, we will see something startlingly different from that which was seen by the Reformers.

By approaching pre-Reformation piety from such a position we will also avoid the assumption that it was necessarily aliturgical, such an assumption being based largely on the fact that the people did not understand Latin (and some priests only poorly) and that they did not communicate regularly. From the standpoint of the liturgical reformer, these contentions are difficult to counter, particularly since there are few texts that illumine the nature of popular piety. However, the few texts that remain deserve focused study. For example, evidence from parish priests indicates the quality of their liturgical piety. Robert Parkyn, whom Sheingorn mentions in connection with the Easter sepulchre, was the curate of a small parish near Doncaster until his death in 1570. From some time around 1550 he kept an account of the liturgical changes. A rhetorical analysis of his style suggests just how painful these changes were, the repeated "no" acting as Leitmotif: "In anno domini 1547 on the Purification Day of Our Lady . . . , there was no candles sanctified, born or holden in men's hands, as before times laudably was accustomed," on Ash Wednesday "no ashes," on Palm

Sunday "no palms, no procession, on Easter Eve no fire was sanctified, no paschal candle, no processions unto the font, no candle present at the sanctifying thereof." A similar reaction, though in a different tone, came from Nathaniel Gill about one hundred years later when the rites of the Anglican liturgy were forbidden. He kept a record of his outrage in the parish register of Burgh-next-Aylsham in Norfolk, and in 1647 noted that he baptized according to the custom of the ancient church, "more meo--antiquo ecclesiastico." Although the education of both priests may not have been typical, their emotional reaction to liturgical changes suggests a vital rather than merely formal contact with the liturgy. Furthermore, we know that Parkyn was pastorally sensitive, since among his many projects he wrote a long versified life of Christ in English which he apparently read to his congregation.

If we move back into the fifteenth century, we have texts of two extraordinary women, Julian of Norwich and Margery Kempe. Even a superficial reading of these women's works reveals the impact painted images had on their piety, yet their piety is neither subjective nor overly materialist. Indeed the work of both women suggests that the liturgy was central in their piety rather than peripheral. The sacraments figure prominently in Julian's theology of the Second Person of the Trinity as nurturing Mother, and the liturgy with its annual cycle of feasts was the immediate source for the mystical experiences of the unlettered Margery Kempe, whose devotional life had its roots in her parish church of St. Margaret. In the end we may discover that pre-Reformation icon-rich liturgy, whatever its

flaws, remained a vital force in popular piety precisely because of the images. As Julian commented in her meditation on the twelfth revelation, she hoped "to see and thereby to learn." Perhaps in the long run Gregory had been right, though in a sense he had not intended. Unable to understand the Word of God they heard proclaimed in liturgy, the people saw the words in the images about them.

Although the majority of the articles in this collection focus on aspects of Reformation iconoclasm, two extend the chronological range: Ugolnik's study of the *Libri Carolini* and Nichols' consideration of Victorian restoration. It is also useful to recognize that the twentieth-century reform movement leading to and culminating in Vatican II is in actuality a continuation of the Protestant Reformation begun in the sixteenth century. In many a Roman Catholic church the baptismal font has disappeared to be replaced by a ceramic (rather than pewter) basin. Even the altar has been exchanged for a communion table, and prayers (including those of the Canon) are no longer spoken or intoned toward the East, the direction associated with the expectation of Christ's return in glory. Relics too have been downgraded, with their veneration being regarded as old fashioned--and this in spite of the very great antiquity of such veneration in the life of the Church. To give one example rather at random, a reliquary chapel at a college in the Midwest with a surprising array of relics is now rarely visited, while its Holy Stairs, conceived in imitation of the scala sancta (believed by some to have led to the praetorium where Christ was condemned by Pilate) at the chapel of the Lateran Palace in Rome, is seldom any longer

climbed by penitents. We are not making any claim here about the greater or lesser value of pre-Vatican II piety since to do so would raise a large number of complex issues which are not relevant to the present discussion. Nevertheless, we are concerned about the effects of current attitudes toward things seen, since in this aspect surely we are in the midst of a period of decadence. The visible and the physical seem to lack the power to convey a sense of transcendence, and with the loosening of the connection between the seen and the unseen lies a widening chasm that is symptomatic of the alienation of modern man who lives in a universe less understood at the same time that more is known about it.

Oddly also, while the role of seeing, of the visual in the process of cognition and learning has become recognized and respected, religious practice has increasingly rejected things seen, including images and relics, as paths to transcendent experience. Such a direction, which serves to disconnect the present from the past, is anti-ritualist and anti-traditional; it ignores even the role of tradition in establishing our entire culture and our ways of thought. This kind of change, we believe, involves loss. But herein also lies another field for the study of iconoclasm--the destruction of church art since Vatican II. The modern art historian is unlikely to mourn the loss of plaster statues that formerly adorned the wedding-cake reredoses of Catholic churches, but for the sake of ecclesiastical history we perhaps need a preservation society for pre-Vatican II church furnishings. A few unreformed churches still remain, often in conservative small towns, in

the United States, although in the upper Midwest
city in which one of the editors resides the only such
church is St. Martin's Lutheran Church--a reminder
perhaps of the tendency in Lutheranism from the
beginning to conserve church art. Some Anglo-
Catholic churches also are intent on preserving the
visual effect that for centuries was part of the
experience of the liturgy though only fully redis-
covered by Anglicanism in the nineteenth century
largely through the efforts of the Cambridge Camden
Society and the so-called "high Church" movement of
that time. Thus, for example, the church of All
Saints, Margaret Street, London, designed in 1849
by William Butterfield with the intent of building a
liturgically "correct" church that would serve as a
model, still retains its imagery and its orientation to
the East. Similarly, at such a church as St. Mary the
Virgin, Bourne Street, not only is the Catholic
imagery still very much present, but also the music
sung at Mass on Sundays will transport the wor-
shipper to the eve of the Reformation which in
England swept away such glory.

We are grateful to colleagues who have en-
couraged us in the task of editing this volume and to
those librarians and archivists who have aided our
work in preparing our own research. Clifford
Davidson's research was aided by a summer research
fellowship and grant from Western Michigan Univer-
sity, and Ann Eljenholm Nichols acknowledges
support from the Winona Foundation and Winona
State University, in particular Dean Richard Cough-
lin for granting her released time for research.
Permissions for the use of illustrations in this book
have kindly been granted by the British Library, the

British Museum, the City Council of Coventry, the Dean and Chapter of Canterbury Cathedral, the Dean and Chapter of Ely Cathedral, the Dean and Chapter of Westminster, the Huntington Library, the Cambridge University Library, the Royal Commission on the Historical Monuments of England, the Suffolk Record Office, *Country Life*, the rector of St. Thomas' Church, Salisbury, and the churchwardens of Cratfield Church as well as its former incumbent, the Reverend Ken Francis.

Clifford Davidson
Ann Eljenholm Nichols

The *Libri Carolini*:
Antecedents of Reformation Iconoclasm

Anthony Ugolnik

Reformation iconoclasm had a curious relation-ship to tradition. In its inception, it denied what had become a tradition of long standing in the medieval Church: the tradition of images and their veneration. That the reformers claimed Scripture as their auth-ority is, of course, widely recognized. Less fully realized, however, are the claims the reformers made upon a Church tradition of their own. Calvin, in his *Institutes*, identifies the "purer doctine" of the early Church in its hostility to images. That purity was interrupted, he maintains, by the Second Council of Nicea: "This Council decreed not only that images were to be used in churches, but also that they were to be worshipped." Calvin then makes an interesting contrast:

> Those who defend the use of images appeal to that Synod for support. But there is a refutation extant which bears the name of Charlemagne, and which is proved by its style to be a production of that period. It gives the opinions delivered by the bishops who were present, and the arguments by which they supported them. (*Institutes*, I.xii.14)[1]

1

Calvin thus associates the Byzantine council called under the Empress Irene with a break in the purer tradition of the Church, a tradition which he sees affirmed in the Carolingian document, the *Libri Carolini*. The English reformers endorse and expand Calvin's position. In "An Homilie agaynst perill of Idolatry and Superfluous deckyng of Churches," a long homily appended early in Queen Elizabeth's reign to the Church of England's collection of sermons and homilies, the homilist elaborates upon the contrast between the Byzantines and Carolingians. His contrast, however, is more complex than Calvin's. Irene in her wicked endorsement of images becomes a machination, contrary to the will of godly Byzantine kings. The homily thus refers to the Byzantine iconoclast Leo III as "Sirian borne, a very wyse, godly, mercyfull and valiant prince."[2] In alliance with these godly iconoclastic monarchs is Charlemagne, whose treatise on images is clearly familiar to this author as well:

> Notwithstandyng, the booke of *Carolus magnus* his owne wrytyng, as the tytle sheweth, which is nowe put in print and commonly in mens hands, sheweth the judgement of that Prince, and of the whole counsell of Frankforde also, to be agaynst Images, and agayste the Seconde counsell of Nice, assembled by Hirene for Images, and calleth it an arrogant, folyshe, and ungodly counsell, and declareth the assemble of the counsell of Frandforde to have been directly made and gathered agayst that Nicen counsell and the errours of the same.[3]

An important element in the discussion of both Calvin and the Elizabethan homilist is the new awareness of this Carolingian document and of the importance of that document in confirming and

authenticating the grounds for the reformers' icono-
clasm. Byzantine iconoclasm and what the reformers
see as its Carolingian affirmation clearly prefigure
the new iconoclasm of the Reformed Church.

This realization challenges some common as-
sumptions about the reformers' relationship to early
medieval thought. Without a recognition of the *Libri
Carolini* and its Byzantine context, the Carolingians
seem to be the founders of, or at least the antecedents
to, the medieval Catholic tradition which the reform-
ers rejected. It was this very tradition, it may thus be
assumed, which the reformers sought to "loop over" in
their effort to connect with the authentic and primi-
tive early Church.

This discussion is meant to illuminate the "tradi-
tion" of iconoclasm in the Western Church. It will
attempt to examine the Carolingian mind and see it
in reaction to or *reform of* the Christian mind of the
East, a mind which in its own era occupied a privi-
leged position of prestige, wealth, and honor. To
those sensitive to the resonances of Byzantium in the
West, the Carolingians themselves emerge as self-
conscious "reformers." By their own admission, the
Reformation iconoclasts rejected the Byzantine
champions of images and identified with their Caro-
lingian critics. To examine the medieval Caroling-
ians is to understand the Reformation iconoclasts
more fully. The eighth-century scholars and eccle-
siastics of Charlemagne's court consciously revised
the epistemology of the Christian East as they laid
the foundation for a Western Christian aesthetic, an
aesthetic from which the Reformation freely draws.
In doing so, the intellects of the eighth century also
recast the relationship between civil and ecclesias-

tical authority in a way which anticipated and prefigured the mind of the Reformation.

This thesis demands a premise: that we view the West in the early Middle Ages as a world in intellectual and spiritual commerce with the East. It is a premise fully established in recent scholarship, but one which has yet to make its full impact among medievalists. A Gibbonesque view of the dark labyrinths of Byzantium, replete with sinister eunuchs and inscrutable conspiracies, has its heritage in our long failure to recognize the Eastern stamp upon the early Western mind. The emergence of that stamp was quite literal in the excavations at Sutton Hoo. The rich find of the Old English ship burial with its many Byzantine artifacts proves that Byzantine works of art, at least, were highly valued as early as 625.[4] Extensive coin-hoards uncovered in subsequent Germanic excavations also reveal that the early Germanic coin artists repeatedly employed Byzantine symbols to indicate the transformation of tribal chieftains into self-consciously Christian kings.[5]

The Old Irish Church, in metalwork and manuscript illumination, shows the geometric minuet characteristic of Coptic models.[6] Not only in art, but also in liturgy the Old Irish show an Eastern stamp: in their dating of Easter and the tonsure of their monks, the Celts followed Eastern models. Nonetheless, the assumption has been that with the Synod of Whitby in 664 the Roman practices favored by the Anglo-Saxons prevailed in the Germanic world. Indeed, Pope Gregory I (590-604) himself admitted that he did not know Greek--even after his service as a papal legate in Constantinople. And a

survey of source books known to Anglo-Latin writers, while it uncovers translations from the Greek, reveals a dearth of actual Greek sources.[7] An acceptance of pervasive Latinization in the West has allowed us to see the Carolingian era in some isolation from the Eastern Empire with which it was consistently engaged.

Yet from this perspective scholars can see the relationship between East and West from but one side of the lens. As the Slavicization of the Balkans caused a displacement of a Greek-speaking and Byzantine population, the Italian peninsula hosted a substantial Greek immigration. Another influx of Byzantine refugees accompanied the Arab invasions of Palestine, Syria, and Egypt. But, most importantly, the iconoclastic movement initiated by the Emperor Leo III created massive social upheaval and a civil war in two phases, 717-87 and 815-43. As the defenders and opponents of religious images contested with each other for dominance, a population deeply affected by this controversy and immersed in the Byzantine intellect moved West. Nor was the influx limited to the south of Italy; it reached Rome and further westward. Thus in a search for any "Byzantine influence" which affects the Carolingians, we must look to the Greek people themselves who, in the fluid linguistic environment of the medieval world, made their influence felt in the idiom of the area in which they settled.

Pope Agatho (678-81) was a Greek from Sicily. In the next century Pope Zacharias (741-52) came from the Greek population of Calabria. Of the intervening decades, H. J. Magoulias observes that eleven of thirteen popes were Greek-speaking.[8] Theodore, the

long-reigning second Archbishop of Canterbury (668-90), was a bishop from Tarsus in Asia Minor, a former student at Justinian's school in Athens, and a Byzantine.[9] Hadrian, his deputy, was also a Byzantine from Africa. The cathedral schools Theodore founded among the newly-Christianized Anglo-Saxons gave special attention to the study of Greek, and he himself in his *Penitentials and Canons* presents a Byzantine rationale for sacral kingship. Thus Theodore, the agent of the consolidation of civil and religious authority in a newly Christianized realm, sees a mimetic relationship between the monarch and the Christian subject. The faith of the people reflects the faith of their "right believing" monarch.

The cult of Constantine, with its own full development in the West, is an outgrowth of this Byzantine-derived rationale for kingly authority. Indeed, Carolingian and Old English sources show that Constantine came readily to mind as the kingly victor *par excellence.* Thus Clemens, writing to a Carolingian general fighting in Bavaria at the ends of the empire, instantly evokes Constantine:

> Tribuat Dominus victoriam Daissiloni et omni populo eius, sicut dedit regi Constantino filio Helenae, cui Dominus ostendit signum crucis in coelo nocte ante pugnam et audivit vocem dicentem sibi: "Constantine, in hoc signo vinces." Hinc portata est crux ante eum in pugnam et omnes barbares fugerunt illi.[10]

> May the Lord grant victory to Tassilon and all his people, as he did to king Constantine the son of Helen, to whom God revealed the sign of the cross in heaven the night before battle. He heard a voice saying to him, "Constantine, with this sign you shall conquer." This cross was borne before him in battle and all the barbarians fled.

Sedelius the Scot, in the genre of the Fürstenspiegel favored by his age, also sees Constantine as the extension of the Old Testament covenant with the godly kings in the new dispensation.[11] Sedelius reflects Charlemagne's own tendency to see himself as *novus Constantinus*, and in the Carolingian sources we see that the term *barbaroi*, used by the Greeks to signify non-Byzantines, now comes to signify those Arians or non-Christians who do not fall under the power of the Christian king. The Christian leader takes on a martial role; indeed, the monarch comes to champion a militant Christian order. Sedelius goes so far as to invoke the example of Constantine to prove that war is a more beneficial social activity than peace:

Interdum vero plus nobis utilia sunt bella et qualibet adversa quam pax et otium, quia pax delicatos et remissos facit ac timidos: porro bellum et mentem acuit, et presentia quasi transeuntia contemnere persuadet. Ac saepe superna disponente gratia dulcissimos fructus majoris pacis et concordiae progenerat. Unde et Constantinus imperator, Suaviores, inquit, sunt amicitiae post inimicitiarum causas ad concordiam restitutae.[12]

Now and then wars and adversities of any sort are more useful to us than peace and tranquility, for peace fosters softness, inactivity, and cowardice: war, on the other hand, both sharpens the mind and encourages the scorn of present material things as if they were transitory. Also, a celestially granted peace has often engendered the sweetest fruits of a greater peace and concord; wherefore, the Emperor Constantine said, "Sweeter are those alliances restored to concord after causes for enmity."

Thus the Byzantine Theodore is instrumental in

shaping the model of Christian kingship in the West, and the Constantinean archetype itself takes root in Western soil. Indeed, the Byzantine Constantine Porphyrogenitus himself sees Constantine as a figure who symbolically connects his realm to that of the Western Franks, "quia illis ex partibus originem duxerat; cognitio enim et commercia magna erant inter Francos et Romanos." Constantine's Western origins as well as the great commerce between the Franks and the Byzantines meant that the Byzantine emperors regarded the Franks alone as the only non-Greeks with whom the Byzantine royalty could form a marriage alliance.[13]

This vision of Christian kingship, with its Byzantine antecedents, engenders an important new evaluation of the source of authority in the Church. For just like the Elizabethan reformers who cited them, the Carolingians placed the king at the center of the political and theological cosmos. As the Byzantines fought bitterly for more than a century not only over the role of images but also over the role of the king in deciding the dispute, the Carolingians too engaged in a re-evaluation of episcopal authority. The bishop, in repeated sources, takes on a role supportive to that of the monarchy but by no means independent of it. The bishop, indeed, sustains the religious order in co-regency with the monarch.

Once more Constantine emerges as the paradigm for this political and religious synthesis: just as the king is obliged to lead and call together the bishops in council, so also the bishops were obliged in turn to direct the king and the nation in the path of right doctrine. Jonas of Orléans in his *De institutione regia* (c.834) cites a speech which Constantine is said

to have delivered to his bishops: "Vos enim nobis a Deo dati estis dii, et conveniens non est ut homo judicet deos, sed ille solus de quo scriptum est: Deus setetit in synogoga deorum; in medio autem deos di judicat"[14] ("For you are gods given to us by God, and it is not suitable that man should judge the gods, but he alone of whom it is written: God stands in the assembly of the gods: yea in the midst he adjudges the gods"). The significant development of this theme is related directly to the Carolingian ecclesiology. As Ullman describes it, "the king . . . was exalted by the ecclesiastics with all the doctrinal and biblical ammunition at their disposal; the bishops and other higher ecclesiastics were enhanced by the Ruler in their status by his governmental measure."[15]

These ideas are linked not only to the iconoclastic controversy then raging in the East but also to the Reformation to come. The model of sacral kingship deeply affects the Carolingian perspective upon the *magisterium* of the Church. In hagiography and epic works such as Cynewulf's *Elene*, the poet consistently exalts the sacral priesthood of the monarch. It is from him indeed that the sanction for episcopacy springs. In the following excerpt from a letter to Charlemagne written by Alcuin in June 799, the Anglo-Saxon scholar plainly casts Charles in the role of the universally redemptive king. Alcuin in fact challenges the very centrality of papal authority:

> Nam tres personae in mundo altissime hucusque fuerunt: id est apostolica sublimitas, quae beati Petri principis apostolorum sedem vicario munere regere solet; quid vero in eo actum sit, qui rector praefate sedis fuerat, mihi veneranda bonitas vestra innotescere curavit. Alia est imperialis dignitas et secundae Romae saecularis

potentia: quam impie gubernator imperii illius depositus sit, non ab alienis, sed a propriis et concivicibus, ubique fama narrante crebrescit. Tertia est regalis dignitas, in qua vos domini nostri Iesu Christi dispensatio rectgorem populi christiani isposuit, ceteris praefatis dignitatibus potentia excellentiorem, sapientia clariorem, regni dignitate sublimiorem. Ecce in te solo tota salus ecclesiarum Christi inclinata recumbit.[16]

Up to this time there have been three persons who were the highest in this world: one is the Apostolic Majesty [the Pope], who is accustomed to hold as vicar the seat of blessed Peter, prince of the Apostles; of what has been perpetrated upon him, who has been the right ruler of that See, your grace has informed me. Another is the imperial dignity and secular power of the Second Rome [Constantinople]: how its impious ruler has been deposed from his empire, not by foreigners, but by his own people and co-citizens, is a tale which travels everywhere in the telling. The third is the regal dignity in which the rule of our Lord Jesus Christ has provided you as ruler of the Christian people, your power more excellent than that of the others I have mentioned, your wisdom clearer, your royal dignity more sublime. The whole safety of the Churches of Christ rests in you alone.

Clearly, the instability of Constantinople stands in contrast to the power of Charlemagne, whose celebrated papal anointing is to occur but a year after the letter is written. The Old English verb that describes this rite is *trymman*, "to strengthen or confirm." Thus Cynewulf says of Constantine: "Hine god trymede,/ mærðum ond mihtum" (*Elene*, ll. 14-15) ("God confirmed him with glory and might").[17]

The iconoclastic movement in Byzantium, far from supressing all pictorial arts, served in fact to exalt imperial images. Though the iconoclasts smashed religious images, it is important to remem-

ber that they allowed images of the emperor: in fact, they are said to have decked the interior of basilicas with royal portraiture. Georges Ostrogorsky sees the iconoclastic movement as representing an exaltation of the secular royal image.[18] Roger Hinks characterizes the nature of the imperial imagery which gained ground in the West during the iconoclastic controversy:

> [W]e may also find on the Aurelian column, and with increasing frequency in later works, a different type of *adlocutio* scene, in which the emperor and his staff are centrally placed, with the audience grouped in a ring all round: here the psychological current is radiated outward from a center. This is the aristocratic and medieval conception; and instead of a scene, in which all the elements are of balanced importance, we have an effigy occupying the middle of the picture and subordinate accessories, human and material, disposed as a sort of framework about the central point of focus.[19]

Significantly, the cross--an image aligning the victorious standard of the Christian monarch with the victory of Christ--becomes a central symbol among the Byzantine iconoclasts.[20] Similarly, the eighth and ninth centuries see a shift in iconographic representation in the West. The simple cross becomes a frequent symbolic theme, often associated with the monarch's victorious power. In this period the *inventio crucis* theme and its liturgical feast become standardized in the West.

The *Libri Carolini* are those books commissioned by Charlemagne to register the Carolingian reaction to the Second Nicene Council in 787, the Byzantine Council which restored images and concord between the Church and the Empress Irene. It is no wonder,

then, that the iconoclastic reformers took up the spirit of reform implicit in those books when they first encountered them; the rhetoric of the Elizabethan homily "agaynst perill of Idolatry" pulses in synchrony with the Carolingian invective against the East. Modern Western scholarship has focused upon the internal political significance of these documents. Commentary upon their intellectual import has been sparse. Yet in these books, which register a critical reaction to the proceedings of the Council, we see a crucial development. At this early point in ecclesiastical history--long before any formal schism between East and West and even longer before any synchronized Reformation in the West--the Carolingians see themselves as conscious reformers. Under the standard of an enlightened monarch, they oppose and criticize the decisions of an errant council. It is this reformist and iconoclastic mentality in the *Libri Carolini* which the later reformers recognized and adapted to their own purposes. In the *Libri Carolini* the iconoclastic reformers found, already shaped, a mentality which is significant to the development of Western epistemology.

The Second Nicene Council, which restored images, sanctioned the ritual and cultic honor paid to them in worship. The authors of the *Libri Carolini*, as has been noted with frequency, misunderstood the distinction in the Council documents between the worship offered to God (*latreia*) and the veneration due to images of Christ and the saints (*proskynesis*). Relying on a poor translation of the Council proceedings, the Carolingians read both terms interchangeably as the Latin *adoratio*; the authors of the *Libri Carolini* thus condemn at great

length what they see as the Greek sanction of idolatry. The Elizabethan homilist refutes a like distinction in his own attack against the proponents of images:

> And yf they say they exhibite that hounoure not to the Image, but to the Saint whom it representeth, they are convicted of folly, to believe that they please Sainctes with that honour which they abhore, as a spoyle of Godes honour.
> And herewithal is confuted theyre lewde distinction of *Latria* and *Dilia*: where it is evident that the Sainctes of God, cannot abide that as muche as any outwarde worshippynge be done or exhibited to them.[21]

The Elizabethan reformer, though he cites the *Libri Carolini* as a general authority, is responding to a finer distinction. He sees beneath the Latin translation to a fuller distinction inherent in the Greek; yet he adheres to the basic intellectual position of the Caroline texts. The modern scholar too can respect the document of the Caroline books as a testimony to the Carolingian mind. First, the books confirm the emerging Western attitude toward the authority in the Church and its proper administration: the books reveal a pronounced ideological sympathy with the iconoclastic emperors and their reliance upon the cross as a central symbol. Secondly, the books also testify to a distinctly Western attitude toward the arts--an attitude in harmony with the text-centered, word-anchored understanding of the Reformation reformers. Calvin's endorsement of the *Libri Carolini* as books which constitute an authority in harmony with the pure iconoclastic tradition of the Church is proof of his own resonance to the rhetoric of the text. (It is interesting to note

that because of this hospitality of the Caroline books to the Reformation mind, they were listed on the Roman Catholic Index into this century.)

From the very beginning of the text, the books claim Constantine to be in concert with his bishops as the central authority: Constantine is the king who has liberated the world from idols, and it is his exegetical model which the *Libri Carolini* seek to follow (*Praefatio*). In fact, it is Constantinean texts which the first book of the series purports to follow. Drawing from such sources as Constantine's letters to Pope Hadrian (I.iv), the textual structuring of the books creates a resonance between kingly and episcopal authority. The ultimate authority of the argumentation comes from Scripture: yet the scriptural quotes are contained within the frame of Constantine's own counsel to pope or bishop. The two forces, episcopal and royal, thus reinforce each other.

Clearly, it is the phenomenon of *text* in the *Libri Carolini*, whether scriptural or epistolary, which is the very source of meaning. The text supersedes the image. The very act of intellection, whether applied to image or to Word, proceeds from within the soul. The first book makes a clear distinction between the faculties of the "interior" and "exterior" person. Clearly, it is the "interior person" which is made in the image of the Triune God: it is the confusion of this quality with the "exterior person" which has made the error of the Second Nicene Council possible. The fallen Adam is the corruptible exterior man; Christ is the incorrutible interior: "Quomodo ergo est ipse et exterior ac secundum corpus, ut interior sit secundum animam; et interior sit resur-

rectio et renovatio, quae nunc fit secundum mortem prioris vitae, id est peccati, et secundum regenerationem novae vitae" (I.vii) ("Thus the exterior is according to the body, that the interior may be the resurrection and renovation which will bring about the death of the first life, that is the life of sin, and effect the regeneration of new life").

Images, then, as the books explain, exist not that they might be "adored" or honored for their own sake, but that they might bring about the instruction of the inner man. Book II in its chapter headings repeatedly articulates the theme *quomodo intelligendum est*: the book seeks to explain the method "whereby it is to be understood" what role images in fact play in the Christian context (II.iv). The Caroline books clearly cast images in a different light from that of the Byzantine world. The Second Nicene Council sees images in primarily a liturgical context: the image, in a symbolic enactment of Incarnation, "enfleshes" an image in artistic, material form and acts as a focus for prayer and the life of worship. The Caroline authors privilege the text and the very act of textual intellection. Sublimating the arts to the act of understanding, they see images as primarily vehicles for instruction (II.iv). The same book, on the same grounds, cannot exalt the Christian artist--who, after all, is but a kind of "craftsman"--over any other artisan who is engaged with other modes of production: "Quid enim ars pictorum amplius habet pietatis artis fabrorum, sculptorum, conflatorum, caelatorum . . . vel ceterorum opificum?" ("How, after all, is the art of iconography any more pious in nature than the art of carpenters, sculptors, farmers, woodcutters . . . or other craftsmen?") (II.xix).

John of Damascus, in refuting the iconoclasts, once asked, "Is not the ink in the most Holy Gospel Book matter?"[22] All the senses, in the thought of the Byzantine Fathers, become avenues of intellection. The arts, then, are not only a means of instruction, but also avenues of discernment. The *Libri Carolini* distance the Christian West from the East as they sharply delineate the incorporeality of the Godhead from the flesh in which it became manifest: "qui si invisilibilis est, imo quia invisibilis est, necesse est ut incorporeus sit; et si incorporeus est, necesse est ut corporaliter pingi non potest" (II.xvi) ("If [God] be invisible, verily because he is invisible, it is necessary that he be incorporeal; and if he be incorporeal, then of necessity he is not able to be corporally touched"). The authors make it clear that though Christ's human nature is indivisible from his divine essence, the understanding must clearly distinguish between the religious object (such as the cross) and that concept (mortality of the flesh, victory over death) which it is meant to symbolize. The distinction between the "interior" and "exterior" faculties, then, renders the image primarily a didactic rather than a liturgical concept.

In keeping with their perspective upon the liturgical role of the image, Byzantine Orthodox sources have traditionally seen the artist in a sacerdotal light. The iconographer in the Eastern tradition, often with prayer and fasting, engages in a sanctified act with sacramental overtones. The "sacramentality" of the artist in Eastern Christian thought anticipates the sacramentality of any creative, transfiguring social act. The *Libri Carolini*, however, sharply separate the image or the artist

from any sacramental role. The authors distinguish between the sacrament of the Eucharist in all its materiality and any correspondence or parallel with the materiality of the image:

> Multum igitur, et ultra quam mentis oculo perstringi queat, distat sacramentum Dominici corporis et sanguinis ab imaginibus pictorum arte depictis: cum videlicet illus efficiatur operante invisibiliter spiritu Dei, hae visibiliter manu artificis: illud consecretur a sacerdote divini moniminis invocatione, hae pingantur a pictore humanae artis eruditione. (II.xxvii)

> Much therefore, and more than the eye of the mind is able to discern, distances the sacrament of the Lord's body and blood from the images depicted by the iconographer's art: while the one is effected invisibly through the work of the Spirit of God, the other is visibly produced by the hand of the artisan; the former is consecrated by the priest invoking the Divine Name, the other is painted by the artistry of a human agent.

It is interesting to see what Calvin does with this very distinction between image and sacrament. Rejecting the use of images in churches because such use leads directly to the danger of idolatry, Calvin in the *Institutes* alludes to "living symbols": "Even were the danger [of idolatry] less imminent still, when I consider the proper end for which churches are erected, it appears to me more unbecoming their sacredness than I well can tell, to admit any other images than those living symbols which the Lord has consecrated by his own word: I mean, Baptism and the Lord's Supper, with the other ceremonies" (I.xi.12).

Book III of the series develops the principle embedded in the distinction between visible art and invisible symbol. Working with the term *oculus*

mentis, the "mind's eye" as opposed to the fleshy eye of carnal materiality, the authors seek to undercut the reasoning of the Byzantines. Yet it is interesting to focus upon the epistemology of the *Libri Carolini* not only as it contrasts to that of the Byzantines but also as it reflects Carolingian assumptions about materiality. The Western authors privilege the text because of its accessibility to the "interior soul." The world of sense experience, on the other hand, is less trustworthy as an avenue to knowledge because of its vulnerability to manipulation and deceit. In Book III, for example, the text has a somewhat difficult time rationalizing the veneration of relics. Given the mistrust of corporeality already established in the previous chapters, the authors must account for a difference between relics, which still by tradition receive veneration, and holy images. The authors create a distinction, then, between the relics which are in no sense "representative," for they are of the body itself, and the images which merely portray the body (II.xviii).

Carolingians, of course, reflected the allegorical Augustinian mode of exegesis and recognized *levels of meaning* in Scripture. They also recognized *levels of reality* in Nature itself. Given to establishing the *substance* of elements such as darkness[23]--elements which later ages would regard as insubstantial--they were also mistrustful of the ephemeral nature of sense experience itself. The world was filled with the possibility of deception. Sense experience, then, could be trustworthy only when confirmed by God. John the Scot, one of the most developed meta-physicians of the era, posited a humanity ever posed between illusion and reality. Maintaining in his *De*

divisione naturae that "as many as the souls of the faithful, so many are the theophanies,"[24] John viewed the material world itself as "relatively unreal" when viewed in conjunction with the eternal reality of God.

Though John is unusual in his familiarity with Greek sources, he nonetheless helps to explain the extent to which the authors of the *Libri Carolini* rely upon the *oculus mentis*, the mind's eye which must discover the Absolute beneath layers of seeming. If this world itself is made up of substance--and yet substance is relatively removed from the absolute reality of God--how much more *relative* must the arts themselves have seemed. The term *adoratio* in the text of the *Libri Carolini*, then, though a mistranslation of the Greek, yet is an accurate translation of Carolingian perception. The liturgical context of images, which allows for their use in worship--the closest proximity to the absolute reality of the Divine--seems the fitting object of the scorn that the Carolingians heap upon the Byzantines: "illi dicunt opificum industria praeparatas figuras imaginem esse Dei. O excescrabilis error! o impudens dementia!" (II.xvi) ("They say that respect to the figures produced by human handiwork is respect paid to the image of God. O abhorrent error! O mad impudence!").

Early medieval commentaries on *Genesis* can illuminate their mistrust of sensory knowledge. The Old English reading of the *Genesis* account in the poem *Genesis B* shows that fallen humanity itself is the victim of a deceitful assault upon the senses. Eve in this account succumbs to Satan after considerable machination on his part, and even the poet seems overcome by the seeming injustice of the result:

Heo þa þæs ofætes æt, alwaldan bræc
word and willan. þa meahte heo wide geseon
þurh þaes laðan læn þe hie mid ligenum beswac,
dearnenge bedrog, þe hire for his dædum com,
þæt hire þuhte hwitre heofon and earðe
and eall þeos woruld wlitigre, and geweorc godes
micel and mihtig, þeah heo hit þurh monnes geþeaht
ne sceawode. . . . (*Genesis*, ll. 599-606a)

Then she ate the fruit, she broke the word and will of
the Almighty. Then she could see far and wide through
the endowment of the enemy who had deluded her with
lies, secretly betrayed her. Through his deeds she was
affected in such a way that heaven and earth seemed
more radiant to her and all this world seemed more
beautiful and God's work seemed great and mighty,
though she did not see it through human thought.

This is a significant insight into the early medieval
mind. Eve's fall comes in the midst of an intense
onslaught of pure sense experience. Although the
poet makes it clear that this beauty is apparent
rather than real, the experience is real enough to
Eve, as the vividness of the poet's language testifies.
The deception, in fact, calls into question the very
nature of beauty as perceived by the fallen creature.
The Tempter is no serpent but a pretended Angel-
Messenger of God who imposes upon the deceived
Eve a heightened, sensual perception of Divine
beauty. Though the poet plainly indicates that this
intense apprehension is outside the realm of human
thought, yet it is a sustained illusion which the
Demon reinforces.

The fourth and last book of the *Libri Carolini*, the
most philosophical in nature, is also the book which
most calls into question the categories of beauty and

sense experience as avenues to the divine. The authors have already anticipated the later development of Western religious thought in re-casting the nature of authority in the Church and developing a distinctly aliturgical epistemology. Now the Carolingian thinkers focus upon the illusory nature of beauty. Attacking the Byzantine ritual obeisance directed to images, the authors distinguish between the incorporeal nature of *adoratio* and the carnal, material nature of the liturgical honor sanctioned by the Second Nicene Council: "Adoratur enim Deus, sed non osculatur; venerantur sancti qui e saeculo cum triumphis meritorum migraverunt, sed nec adorari debent cultu divino, nec osculari possunt" (IV.xxiii) ("For God is to be adored, but not embraced; those saints who have passed into eternity with the triumph of their merits may be venerated, but they must not be adored with any divine cult, nor must they be paid reverence with the body [i.e. 'kissed']"). The text views the kind of ritual honor paid to images by the Byzantines as fitting honor for spouses to pay each other, or for "free" persons to bestow upon one another, but not as fitting honor for servants to pay to their Divine Master. Furthermore, it seems to the authors that the kind of multiple awareness required of the one who indeed pays ritual honor to the image, distinguishing between object and that which it represents, results in a distortion of an essential unity. "Quomodo ergo erit nominum tanta in sensu unitas, cum rerum in intellectu sit tanta diversitas?" ("How will there be such unity in the sense of things, when at the same time there is allowed such a diversity of things in the intellect?") (IV.xxiii). Like Eve at her fall, the soul

may fall victim to the deceit imposed by the "layers of seeming" in this fallen material world.

Painstakingly, complete with chart to illustrate Aristotelian distinction, the books conclude with a philosophical illumination of scriptural injunctions to love. One cannot "adore" images composed of a particular materiality and at the same time love the universal God (IV.xxv). In the attempt to show that the Byzantine mind has admitted of mutually exclusive propositions, the Carolingians also indicate their own reliance upon rational intellection as they perceive it. Images are by their very nature *particular*, partitive in nature. The Byzantine mind embraces the image as in its wholeness representative of the Divine, and binds the artist to strict convention lest the work of art be viewed as too distinct from all other particular images. The Western Carolingian mind, however, immediately measures the image against the Absolute it is meant to portray. The authors see beauty itself as relative, as partitive, as standing in the way of the purest religious perception:

> Nam si qualibet imago quanto pulchrior est, tanto amplius habet sanctitatis atque virtutis, necessa est ut ea quae feodior est, minus habeat sanctitatis atque virtutis, necesse est ut ea quae foedior est, minus habeat sanctitatis atque virtutis; et si ea quae foedior est minus habet, necesse est ut foedissima quaelibet aut nihil aut modicum habeat. . . . (IV.xxvi)

> For if a specific image is more beautiful to a certain degree, to that degree it has the greater measure of sanctity and virtue; it is also necessary to discern that the image which is less attractive has less sanctity and virtue. And if that which is less beautiful has less

virtue, then of necessity the least attractive icon of all
has either nothing at all or just a modicum of virtue. . . .

This Carolingian discussion illuminates the later
ambivalence of some iconoclastic reformers toward
the representational beauty of secular art and
drama. Beauty, in the Carolingian view, is qualified
and quantified. No beauty is of itself absolute; hence
the image will always by virtue of its materiality
stand apart from the fullness it is meant to portray.
It is in the text, in the Book, or perhaps in the
symbolic imagery of the cross that the mind will be
able to posit the fullness of the Absolute. In the
Carolingian perception, the image is a means of
instruction, an object of production, which can never
evoke the surrender which it does in the Byzantine
context.

Thus politically, and to a large degree philo-
sophically, the *Libri Carolini* show a sympathy with
an iconoclastic mentality. Their significance, how-
ever, is not limited to their own era; rather, scholars
should see the *Libri Carolini* as important docu-
ments heralding a distinctly Western religious and
critical consciousness. The authors consistently view
themselves as reacting against the errors of the East
in service to a universal Church (IV.xxix), and in
doing so they represent a trend in the West which
anticipates the Reformation. The simple figure of
the cross, which less zealous reformers saw as
exempt from the dangers of idolatry, the Carolin-
gians saw as a martial symbol distinguishing them-
selves from the Byzantines:

Hoc est nostri regis insigne, non quaedam pictura, quod
nostri exercitus indesinentur aspecium legiones. Hoc

est signum nostri imperatoris, non conpaginato colorum
quod ad proelium nostrae sequuntur cohortes.
(II.xxviii)

Not any sort of icon, but this [cross] is the standard of
our king, and upon it our armies and our legions cast
their eyes. This, not a blending of colors, is the symbol
of our emperor which our troops follow into battle.

There is much evidence that the iconoclastic under-currents in the West reached the surface soon after the *Libri Carolini*. Cynewulf ended his epic *Elene*, both a celebration of Constantine's kingship and an account of the *inventio crucis*, with a plea to observe the feast of the Holy Cross on 3 May.[25] By the 820's Dungalus the Scot complained of a Church divided in dispute involving representations of the saints and celebrations of the cross.[26] Dungalus engaged in a fierce debate with Claudius of Turin, a pure icono-clast who objected not only to images but also to cultic honor paid to the cross.[27] A number of ecclesi-astics, including Jonas of Orléans, became involved in the dispute,[28] and ultimately images and the religious arts found their honored place in the West. Pope Adrian responded to the *Libri Carolini* criti-cally with his own defense of images.[29] Yet the legacy of the Carolingian authors is an articulation of the Western attitude towards the arts and the image. This legacy emerged in the Reformation-era printing of the *Libri Carolini*, and it helped to shape the thought of the iconoclastic reformers.

The Reformers, and Calvin in particular, emerge in continuity with a Western tradition apparent in the Carolingians. St. Augustine, the Doctor of the West, dramatically illustrates a Western paradigm.

Sequestered in his garden with Paul's Epistle to the Romans at hand, he hears a voice: "Tolle lege," "take up and read." When Augustine takes up the Book, he creates a primary epistemological model for the West, a model which the Carolingian authors embrace. The reader relates to the text and therein finds meaning. In approaching the very phenomenon of meaning, it is this model to which the Western mind turns in the act of interpretation. When the Renaissance mind speaks of the world itself as God's book, materiality itself is envisioned not as an image primarily but rather as a text. Calvin in the first book of the *Institutes* reveals the terms of his own act of interpretation: "on each of his works his glory is engraven so bright, so distinct, and so illustrious, that none, however dull and illiterate, can plead ignorance as their excuse" (I.v.1).

Calvin in all his imagery sees the act of reading as the central metaphor for discerning meaning and the text as the source of meaning itself: "There is no part of the world or its creatures so small, so apparently insignificant, that it does not contain some perspicuous mark of divine nature" (I.v.1). As Thomas Luxon observes in his discussion of Calvin on Word and Image, Calvin sees God as having "written" himself upon the world. Each element in the cosmos constitutes an orthography, a character in a vast document. "Looking at things is presented under the metaphor of reading and interpreting words. And the failure of communication in this literary affair bespeaks not so much a *deus absconditus* as a *homo obtusus*."[30]

Luther chooses another model, that of "the story," for conveying the fullness of truth. In his popular

preaching, Luther seeks to relieve the Gospel of textual weight: "The gospel is a story about Christ, God's and David's Son, who died and was raised and is established as Lord. This is the gospel in a nutshell."[31] Though emphasizing the oral transmission of its contents, Luther recognizes the text as prime referent. Ultimately, he too returns to the Book as his source for validation: "Gospel is and should be nothing else than a discourse or story about Christ, just as happens among men when one writes a book about a king or prince, telling what he did, said, and suffered in his day."[32] Thus Luther, like Calvin, adopts the Book as the central epistemological metaphor. Hermeneutics becomes a relationship to the written word.

The Second Nicene Council, on the other hand, articulates for the East the centrality of the Image. As John of Damascus writes, "Just as words speak to the ear, so the image speaks to the sight. It brings us understanding."[33] By placing its declaration on images in the context of a proclamation on worship, the Council did two important things which distinguished the religious sensibility of the East from that of the West as we have seen it in the *Libri Carolini*. First of all, among the Byzantines the quest for meaning emerges in a liturgical, communal, sociocultural context. The terms of individualism take on their own character in the West as the hermeneutic act becomes primarily one of the reader relating to the text. Secondly, the Byzantines also established liturgy, with its orchestrated appeal to all the senses, as the central vehicle for theological meaning. Liturgy itself, in communal celebration, creates the *context* for the *text*, fully engaging the

body as well as the mind. The Carolingians, like the Westerners who would follow, placed the act of intellection in the *oculus mentis*, the "mind's eye" of intellectual discernment. The Byzantines celebrate the image: the Word made Flesh, material and incarnate, communicates himself materially and "in-carnally" as the Image of Christ. The Carolingians see images as but peripheral to the centrality of the text.

Viewed in this light, we can see the early medieval mind not as the antithesis of the Reformers who followed, and against which they reacted, but instead as their precursor. Both Calvin and the authorized Elizabethan homilist cited the *Libri Carolini* as authoritative books expressive of a *pure*, unsullied tradition in the Church which they applied in their own contemporary context. The reaction against the image, in this sense, is the *primal reform* which gives birth to the principle underlying the Western arts. Even before the reader develops the sense of autonomy which shapes modern critical theory, we see the birth of a distinctly Western consciousness. *Allegoresis* makes a book of the cosmos: in the "Book of Nature" the medieval intellect figuratively "reads" the phenomena apparent to the senses. The medieval Dreamer, in literary convention, "falls" in sleep from the book on the lap to the rich and morally significant world within. In the hermeneutic of Western medieval narrative, as in the polemic of the Reformers, the Book forms the medium through which meaning is discerned.

Similarly, in league with the theological mistrust of the Image as a theological vehicle grows the individuality of the artist, the *artistic autonomy*

27

which emerges as the arts grow more secular. The self-portrait is born. In the margins of manuscripts and interwoven with their illumination, the tiny portrait of the artist appears, bowing in homage before the saints he has drawn. In contrast, the Eastern artist remains as invisible as he is anonymous. Eventually, just as Western guilds celebrate master craftsmen, Western artists too draw admiration to themselves as well as to their works. Reflecting the analogies of the *Libri Carolini*, artists organize themselves much as weavers or carpenters or woodcutters do. And in literature, within the realm of the book itself, the persona of the artist becomes a conscious actor within the text the artist creates. As an example we can turn first to Cynewulf, contemporary of the Carolingians, who weaves the runes which spell his name into the conclusion of his epics. He becomes the first *self-named* English artist, and his name is itself his self-portrait. In the runic passages Cynewulf makes of himself a kind of Everyman reflecting the conversion narrative itself. He becomes a paradigm of the Western Christian artist, finding meaning through the text which is his central metaphor.

Eastern Orthodox theologians and scholars have long seen the heritage of iconoclasm in the Reformation.[34] But those familiar with Byzantine thought can draw even more striking parallels. From the perspective of the Christian East, Reformation iconoclasm did not spring anew in the intellectual history of Europe, but rather drew from its own established tradition in the West. Standing within the Byzantine tradition, and themselves employing the epistemology of the Image, scholars of

the Christian East have drawn the conclusion that the Western Church is more unified an organism than the Western mind, employing its usual methodology of distinction and contrast, has been willing to recognize. In the Caroline books, the reformers recognized an iconoclastic tradition which had shaped Western attitudes toward the arts.

The *Libri Carolini*, long centuries before the Reformation, show indeed a hospitality to the principle of reform. The reformers themselves were aware of it. A thoughful re-examination of this long-neglected document provides some valuable insights. Ann Freeman thus has recently begun to place the *Libri Carolini* in a Reformation context.[35] Margaret Aston, in her thorough work on iconoclasm in England, has also documented the influence brought to bear on Calvin through the publication of Jean du Tillet's Paris edition of the *Libri Carolini* in 1549.[36] The present essay attempts to extend the discussion by showing the Caroline books in their aesthetic and critical context. Modern critical theory is self-enclosed in its exclusively Western assumptions about text and epistemology, and examination of the Carolingian West in the light of its reaction to the Byzantine East places Reformation iconoclasm in clearer perspective. The Carolingians show us that the Western hermeneutic has indeed been an integral process and the product of a long tradition. They also show us the birth of a distinctly Western aesthetic--an aesthetic which arises in reaction against the centrality of the image in Eastern Christian thought. In the *oculus mentis*, the "mind's eye" of the *Libri Carolini*, we can see the first glints of a Reformation consciousness.

ANTHONY UGOLNIK

Notes

[1]John Calvin, *Institutes of the Christian Religion*, trans. Henry Beveridge (Edinburgh: T. and T. Clark, 1863), p. 102. All subsequent citations are from this edition.

[2]*Certayne Sermons, or Homilies* (London, 1563), II, fol. 33.

[3]Ibid., II, fol. 38.

[4]See Rupert Bruce-Mitford, *The Sutton Hoo Ship Burial, I: Excavations, Background, the Ship, Dating and Inventory* (London: British Museum, 1975).

[5]For a list of Byzantine coin-hoards dating from the Carolingians era but excluding Sutton-Hoo and Crondall, see ibid., pp. 665-66.

[6]H. W. Haussig, *A History of Byzantine Civilization*, trans. J. M. Hussey (New York: Praeger, 1971), p. 236.

[7]J. D. A. Ogilvy, *Books Known to the Anglo-Latin Writers from Aldhelm to Alcuin (670-804)* (Cambridge, Mass.: Medieval Academy of America, 1936).

[8]Harry J. Magoulias, *Byzantine Christianity: Emperor, Church, and the West* (Chicago: Rand McNally, 1970), p. 90.

[9]*A Dictionary of Christian Biography*, ed. William Smith and Henry Wace (London: John Murray, 1887), IV, 926-32.

[10]Clemens, *Epistolarum*, ed. Ernest Duemmler, Karolini Aevi, Monumenta Germaniae Historica, 2 (Berlin: Weidmann, 1895), IV, 496.

[11]*Patrologiae cursus completus*, series Latina, ed. Jacques Paul Migne (Paris: Garnier, 1800-75), CIII, 318; hereafter cited as *PL* (Greek series as *PG*).

[12]*PL*, CIII, 343.

[13]*PG*, CXIII, 185-86. For an English translation of this text, see R. J. Jenkins, trans., *Constantine Prophyrogenitus: De Administrando Imperio*, ed. Gy. Moravsik (Budapest: Institute of Hellenic Philology, 1949).

[14]*PL*, CVI, 286.

[15]Walter Ullmann, *The Carolingian Renaissance and the Idea of Kingship* (London: Methuen, 1969), p. 56.

[16]Clemens, *Epistolarum*, IV, 288.

[17]*The Anglo-Saxon Poetic Records*, ed. George P. Krapp and Elliott Van Kirk Dobbie (New York: Columbia Univ. Press, 1931-42), II, 66. Subsequent citations of Old English poetry are to this edition.

[18]See George Ostrogorsky, *History of the Byzantine State*, trans. Joan Hussey (New Brunswick, N.J.: Rutgers Univ. Press, 1969), p. 173.

[19]Roger Hinks, *Carolingian Art* (London: Sidgwick and Jackson, 1935), p. 128.

[20]*PL*, XCVIII, 1002. Citations from the *Libri Carolini* refer to this edition, cols. 1002-1243.

[21]*Certayne Sermons, or Homilies*, II, fol. 53.

[22]*Apology* I, 16, in John of Damascus, *On the Divine Images: Three Apologies Against Those Who Attack the Divine Images,* trans. David Anderson (Crestwood, N.Y.: St. Vladimir's Seminary Press, 1980), p. 23.

[23]See, for example, the argument of Fredegisus that darkness, if it truly lay over the face of the abyss, was tangible and palpable and hence *etiam corporales esse* ("of corporeal substance") (Clemens, *Epistolarum*, IV, 555).

[24]Henry Bett, *Johannes Scotus Erigena: A Study in Medieval Philosophy* (Cambridge: Cambridge Univ. Press, 1925), p. 25, quoting and commenting upon Scotus' *De divisione naturae* V.7.

[25]"May the door of hell be shut, that of heaven revealed, the kingdom of angels eternally opened, joy unending, and the lot shared with Mary of every one who keeps in mind the festival of the most precious cross . . ." (*Elene*, ll. 1228b-1235).

[26]Clemens, *Epistolarum*, IV, 583.

[27]See M. L. W. Laistner, *Thoughts and Letters in Western Europe, A.D. 500 to 900*, 2nd ed. (Ithaca: Cornell Univ. Press, 1966), pp. 290-91.

[28]Clemens, *Epistolarum*, IV, 611.

[29]*PL*, XCVIII, 1242.

[30]Thomas Luxon, "Calvin and Bunyan on Word and Image: Is There a Text in the Interpreter's House?" *English Literary Renaissance*, forthcoming.

[31]"A Brief Instruction on What to Look For and Expect in the Gospels," in *Word and Sacrament I*, in Martin Luther, *Works*, ed. E.

Theodore Bachmann and Helmut T. Lehmann (Philadephia: Muhlenberg Press, 1960), XXXV, 118.

[32]Ibid., XXXV, 117.

[33]John of Damascus, *On The Divine Images*, p. 25.

[34]See, for example, Leonide Ouspensky, *Theology of the Icon* (Crestwood, N.Y.: St. Vladimir's Seminary Press, 1978), p. 145.

[35]"Carolingian Orthodoxy and the Fate of the Libri Carolini," *Viator*, 16 (1985), 65-108.

[36]*England's Iconoclasts: Law Against Images* (Oxford: Clarendon Press, 1988), pp. 33ff.

The Anti-Visual Prejudice

Clifford Davidson

In the discussion of drama and art--i.e., of imag-
inatively conceived *things seen*--of the historical
period which follows the Middle Ages, there is
currently the likelihood that we might see a ten-
dency to identify the anti-visual prejudice as a
specific and unique Reformation phenomenon leading
to acts of iconoclasm directed against both visual
arts of a religious nature and the religious theater[1]--
acts of iconoclasm that would, after a certain point,
be extended to the secular stage,[2] also eventually to
be suppressed in 1642. Nevertheless, while neither
the iconoclasm of the Reformation nor even its effect
on the theater may be regarded as historically
unique if we examine the Byzantine iconoclasts or
the anti-representationalist artistic stance of Islam,[3]
the anti-theatrical prejudice which has been so ably
described by Jonas Barish[4] does in fact rest in part,
at least for the Renaissance, on the foundations in
Western Europe of an unparalleled iconoclastic
fervor that wished for the destruction of all images
with sacred content. The religious phobia which was
the driving force behind such iconoclasm in turn was
rooted in medieval thought about cognition and

vision. It will thus be useful to survey not only the nature of Reformation iconoclasm but also its historical relationship to the understanding of the sense of Sight.

We all know that the latter part of the Middle Ages was particularly enthusiastic about images that appealed to the eye and the imagination; medieval churches were decorated with statues, carvings, wall paintings, and painted glass containing an almost endless variety of saints and scenes from biblical and sacred history, while similar scenes were included in the plays presented in the streets of York, Chester, Coventry, and other locations in England. The images and the scenes of saints and biblical stories were expelled from the churches in England at the Reformation, as we also know all too well, so that by the early years of Elizabeth I's reign the buildings of worship were quite thoroughly "cleansed" so far as was practical, the expensive glass windows remaining on account of the prohibitive cost of replacement. Normally it was the duty of the churchwardens to see that images, paintings, and other pictures, regarded quite literally as "dangerous monuments," be "defaced and removed out of the church and other places and . . . destroyed; and the places, where such impiety was, so made up as if there had been no such thing there."[5] Even chapels such as the Guild Chapel at Stratford-upon-Avon, which had been spared during the Edwardian period, eventually was forced to conform in 1563-64, when John Shakespeare, the father of the playwright, was recorded as chamberlain to have covered over the controversial wall paintings, including such subjects as the finding of the true cross by St. Helen and its return to

Jerusalem by the Emperor Heraclius, the martyrdom of St. Thomas Becket, St. George and the dragon, and the Last Judgment in addition to other subjects.[6] The Catholic religious drama, modified to appease the Protestant authorities to be sure, lasted longer at locations such as nearby Coventry, on the whole being suppressed prior to the 1590's. (An exception was the Corpus Christi play at Kendal, which apparently survived into the seventeenth century; about this play Thomas Crosfield, writing in his *Diary* some thirty years after its suppression, wondered whether it "was tolerable by Gods law bec*ause* it seemes to be a kind of preaching or setting out of ye script*ure* to edification. . . ."[7])

It is, of course, true that the English Protestantism of the sixteenth century, particularly in the second phase initiated during the reign of Edward VI, adopted an attitude of iconoclasm that was matched only by the more radical of the continental reformers[8]--an attitude that stood in strong contrast to the mere shift in attitude toward pictures and images in the Lutheran countries of northern Europe where churches were allowed to retain their medieval glory. This iconoclastic period in English history has been described by John Phillips in his book *The Reformation of Images*,[9] just as the Protestant attack on the religious stage had previously been discussed by Father Gardiner in his *Mysteries' End*.[10] As religious experience, the religious stage and images or pictures inspired similar objections from the official (and more radical elements in the) Church of England, both forms of seeing being condemned alike.

The shift from approval of the seeing eye to the

hearing ear as the principal source of religious illumination is neatly summarized in William G. Madsen's *From Shadowy Types to Truth*,[11] which though focused on John Milton as a literary artist nevertheless surveys the change away from reliance on sight to the auditory sense. Madsen quotes Richard Sibbes: "Hearing begets seeing in religion."[12] Such a statement indeed stands in contrast to the spiritual dynamic implied by the cycle drama which epitomized the Franciscan emphasis on seeing the sacred story, especially the Passion, in an imaginative way as central or even necessary to the process of salvation.[13] Instead of originating in the sense of sight, therefore, any religious experience involving the imagination must have its origin in the experience of the Word, the Scriptures, principally as these sacred writings are pre-digested in sermons and heard by those in attendance. Nor were these imaginative experiences to be transferred into visible artifacts that might be seen by others. In fact, such visual display, either on stage or in the visual arts, was to be regarded as dangerous. Stephen Gosson, whose attack, to be sure, was directed against the secular as well as the religious stage, commented: "There commeth much euil in at the eares, but more at the eies. . . . Nothing entereth more effectualie into the memorie, than that which commeth by seeing: things heard do lightlie passe awaie, but the tokens of that which wee haue seene, saith Petrarch, sticke fast in vs whether we wil or no. . . ."[14]

The official position with regard to both religious plays and pictures or images was indeed clearly enunciated. Matthew Hutton's objection to the York Creed Play in 1568 indicates that, while he praises

the antiquity of some of the contents of the play, "so see I manie thinges, that I can not allowe, because they be Disagreinge from the senceritie of the gospell. . . . suerlie mine advise shuld be, that it shuld not be plaid . ffor thoghe it was plausible 40 yeares agoe, & wold now also of the ignorant sort be well liked: yet now in this happie time of the gospell, I knowe the learned will mislike it and how the state will beare with it I knowe not."[15]

The Royal Injunctions of Queen Elizabeth in 1559, repeating the Injunctions of Edward VI dating from 1547,[16] had forbidden "thinges superstitious" in churches: "that they shal take away, vtterly extinct and destroy al Shrines, coueryng of Shrines, al Tables, Candlestickes, Tryndalles, and rolles of waxe, pictures, payntinges, and all other monumentes of faigned myracles, pylgrimages, idolatrie, and superstition, so that there remayn no memorie of the same in wals, glasse wyndowes, or els where within their Churches and houses, preseruyng neuerthelesse, or repayring both the walles and glasse windowes." However, her Injunctions then continue: "no persons [shall] kepe in theyr houses any abused images, tables, pictures, payntynges, and other monuments of faigned miracles, pylgrimages, idolatrie, and superstition."[17] Visitation articles during the reign of Elizabeth give evidence of a concerted effort to destroy the visual images, associated with the "old religion" (and therefore with superstition), as idolatrous and hence diabolical, though royal protection was extended to memorials for individuals,[18] and this act saved much (including painted glass) from destruction. Looking at religious images, pictures, and plays hence still is not some-

thing neutral, but instead the tendency was increasingly to see this practice as dangerous rather than as beneficial.

The benefit of the religious image, whether a statue of a saint or the visual image on stage, was recognized in the later Middle Ages to be centered in the viewer's identification with the event witnessed or in the special relationship established by him with the figure who is depicted.[19] Through imagination, the events can be made *as if* present before the eyes of the viewer, or the image can be a conduit to the saint represented therein. Thus prayers spoken to a saint before a statue of him or her would all the more effectively reach that saint in heaven. The image or picture, therefore, participates in the reality of the event or of the saint, and indeed in practice the visual depiction is more than a merely didactic presentation to teach church doctrine to the unlearned. But it was precisely this *participation*[20] to which the Reformers objected, though it is crucial that they did not object to a central aspect of the psychology which underlay the older Catholic position with regard to this visual experience.

Gosson had denounced the visual experience of the theater as opening up sights to the mind, as allowing something illicit thereby to break "into the soule."[21] Theatrical sights, like the sight of allegedly superstitious images, are like spiders' webs to entangle the unwary.[22] The important thing to notice here is that he assumes a direct point of contact between the viewer and the thing seen. While Gosson, as we have observed, is an extremist who is attempting to broaden the attack on the theater to a wide-ranging denunciation of the secular

stage, he nevertheless points to the psychological principles that are at the heart of the anti-visual prejudice which emerged in English Protestantism in the sixteenth century. We can assume that the English Protestants who shared the anti-visual prejudice did not have a single or even consistent theory of vision such as one would find in St. Augustine or Roger Bacon, whose differing views nevertheless can provide some perimeters for our analysis of the mechanism of sight. For Augustine in his *De Trinitate*, the rays coming from a person "shine through the eyes and touch whatever we see"; furthermore, "Before the vision was produced, there already existed a will which to form the sense attached it to the body to be perceived."[23] Bacon, on the other hand, "firmly adopted the theory that in vision material light, travelling with enormous though finite velocity, passed from the object seen to the eye, but he pointed out that in the act of looking something psychological 'went forth,' so to speak, from the eye."[24] To see a thing is thus to participate in it somehow, since the eye's rays must extend outward to take it in--and this is the case whether or not the thing is felt to send forth rays which penetrate the eyes. To touch something beneficial, such as a holy statue, with one's sight would be a good thing, but if that statue were to be redefined as an idolatrous, superstitious, and therefore dangerous image the act of touching it with one's sight would surely be a very bad thing indeed. So too a religious play, though not entirely misliked of all Protestants (presumably of the "ignorant sort") until well into Elizabeth I's reign, had been seen as useful even toward salvation, but now became understood in

terms of ceremonies even unlawful and forbidden.

In Queen Mary's time, John Careless of Coventry, who would be designated as a Protestant martyr by John Foxe, could be given a temporary leave of absence from his jail where he was suffering for his conscience's sake so that he might play in the Corpus Christi cycle of that city.[25] Within a generation, however, this play cycle would be suppressed by the same forces of Protestantism which he had espoused, and the plays would at this later time presumably have been linked with all the visual displays of ceremony and alleged idolatry associated with Roman Catholic worship. William Lambarde, beginning work on a topographical dictionary of England--a project he abandoned in July 1585--described the puppet show which dramatized the Resurrection at Witney, Oxfordshire, and the ceremony for Pentecost at St. Paul's Cathedral in London from the period before the Reformation.[26] The "pleasant spectacle" of the puppet show was regarded by him as essentially deceptive, designed "to exhibit to the Eye the hole action of the Resurrection" through the use of little puppets impersonating Christ, Mary, and the soldiers who watched at the tomb. At Pentecost at St. Paul's, "the coming down of the *Holy Gost* was set forthe by a white Pigeon, that was let to fly out of a Hole . . . in the midst of the Roofe of the great Ile" and also by the censing of the building by means of a censer also let down from above.[27] These dramatic shows and ceremonies, however, serve Lambarde as examples of "Popishe maumetrie"--the "Shadowe" rather than the "Bodye" or substance and "*Christ* rather played with then preached." "[T]rue faith," he insists, "cometh by hearinge and not by seinge" and

"is more then al the Spectacles in the World can bringe to passe." Such allegedly illicit practices "serve the Eye, and sterve the Eare."[28]

In the case of images likewise the English Protestant attitude was likely to descend into a phobic reaction against certain ancient practices of the Church. A treatise attributed, very likely incorrectly, to Bishop Nicholas Ridley thus insisted, for example, that "it is evident that millions of souls have been cast into eternal damnation by the occasion of images used in place of religion; and no history can record that ever any one soul was won to Christ by having of images."[29] The eye, being attached to such false images, becomes in this view a servant of idols. Sight, devoted therefore to false shadows instead of the inward reality established by the Word which is received through hearing, becomes a threat to the spiritual life that can only be overcome by the iconoclastic cleansing of churches, by the prohibition of quasi-dramatic and dramatic ceremonies on the feast days of the Church such as Easter, Christmas, Palm Sunday, and Pentecost, and by the suppression of the vernacular drama associated with the older Catholic visual traditions.

The anti-visual prejudice, though it is most dramatically illustrated by the Reformation attack on *things seen*, is not, of course, unconnected from the thoughts and prejudices of the previous one thousand years and more of Christianity. The desacralizing of images and their desecration were evidences of extreme attitudes, but such acts were a matter of degree rather than of kind when compared to the evidence of the previous centuries of the Christian era. In patristic times Tertullian's well-

known strictures against the ancient drama and thereafter the apparent virtual suppression of the theater at the end of the classical period would appear in each instance to be grounded in an understanding of seeing as participating in what is seen and thus in a stance that is essentially anti-visual. Yet we need to see that the sense of sight was commonly regarded paradoxically from the time of the Church Fathers to the Renaissance as at once a metaphor for illumination and knowledge on the one hand and on the other a sign of illusion and danger.

In the traditions of the visual arts, Sight in its negative capacity was commonly associated with the sin of pride and hence was often pictured by a man or woman with a mirror.[30] At Longthorpe Tower in Northamptonshire, Sight as placed on the wheel of the senses (fig. 1) is represented by a cock, a symbol then (as today) of male sensuality.[31] A further element is added in the adopting of game and play to present the scenes of the theatrical event, which thus differs of necessity in this respect from the static visual arts. Yet making a game of playing sacred events for the delight and edification of an audience was likewise symptomatic of pride in the view of the writer of the anonymous Wycliffite *Tretise of miraclis pleyinge*, who insisted upon advising people to avoid the vernacular plays with their false spectacle or "veine sightis" of costumed and masked disguise.[32] These plays, according to this writer, unfortunately show "signis withoute dede" and hence are lies.[33] What is so different about the anti-visual prejudice in the Reformation is that, unlike its expression in the period when *A tretise of miraclis*

pleyinge was written, it has become public policy and that it is thus able to form the basis for the transformation of the theatrical experience in England.

Notes

[1]See especially Michael O'Connell, "The Idolatrous Eye: Iconoclasm, Anti-Theatricalism, and the Image of the Elizabethan Theater," *ELH*, 52 (1985), 279-310.

[2]On the extension of the attack on the theater to the secular stage, see William Ringler, "The First Phase of the Elizabethan Attack on the Stage, 1558-1579," *Huntington Library Quarterly*, 4 (1942), 391-418. The polemic of William Stubbes, focused initially on the religious stage and then extended to the secular theater and stage players, defines standard objections which pertained until the Civil War in the middle of the seventeenth century (*The Anatomy of Abuses* [London, 1583], sigs. L5r-M1r). For further discussion of the attitudes involved, see Russell Fraser, *The War Against Poetry* (Princeton: Princeton Univ. Press, 1970), *passim*.

[3]See *The Image and the Word*, ed. Joseph Gutman (Missoula, Montana: Scholars Press, 1977), esp. pp. 49-74.

[4]*The Anti-Theatrical Prejudice* (Berkeley and Los Angeles: Univ. of California Press, 1981).

[5]*Visitation Articles and Injunctions of the Period of the Reformation*, ed. Walter H. Frere, Alcuin Club Collections, 16 (London: Longmans, Green, 1910), p. 90.

[6]*Minutes and Accounts of the Corporation of Stratford-upon-Avon*, ed. Richard Savage, Dugdale Soc., 1 (1921), I, 128. On the wall paintings of the Guild Chapel, see Clifford Davidson, *The Guild Chapel Wall Paintings at Stratford-upon-Avon* (New York: AMS Press, 1988).

[7]*Cumberland, Westmorland, Gloucestershire*, ed. Audrey Douglas and Peter Greenfield, Records of Early English Drama (Toronto: Univ. of Toronto Press, 1986), p. 213.

[8]See the summary provided by McConnell, pp. 294-97. Of course, the *practice* of iconoclasm in various parts of England was severe as early as the mid-1530's; see, for example, Robert Whiting, "Abominable Idols: Images and Image-breaking under Henry VIII," *Journal of Ecclesiastical History*, 33 (1982), 30-47, and Margaret Aston, "Iconoclasm

CLIFFORD DAVIDSON

in England: Official and Clandestine," below.

[9]Berkeley and Los Angeles: Univ. of California Press, 1973. A more thorough survey is Margaret Aston's *England's Iconoclasts* (Oxford: Clarendon Press, 1988).

[10]Yale Studies in English, 103 (1967; rpt. Hamden, Conn.: Archon Books, 1967).

[11]*From Shadowy Types to Truth* (New Haven: Yale Univ. Press, 1968), pp. 145-80. See also Ernest B. Gilman, *Iconoclasm and Poetry in the English Reformation* (Chicago: Univ. of Chicago Press, 1986), pp. 31-45.

[12]Richard Sibbes, *Works*, ed. A. B. Grosart, Nichol's Standard Divines (Edinburgh, 1863), IV, 252, as quoted by Madsen, *From Shadowy Types to Truth*, p. 158. For Calvin's influential view which held that material and visible signs cannot serve as a bridge to God, see his *A Very Profitable Treatise . . . declarynge what great profit might come to al christendome, yf there were a regester made of all Sainctes bodies and other reliques*, trans. Steven Wythers (London, 1561), sig. A5[r].

[13]Clifford Davidson, "Northern Spirituality and the Late Medieval Drama at York," in *The Spirituality of Western Christendom,* ed. E. Rozanne Elder (Kalamazoo: Cistercian Publications, 1976), pp. 133-34; *Meditations on the Life of Christ,* trans. Isa Ragusa (Princeton: Princeton Univ. Press, 1961), p. 33; David L. Jeffrey, *The Early English Lyric and Franciscan Spirituality* (Lincoln: Univ. of Nebraska Press, 1975), *passim*; see also Joy Russell-Smith, "Walter Hilton and a Tract in Defence of the Veneration of Images," *Dominican Studies*, 7 (1954), 194.

[14]*A Second and Third Blast of Retrait from Plaies and Theaters* (1580), as reprinted in *The English Drama and Stage under the Tudor and Stuart Princes, 1543-1664,* ed. W. C. Hazlitt (1869; rpt. New York: Burt Franklin, n.d.), pp. 141-42.

[15]*York*, ed. Alexandra F. Johnston and Margaret Rogerson, Records of Early English Drama (Toronto: Univ. of Toronto Press, 1979), I, 353. Mention by Hutton of the "ignorant sort" may be a reference to St. Gregory's defense of images and biblical scenes for the illiterate or ignorant. For a summary of St. Bonaventure's important extension of Gregory's thought concerning images, see William R. Jones, "Art and Christian Piety: Iconoclasm in Medieval Europe," in *The Image and the Word*, ed. Gutman, p. 84.

[16]Injunction 28 (sigs. C2[v]-C3[r]); *Tudor Royal Proclamations*, ed. Paul L. Hughes and James F. Larkin (New Haven: Yale Univ. Press, 1964), I, 396.

[17]Injunction 23 (sigs. B3[v]-C2[v]; *Tudor Royal Proclamations*, II, 123.

The Ten Articles of 1536, however, had merely been aimed at the abuses of images and not at their destruction (*Articles Devised by the Kynges Maiestie,* sig. C4). A more restrictive interpretation of the concept of image abuse was promoted by the publication in 1561 of Calvin's *A Very Profitable Treatise,* which, though focused on relics, also took aim at the devotional image; see esp. sigs. A4v-A5r. This work by Calvin was advertised on its title page as "Set furth and authorised according to the Queenes Maiesties Iniunctions." For discussion of the Protestant understanding of the idolatry associated with images, see also the chapter entitled "A Poetics of Idolatry," in Kenneth Gross, *Spenserian Poetics: Idolatry, Iconoclasm, and Magic* (Ithaca: Cornell Univ. Press, 1985), pp. 27-77, and Carlos M. N. Eire, *War Against the Idols* (Cambridge: Cambridge Univ. Press, 1986), *passim.*

[18]John Strype, *Annals of the Reformation* (Oxford: Clarendon Press, 1824), I, Pt. 1, 279-81.

[19]See especially Ellert Dahl, "Heavenly Images: The Statue of St. Foy of Conques and the Significance of the Medieval 'Cult-Image' in the West," *Acta ad archaeol. et artium hist. pertinentia,* 8 (1978), 175-91, and Sixten Ringbom, "Devotional Images and Imaginative Devotions," *Gazette-des-Beaux-Arts,* 73 (1969), 159-70.

[20]For the term 'participation' I am indebted to Owen Barfield's *Saving the Appearances* (New York: Harcourt Brace Jovanovich, n.d.), pp. 28-35, 40-45.

[21]*The English Drama and Stage,* ed. Hazlitt, p. 141.

[22]Ibid., p. 142.

[23]*De Trinitate* 9.3.3, 11.5.9, as quoted by Margaret Miles, "Vision: The Eye of the Body and the Eye of the Mind in Saint Augustine's *De trinitate* and *Confessions,*" *The Journal of Religion,* 63 (1983), 127. See also the important comments of Dahl, who cites the widespread medieval belief that "the eyes are the 'window of the soul'" ("Heavenly Images," p. 187).

[24]A. C. Crombie, *Medieval and Early Modern Science* (Cambridge: Harvard Univ. Press, 1963), I, 104. See also Margaret Miles, *Vision as Insight* (Boston: Beacon Press, 1985), pp. 96-98.

[25]*Coventry,* ed. R. W. Ingram, Records of Early English Drama (Toronto: Univ. of Toronto Press, 1981), p. 207.

[26]William Lambarde, *Dictionarium Angliae Topographicum et Historicum: An Alphabetical Description of the Chief Places in England and Wales* (London, 1730), pp. 459-60.

[27]Ibid., p. 459.

[28]Ibid., p. 460.

[29]In Nicholas Ridley, *The Works*, Parker Soc. (Cambridge: Cambridge Univ. Press, 1841), p. 94. See Ann Eljenholm Nichols, "Books-for-Laymen: The Demise of a Commonplace," *Church History*, 56 (1987), 467n.

[30]Carl Nordenfalk, "The Five Senses in Late Medieval and Renaissance Art," *Journal of the Warburg and Courtauld Institutes*, 48 (1985), 4, 10, 12.

[31]E. W. Tristram, *English Wall Painting of the Fourteenth Century* (London: Routledge and Kegan Paul, 1955), p. 220. For a discussion of the iconography of the cock, see Lorrayne Y. Baird, *"Priapus Gallinaceus*: The Role of the Cock in Fertility and Eroticism in Classical Antiquity and the Middle Ages," *Studies in Iconography*, 7-8 (1981-82), 81-111.

[32]*A Middle English Treatise on the Playing of Miracles*, ed. Clifford Davidson (Washington, D.C.: Univ. Press of America, 1981), p. 38.

[33]Ibid., p. 40.

Iconoclasm in England:
Official and Clandestine

Margaret Aston

Iconoclasm was a feature of the English Reformation from its very beginning.[1] It recurred, intermittently and sporadically, from the 1530's to the 1640's, and made an important contribution to events at each significant phase of settlement. The influence of iconoclasts in England is comparable to that of iconoclasts abroad, but reflects the peculiar nature of English reform, which was both tightly controlled from the center and also upsetting in its switchback course. The removal and return of images, and the prolonged process of attrition that bore on some categories of imagery, caused individuals to express themselves through iconoclasm much longer than was the case in most continental centers of reform.[2]

The work of European iconoclasts stood throughout as an inspiration--or deterrent--to the complete clearance of all imagery from all churches. There were individuals who looked ahead, even under Henry VIII, to the ultimate iconoclastic position that was reached a century later. But official policy moved in effect by stages, proscribing a wider range

of imagery as time went on, with the result that iconoclastic reformers, jumping ahead to deal with further categories of idols, vented their dissatisfaction by acts of demonstrative destruction. Breaking an image might be a way of stealing a march on hesitant or procrastinating magistrates. Officials and policy-makers, iconomachs themselves, were repeatedly at odds with more radical iconoclasts. Iconoclasm, always declaratory of Reformation on the move, itself declared divisions in the movement of reform. It raised in an acute manner the question of authority.

The eradication of idols presented many reformers with their Catch 22. One could not achieve a purified rite while churches still flaunted traces of idolatry. But to sweep away all the trappings of idols and false worship without first securing the hearts and minds of believers might jeopardize the reforming process. Luther, faced by the hasty iconoclasm of Karlstadt and the "Heavenly Prophets," saw this clearly. Until the idols of the mind had been dealt with, it was pointless (as well as dangerous) to start demolishing external idols. In Strasbourg Capito said much the same thing. The suppression of idols (which meant all sorts of objects regarded as sacred) before preaching had implanted the true faith would, he said, offend weak consciences and invite a reaction against reform.[3]

On the other hand, independent zealots found the destruction of images a useful lever to promote or accelerate reform. To demolish images--or to clear a church of sculptures, paintings, and reredoses--was a declaratory act of faith which presented a physical rupture with the past. It could amount to a chal-

lenge to cautious or conservative authorities who were proving dilatory over the implementation of doctrinal change. Another catch situation was created, for to replace the ousted images in such circumstances would itself inevitably be contentious, while to acquiesce amounted to capitulation.

We can see a kind of counterpoint developing between the private and public destroyers: between the official, publicized, propagandist acts of iconoclasm, and the spontaneous, clandestine, illicit breakings or burnings undertaken by private groups or individuals. Strange though it may now seem, the public iconoclastic spectacle became part of the repertoire of government propaganda almost as soon as Henry VIII decided, under Thomas Cromwell's guiding hand, to sponsor the process of reform. The nearest modern equivalent that comes to mind is the breaking up of statues and ripping down of photo portraits that has taken place in this century at changes in Eastern bloc regimes. But that is not an exact parallel, for the statues of Stalin (for example) were of recent vintage, and even those who erected them were familiar with the language of the image-breakers and the vulnerability of public icons of this kind. Reformation iconoclasts, on the other hand, though they likewise destroyed for the end of *renovatio*, were employing a method that, being known at the time only as a proscribed activity, was quite novel as a government procedure. Its very adoption declared such magistrates to be reversing the world they were changing.

The spectacular burning or dismemberment of idols served the purpose of winning support for religious change by calling crowds to witness the

ritual dismissal of rejected cult objects. Corporately venerated objects were corporately eliminated. Iconoclasm was a social process, designed to give group solidarity to the inauguration of doctrinal change. But as all recent advocates or perpetrators of such deeds had been condemned or burned as heretics, it must have appeared to some observers that their world was veritably turning upside down. For some that would naturally not have been unwelcome. Individuals were ready to take their cue, and there were various occasions on which government iconoclasm was imitated or followed by illegal acts of destruction. The motives were doubtless mixed, ranging from conscience-stricken new belief to revenge on failed intercessors, youthful pranks or drunken demonstrations, and conscious efforts to challenge authority.

Only a few years before Henry VIII's volte-face, steps were taken to counter some quite daring acts of clandestine iconoclastic destruction. It was probably in 1522 that Cardinal Wolsey and John Longland, bishop of Lincoln, together issued an indulgence promising pardons to all those who contributed to the restoration of the church of Rickmansworth in Hertfordshire, which had been badly damaged by nocturnal arson. "Wretched and cursed people cruelly and wylfully set fyre upon all the ymages and on the canape that the blessyd sacrament was in" and also set light to the church vestry, with the result that this building with all the ornaments in it and the chancel were burned. These undercover culprits remain unknown, though it seems quite probable that they were Lollards, or at any rate were

in some way caught up in the recent anti-heretical proceedings that had disturbed the entrenched communities in the neighboring Chiltern hills.[4]

More deeds of this kind are reported to have taken place early in the following decade, when the likelihood of continental inspiration of some kind is greater though still not explicit. According to John Foxe, many images were "cast down and destroyed in many places" in 1531-32.[5] In fact, the examples he cited were all in one area in Essex and Suffolk, from Ipswich and several villages around Colchester. The incident to which this report was attached, described in graphic detail that had been given to the martyrologist by one of the participants, belonged to the same region. This was the burning of the rood of Dovercourt, a village in Essex just south of Har- wich--an episode dated by Foxe to 1532. Like the Rickmansworth incident, it was carried out under cover of darkness, though in this case the per- petrators were caught.

The Dovercourt image was revered for miraculous powers, which according to Foxe (whose evidence obviously leaves something to be desired) included the ability to prevent anyone shutting the church door. The four men who set out to disprove this "idol," including Foxe's narrator who was called Robert Gardner, came from the villages of Dedham and East Bergholt some ten miles and more away to the west at the head of the Stour estuary. They were favored by "a wondrous goodly night, both hard frost and fair moonshine" for their exploit--as well as by the fact that that there was no need to break into the church, since local belief was such that nobody dared to shut its door. The mere ability to remove the rood

and to carry it a quarter of a mile away "without any resistance of the said idol" seemed itself to negate its repute, but the marauders left nothing to chance and made a bonfire of the vanquished carving before returning home. Within six months, according to Foxe's circumstantial account, three of these offenders were indicted for felony and hanged (fig. 2). Only Robert Gardner managed to escape.[6]

But the tale does not end here, for Foxe also tells us of the involvement of another man, a cleric. This was Thomas Rose, rector of Hadleigh, a village in Suffolk, about eight miles northwest of Dedham and East Bergholt. Rose was a convinced supporter of reform who survived various troubles, including two flights abroad under Henry VIII and several examinations and another exile under Mary, to see his own life story published by Foxe in Elizabeth's reign, by which time he was well into his seventies, though still active as a preacher at Luton in Bedfordshire. Nearly half a century earlier, Rose's sermons at Hadleigh had attracted attention for their vehemence against images, and among those he inspired to plot destruction were the four Dovercourt iconoclasts. After their successful mission they handed over the coat that had been on the rood to Thomas Rose, and he duly proved his own convictions by burning it.[7]

Although, according to Foxe (who remains our sole source for these events), the four iconoclasts refused to implicate Rose, he did not escape scot-free. He had enemies at Hadleigh who complained in high places with the result that he was examined before the Council and imprisoned in Bishop Longland's house for several months. It was thanks to Cranmer

that Thomas Rose's fortunes improved. After Cranmer's consecration in March 1533, the offender was moved to the custody of the archbishop at Lambeth, a change which may be ascribed to the fact that his living belonged to the patronage and immediate jurisdiction of the archbishops of Canterbury. This connection may also have helped to get Thomas Rose reinstated in his living, and in March 1534 Cranmer wrote to the parishioners of Hadleigh suggesting that they should let bygones be bygones and forget their old grudge against their rector.[8]

The Dovercourt affair took place at an interesting moment. While from May 1532 steps were being taken towards the unilateral action that would cut the knot of the king's divorce, there was little to indicate that Henry might be ready to support the image-breakers. All iconoclasts, still suspect and subject to the ancient proscription of Church law as dangerous heretics, acted perforce by subterfuge. Anxiety about the heretical dimensions of the case against church images was increasing (witness the expanded 1531 edition of Thomas More's *Dialogue Concerning Heresies*), and in the minds of conservatives the aspirations of native critics were conflated with the challenge of continental reformers. A sermon delivered some time before 1534 by Henry Gold, vicar of Hayes in Middlesex, warned against the dangerous teaching of Karlstadt as the source of such horrific deeds as the recent burning of a crucifix.[9] Old Lollard objections to images and pilgrimages entered a new domain. Whatever the persuasions of those who attacked images, they would be judged at the bar of a new set of expectations, and by 1532 texts of continental reformers

dealing with this topic had reached England.

If theology of some kind, at some remove, lay behind the Dovercourt destruction, it is difficult to say whose it was. What had Thomas Rose been reading? We do know of someone he had almost certainly been hearing. Thomas Bilney, whose opposition to images was one of the salient features of his teaching, had preached at both Ipswich and Hadleigh in 1527. And, according to reports of a sermon given in London, he had called for the destruction of images; "as Ezechias distroyed the brasen serpent that Moyses made by the commanndement of God, even soo shuld kynges and prynces now a dayes dystroy and burne the Images of saynts sett upp in churches and other placys."[10] The questions Bishop Tunstall prepared for examining Bilney and Thomas Arthur included one on whether it was more Christian to remove images of saints from churches than to permit them to remain to be gilded and honored.[11] Bilney and Arthur recanted and abjured in 1527. But Bilney, after rethinking his position, was burned at the stake in Norwich in August 1531.

It seems not impossible that there was a connection of some kind between Bilney and this batch of East Anglian image-breakers. The link is established in one case. In 1533 two shoemakers of Eye in Suffolk (about twenty miles north of Ipswich) were examined and abjured certain heresies, including refusal to worship cross or crucifix. One of them, Robert Glazen, was alleged to have said that if he had the rood of Eye in his yard he would burn it. He confessed that the source of his views was a sermon preached by Thomas Bilney at Hadleigh in 1527.[12]

Did Bilney's execution provoke some of his followers into demonstrations of support for his views? Is it possible that the Dovercourt bonfire was some kind of riposte, as the Rickmansworth blaze ten years earlier may have been related to the local executions of Lollards? Such questions must be rhetorical, but we can be sure that the iconoclasts' psychology was complex. Combining with the conscious determination of the "burdened conscience"[13] to free God from the blasphemy of the idol was a heady mixture of derring-do, personal loyalties and frustrations, and the intoxicating excitement of an illicit nocturnal fire.

The situation changed dramatically at the time of the Dissolution. Well before the second set of royal injunctions was issued in the autumn of 1538, the country as a whole had become alerted to the threat (or promise) of royal iconoclasm. Monastic dissolutions were accompanied by the suppression of cult images--parochial as well as conventual.[14] And those for whom the suppression of idolatry was an urgent priority saw to it that the reduction of celebrated "idols"--that is, images that had been pilgrimaged and offered to--received the maximum publicity in their demise. Ritual disproofs of venerated statues, until recently so dangerous an undertaking, now became government stunts, part of an official campaign of propaganda and credal engineering.

In July 1538 there was a public bonfire at Chelsea of the celebrated Virgin statues from Walsingham and Ipswich and of other images collected for this purpose, which (duly denuded of their jewels and ornaments) were burned at the direction of Thomas Cromwell "because the people should use

noe more idolatrye unto them."[15] Earlier in the same
year another event of the same kind had attracted a
good deal of notice and aroused the hopes of re-
formers abroad. This was the ceremonial destruction
of the rood from the Cistercian house of Boxley in
Kent that took place at St. Paul's on Sexagesima
Sunday (also St. Matthias's Day), 24 February. It
was a carefully stage-managed event, undoubtedly
contrived to focus attention on the reformist cause.
For though the numbers of pilgrims to Boxley were
on the decline by the 1530's, it was a well-known
center beside the route to Canterbury. Henry VIII
offered half a mark to the Rood of Grace soon after
his accession, and the papal legate Lorenzo Cam-
peggio stopped off for a night at Boxley on his way to
London in 1518. The abbey's miraculous crucifix was
(or had been) capable or responding physically to the
entreaties of ailing supplicants. It could turn its
eyes and move its lower lip, and may have been one
of those jointed figure carvings (examples of which
still survive abroad) which were able to move like
puppets.[16]

It was as a puppet that the Rood of Grace was
publicly exposed. After an initial disparaging dis-
play on market-day at Maidstone, for the benefit of
Kent locals, the rood was taken up to London for
ritual disproof at the most public of all England's
pulpits. Bishop Hilsey of Rochester preached an
edifying sermon at Paul's Cross, thundering against
the blasphemous and fraudulent deceptions of im-
ages. He made full use of the set piece placed before
his congregation by demonstrating the cords and
devices of the revered crucifix as he denounced the
manipulations of the "engines used in old tyme" in

this image. The climax was dramatic: "After the sermon was done, the bishopp tooke the said image of the roode into the pulpitt and brooke the vice of the same, and after gave it to the people againe, and then the rude people and boyes brake the said image in peeces, so that they left not one peece whole."[17] According to another contemporary, John Finch, who delightedly reported the rood's unmasking to a correspondent in Strasbourg, "after all its tricks had been exposed to the people, it was broken into small pieces, and it was a great delight to any one who could obtain a single fragment, either, as I suppose, to put in the fire in their own houses, or else to keep by them by way of reproof to such kind of imposters."[18] A second iconoclastically disposed bishop, Hugh Latimer, then made his contribution to the occasion. He carried a small statue to the door of St. Paul's and "threw [it] out of the church, though the inhabitants of the country whence it came constantly affirmed that eight oxen would be unable to remove it from its place."[19] This was probably the diminutive figure of St. Rumwold, which had also formed part of the devotions at Boxley.[20]

Euphoric reports such as Finch's radiated exaggerated expectations. The selfconscious theatricality of the occasion, so obviously framed to impress the "simple people," can scarcely have had the instant success that he and others claimed. If some were already conscious that credulity was exploited by clerical maneuvers (and a London crowd was likely to include such skeptics), one or two iconoclastic demonstrations were not going to bring a harvest of converted ignoramuses to condemn the clergy as "mere conjurors" working despicable trickery on the

people. The unprecedented nature of the event must have taken some members of Hilsey's congregation by surprise. It was indeed intended to be a ceremony that shocked by deliberate reversal of ancient assumptions. Latimer, chucking the sculpture out of the cathedral, was providing an ocular demonstration of the emptiness of its supposedly miraculous powers--just as the men who burned the Dovercourt rood had erased a spiritual claim together with a physical object. Throwing the image out of the church, out of consecrated building into the open space outside, was also a symbolic action that stood for the process Hilsey was advocating. It was a matter of de-sanctification, of repositioning the central sanctum of the holy.[21] Idolatry would not be eradicated from believers' devotions until the images they misused had been removed from sacred places and tested in the world as the Boxley rood had been put to the test; images that had proved false must be put where they belonged and profaned in the most profane of secular places.

Native pride and sense of possession apart, it may be that the sheer act of removing the cult image from the place where it had stood, time out of mind, shattered its miraculous power just as devastatingly as its physical breaking. Local beliefs bonded to localized saints, attaching the special mana of venerated relic or icon to a specific location. Holy images, like the bodily remains of holy persons, were believed to have evinced their supernatural power by choosing their place of abode and rendering their removal impossible. Just as St. James the Great or St. Edmund had, through the miraculous journeying or immovability of their mortal remains, identified

their final resting-places, so--according to the Kent legend reported by William Lambarde--the Boxley rood, made by a skilful carpenter to help pay his ransom, had originally arrived in this village as the result of its own extraordinary horse-ride from Rochester.[22]

We should be chary of taking at face value the reformers' triumphant claims about the delighted reactions of crowds who saw holy images being execrated and destroyed. The true (and surely mixed) feelings about these events may be largely a matter of surmise, but one man who made known his grief at the treatment of the Boxley Rood was a London curate, John Laborne. He went on record for passing remarks about the example of St. Augustine, who had not been against converting the English with "a crosse of wode and a picture of christe," and in whose time "so wyse men were as now be."[23] If it was the unscripted illiterate whose misuses of imagery the literate were bothered about, by definition we only know half the story. Some believers might well have been fearful of participating in the dismemberment of holy statues, and maybe it is significant that on two of these occasions at St. Paul's, Wriothesley reports "the boys" as doing the breaking.

Would the demonstration of the rood's "engines" necessarily have undermined people's feelings for it? Mechanical imagery of this kind was not out of the ordinary, and if the locals at Boxley prided themselves on having the handiwork of a specially ingenious craftsman, there were plenty of other such clever devices to be seen in pageants and plays and ceremonial. Some of these were quite sophisticated,

and must have added spectacularly to the illusions of dramatic performances. In 1433, the York Doomsday pageant, for which the affluent Mercers were responsible, included, besides "A cloud and ii peces of Rainbow of tymber Array for god" and a heaven with red and blue clouds, an iron swing or frame pulled up with ropes "that god sall sitte vppon when he sall sty vppe to heuen." A cloud machine of this kind would also have made it possible to execute the stage direction of the York Transfiguration play: *Hic descedunt nubes. Pater in nube.*" At Lincoln Cathedral a contraption with cords enabled the dove of the Holy Ghost to descend at Pentecost. And, not far from Boxley, the Canterbury pageant of St. Thomas (which came to an end about the same time as the Rood of Grace) had a mechanical angel which--though perhaps less cunning than the golden angel that had bent down to offer the crown to Richard II in his coronation pageant--was nevertheless a moving figure. In 1515-16 a penny was spent "for wyre for the vyce of the Angell," and two pence "for candell to lyght the turnying of the vyce."[24]

Popular experience of dramatic imagery was not divorced from the experience of statues of the saints in churches. Remembering this must caution us against falling in too readily with the cause-and-effect skepticism presented by the iconoclasts. John Hoker of Maidstone reported hearty laughter in the market-place of his town when the Rood of Grace went on show. But laughter had not been alien to the devotions at Boxley where the alternating weight and weightlessness of St. Rumwold caused merriment among visitors, seeing "a great lubber to lift at that in vayne, whiche a young boy or wenche had

easily taken up before him." Not all laughter was derisive, and not all illusions were to be equated with delusion. Those who watched a Resurrection play, or a carved Christ being elevated from an Easter Sepulchre on Easter Day, could both revere the miraculous and respect the limitations of physical enactment. But representation itself became different for those who tended to see the suspension of disbelief as akin to submission to misbelief.[25]

Iconoclastic demonstrations were to become familiar. But how would they have presented themselves at this time to those (the majority of believers) who did not share John Finch's views? What points of reference were there for such image-breaking? It may help somewhat to redress the imbalance in contemporary reporting if we consider the contexts in which the "simple believer" might hitherto have encountered the phenomenon of iconoclasm.

In the first place he or she knew--or should have known--that breaking images and crosses was a most serious offense, subject to the severest penalties of Church law. According to the sentence of the great curse, solemnly pronounced to parishioners four times a year, "Alle arn acursed . . . that robbyn, brekyn, or brennyn, holy cherche violently, or chapel, or place relygyous, or othere placys halwyd or privylegyd, or brekyn crosses, awterys, or ymagys, in dyspyght and vyolens."[26] Anyone who lived within range of Rickmansworth or Dovercourt would have known the grave consequences of breaking this law, and as recently as 1529 the sanction of secular authority supplemented the ancient provision when the Reformation Parliament excluded those who pulled down crosses in highways from its general pardon.[27]

There were depictions which showed the terrible punishments that fell on those who transgressed in this way. England has nothing quite so dramatic as the early sixteenth-century Florentine painting of the execution of Antonio di Giuseppe Rinaldeschi, delineated hanging from a window of the Bargello while angels and devils contended over the fate of his soul. Rinaldeschi's crime was the blasphemy of throwing horse dung at a painting of the Virgin.[28] A comparable scene appears among the late fifteenth-century paintings of miracles of the Virgin in Eton College Chapel and the Lady Chapel of Winchester Cathedral (fig. 3). There (illustrating a story in Vincent of Beauvais' *Speculum Historiale*) a perfidious soldier, shown throwing a stone at a statue of the Virgin, is immediately struck dead while the image miraculously bleeds.[29] Divine and human law alike imposed the severest penalties on those who attacked images.

There was, on the other hand, a context in which image-breaking was recognized and legitimate. This too was represented in contemporary art forms, which must have made it relatively familiar to believers.[30] The utter destruction, by supernatural or divinely aided human agency, of the idols of the heathen was a recurring theme in the lives of saints. It was recounted in sermons, and it seems safe to assume that it also featured in the drama of the saints. "Then thay turnet hom to the mawmetes that weron yn the tempull, and commawndet the fendes that weron yn hom forto come out, and schow hom to the pepull, and then plucke the ymages al to powdyr; and soo thay dyd."[31] Mirk's *Festial* thus described the action against Persian idols by SS. Simon and

Jude. The destruction of idols was also part of the story of St. George.

> Likewise Saynt George and Saynt Sebastian
> Despising ydoles which courtes used then,
> Suffered harde death by manifolde torment,
> For love and true fayth of God omnipotent.[32]

Though it was as a dragon-killer that St. George is chiefly remembered, he was celebrated by Alexander Barclay and others as a "most stronge confounder of fals ydolatry" (figs. 4-5). The second part of his life in the *Golden Legend* was taken up by the tale of how St. George refused to sacrifice to idols as commanded by the emperor, the climax of which is God's dramatic answer to the saint's prayer: a descent of fire from heaven, which destroys the pagan temple, with all its idols and priests. Barclay's version of Mantuan's life (which was published by Richard Pynson in 1515) gave a full account of this episode, "and howe at the prayers of saynt George the great temple of the Idollys brast in sonder and sanke into the erth with horryble noyse and murdre of paynyms."[33]

Whether or not this scene featured in plays of St. George, it was certainly recounted from the pulpit and appears, for instance, in an address for St. George's day in the early fifteenth-century *Speculum Sacerdotale*.[34] The saint's arraignment for denouncing pagan idolatry was also one of the twelve images illustrating his life in a window (fig. 7) at St. Neot in Cornwall.[35] Long after the Reformation, fossilized references to St. George's prowess against idols remained embedded in the chivalric farrago of his chapbook fame. The destruction of "each Idol God"

during his mission to Persia appears in *The Life and Death of the Famous Champion of England, St. George* collected by Samuel Pepys, which had some relationship with the Mummers' Play story of the saint, while another chapbook version of about 1750 (see fig. 6) recounts that "As he went he could not forbear taking notice of the idolatry of the Persians, and at last his zeal for the service of Christ transported him so far, that he went into their temples, overthrew their images, &c. which caused the whole kingdom to rise in arms against him."[36] There is an inherent probability that St. George's iconoclasm featured in the many dramatic forms in which his story was presented in the fifteenth century, and a stage direction for a medieval French play shows the kind of scene that could have been enacted: "The dragon must come out of the idol and not be seen again, and the idol must be broken in pieces by the son of the said bishop."[37]

Medieval England did not lack knowledge, then, of legitimate iconoclasm, but this belonged to a completely different world from that of the images encountered in everyday devotions. Given the ancient separation of these worlds--the world inhabited by familiar saints, and the alien world of pagan cults--their sudden assimilation could only have been startling. A capricious switch of royal policy abruptly inaugurated a whole new outlook in which things formerly kept apart were suddenly associated. The proscribed became legal: two kinds of imagery that had not previously been placed in relation to each other were, almost overnight, equated. Christian images of saints were regarded in the same light as pagan idols and were destroyed

just as Christian saints had once destroyed idols of heathen gods. In March 1538, a royal candle was still burning before the image of Our Lady of Walsingham.[38] Four months later the revered statue went up in flames. It is not surprising that some of Henry VIII's subjects began to talk of him as a Lollard.[39]

The inauguration of this extraordinary reversal was given a great deal of publicity as plays, ballads, and sermons produced by Thomas Cromwell's circle hammered home the "fantasies" and errors of England's idolatry. But the situation, despite all the attacks on new-style "idols" that were openly chastised in 1538, was far from clear. For by no means all church images were condemned as idolatrous, and the government, in attempting to distinguish between those that were inadmissible (conceived to have spiritual powers) and those that were valid (as a means of instruction), certainly never intended that individual subjects should start taking initiatives on this matter.[40] This was, however, precisely what happened. The dangerous lead given by the official iconoclasts prompted some radicals to follow suit. Clandestine image-breaking was given a new spur.

Affairs in London illustrate very clearly this threatening interaction between officially sponsored destruction and imitative subversive reform. One incident in particular showed with immediate effect how government destruction could thrill individual enthusiasts. On 22 May 1538, three months after the breaking of the Boxley rood, the capital was treated to another iconoclastic spectacle. This was a double burning, designed to demolish two misbeliefs

in one fire: support for papal authority, and trust in the miraculous powers of images. A large crowd, including various notables accommodated on a specially erected platform, was gathered on this day to listen to an edifying sermon preached by Hugh Latimer and to watch the simultaneous burning of the Observant Franciscan, John Forest--who had been confessor to Queen Catherine of Aragon, and was guilty of loyalty to the pope--and the large figure of St. Derfel, extracted against strenuous local opposition from the village of Llandderfel in Wales, where he was credited with powers to save souls from hell, and of whom it had been prophesied that he would one day set a forest on fire.[41]

There was another aspect of this *auto-da-fé* which would not have been lost on those who saw heresy and orthodoxy changing places. Friar Forest, who was about sixty-eight when he died, was the first person to be burned as a heretic, as well as executed as a traitor, for believing in the Church of Rome and upholding the authority of the pope.[42]

The morning after this event, 23 May, the parishioners of St. Margaret Pattens in the city of London woke up to discover that their church's rood had been broken to pieces in the night. This was done, according to Wriothesley, by "certeine lewde persons, Fleminges and Englishe men, and some persons of the sayd parishe."[43] The rood may have been specially vulnerable because it had been placed in a tabernacle in the churchyard while the church was being rebuilt, offerings to the rood being allocated to the new work, which had at this time progressed as far as the steeple. As one of the more famous images in London, it had for some while been

the butt of denigration and suspect invective. For instance, among the charges reported by Foxe as being brought in 1529 against William Wegen, priest of St. Mary at Hill, was "that he being sick, went to the Rood of St. Margaret Pattens; and said before him twenty Paternosters; and when he saw himself never the better, then he said, 'A foul ill take him, and all other images'." A few years later Jasper Wetzell of Cologne added his voice to such domestic dissent; "being at St Margaret Pattens, and there holding his arms across, he said unto the people, that he could make as good a knave as he is, for he is but made of wood."[44]

Some of the iconoclasts were caught and brought to book. The same day, Thursday, 23 May, recognizances were taken from eight men--all of different trades--in the court of the aldermen, to which they bound over. The eight, associated "by theyre owne confessyon," with twenty more (unnamed), and with James Ellys, pewterer, and John Gough, stationer, "assembled togyther late yn the nyght tyme yester nyght last past pulled downe ther the Roode at Saynt Margaret Paten." The accused were not without defense. They said that according to Mr. Edward Crome's report the Bishop of Worcester (Hugh Latimer) believed it to be Cromwell's will that the said image should be removed.[45]

If a blend of native and imported dissent had been undermining the repute of the rood for some while, there was also a spearhead of underground reforming initiative contributing to its demise. For the stationer named in this list had long been helping to publicize the evangelical case. John Gough was a publisher with a consistent record of

sponsoring reforming books. He had been in trouble for such during the previous decade, and--particularly interesting in the context of the St. Margaret Pattens affair--he may have had a hand three years before this event in the production of the first book that openly canvassed the cause of iconoclasm in English: a translation of Martin Bucer's *Das einigerlei bild.* Given what we know of the background to all these events, it is scarcely surprising that the accused iconoclasts pleaded the belief that Cromwell had ordered the removal of the rood.[46]

The effects of these affairs were felt far afield. Five months later, in the autumn of 1538, Cromwell was sent a letter from Lifton in Devon, written by William Dynham, gentleman. It reported a conversation that had taken place at a supper party at the priory of St. Germans in Cornwall, during which Alexander Barclay, the poet and ex-Benedictine, had been unwise enough to suggest that the removal of images was getting out of hand. "I thinke menne are to besye in pullinge downe of Ymages without especiall commaundement of the Prynce," he said. Dynham, who was keen to expose Barclay's "kankrid harte," egged him on. "I knowe none then pulled downe but sutche as Idolatrye was commytted unto," he replied, adding provocatively that there was much scriptural support for such action. The example of St. Margaret Pattens came up, adding to the heat of the argument, since Dynham advanced the view that although these iconoclasts were "some what dispraised," they had a godly end in view and their doings were therefore tolerated. Barclay demurred. He suggested contrariwise that the serious fire that had taken place in the parish after the rood-

breaking, burning many tenements and some people, represented divine vengeance for a great offense.[47]

The official policy regarding the reform of images at this time was dangerously ambiguous. The second set of royal injunctions, issued the day before Dynham wrote his letter, marked the advent of authorized iconomachy in every parish subject to the supreme head (in theory). For the first time there was an open assault on images and pilgrimage as unscriptural, superstitious, and idolatrous; and for the first time parish clergy were instructed to take down images. This order was, however, limited to a particular category of images. It was those that (in the words of Injunction 7) were "abused with pilgrimages or offerings" which, for the avoidance of idolatry, the clergy were "to take down and delay." The problems were: how to decide--and who would decide--when an image was abused and, if the word *delay* meant simply to bear away, what suitable redress was there for enthusiasts who took the injunction to mean not simply removal but also destruction?[48]

The months and years that followed showed that the iconoclastic reformers had opened up quite a hornets' nest. If on one side it seems remarkable that central government directive could erase with such speed so much ancient observance and ritual, there are, on the other side, plenty of examples of local controversies. Taking down an image was not the same at all as destroying it, and action of either sort might be challenged under the existing law. Although activists, especially those in dioceses whose bishops were iconoclastically inclined (or ready to let the image-reformers take over), could take advan-

tage of the lack of clarity in the new law, they might find themselves up against vociferous resistance. At Salisbury, quite a stir resulted from the officious attempt by the city's under-bailiff, John Goodall, to prevent worshippers in the cathedral from kneeling before and kissing an image of Christ on Easter Day, 1539.[49] In Cranmer's own diocese considerable differences of opinion over interpretations of the 1538 injunctions were revealed by the inquiries set in train by the Prebendaries Plot of 1543, and, while two of the archbishop's deputies seem to have been earnestly bent on curtailing idolatry, others were busy opposing the removal of images. For instance, one Bartholomew, surgeon, was alleged to have said to Cranmer's apparitor, William Burges, "Thou art he that would have pulled down our St. George, but your master lyeth by the heel, and we have showed the taking down thereof to the King's Council and were bid set it up again."[50] In some cases images removed for alleged abuse were indeed subsequently reinstated. The rector of Milton near Canterbury, it was said, "had in his church . . . an image of St. Margaret, to which was a common pilgrimage, and caused it to be taken down. And upon St. Margaret's day last past Mr. John Crosse, sometime cellarer of Christchurch, came to the same church and did set the same image again with a garland of flowers on the head of it, and did strowe the church and said mass there."[51]

Such were the dangers of dicing with these differences of opinion that the authorities themselves sometimes went clandestine. In September 1547, when Edward VI's council was increasingly worried by disputes over the removal of images, the London

authorities directed each alderman "in the moste secrette discrete and quyette maner he can devyse," to visit the parish churches in his ward with the incumbent and churchwardens, and, having "shutt the churche doores" so that no crowds could gather, to make a record of the images--which were offered or prayed to and which not, who had taken them down and what became of them, what misdemeanors had been committed in this process, and what images still remained.[52]

On two occasions when images were removed from St. Paul's, the risk of disturbance in the city was obviated by taking action overnight. The famous rood at the north door of the cathedral, together with the image of St. Uncumber (figs. 8-9), were taken down by the dean of St Paul's (acting on orders sent through the mayor, Sir Richard Gresham) on the night of 23 August 1538.[53] Likewise in November 1547, when the royal visitors--anticipating the action that in the rest of the country took place the following year--were pulling down all images in London's parish churches, the works in St. Paul's were undertaken by night. This proved difficult, and there was an accident as the large rood in the center of the cathedral was dismantled in the darkness. The laborers let the great cross fall to the ground, killing one or two workmen and hurting others. Naturally there were those who drew a moral like Alexander Barclay: God had spoken.[54]

Waverers and opposers of this kind were answered by another iconoclastic display. Ten days after the accident over the rood, a sermon and demonstration at Paul's Cross on the first Sunday in Advent (27 November 1547) announced to the capi-

tal--and to the rest of the kingdom--that the young king was taking up the mantle of Josiah that had been donned by his father in 1538. The sermon was preached by Bishop Barlow of St. David's (who had his own iconoclastic record), and he had exemplary specimens on hand to drive home his moral. In front of his pulpit was exhibited an image of Our Lady which the clergy of St. Paul's had vainly tried to conceal from the royal visitors. Barlow also had a jointed Easter Sepulchre figure of Christ, which likewise may be assumed to have been familiar to a number of his auditors. The moral was double: "the great abhomination of idolatrie in images"; and the great sin of harboring idols. To those of Barlow's mind, there was a world of difference between removing images from churches and destroying them. Idolatry could only be defeated by annihilation. "After the sermon the boyes brooke the idolls in peaces."[55]

Henry VIII, sensing the perils of Cromwellian policy, had retreated in the 1540's from the spectacular iconoclasm of 1538. Reform of images continued, but the supreme head, who did not see eye-to-eye with his archbishop on this score, was readier to complete the termination of major pilgrimage shrines than to undertake the eradication of idolatry desired by a number of his subjects. Some of these evangelicals went abroad when the brakes were applied at the execution of Cromwell. Others found ways of continuing to work for the cause on their own. One such was William Forde who, as usher of Winchester College between c.1543 and 1547, managed--not without personal cost--to execute an iconoclastic maneuver in the college chapel. The

story was recorded for John Foxe by John Louth, archdeacon of Nottingham (d. 1590). Forde, who was himself a scholar at Winchester in the 1530's, returned as usher in his early twenties, having been converted into a "greate enemye to papisme" while at Oxford.

> Ther was many golden images in Wykam's colleage by Wynton. The churche dore was directly over agaynste the usher's chamber. Mr. Forde tyed a longe coorde to the images, lynkyng them all in one coorde, and, being in his chamber after midnight, he plucked the cordes ende, and at one pulle all the golden godes came downe with *heyho Rombelo.* Yt wakened all men with the rushe. They wer amased at the terryble noyse and also disamayd at the greevous sight. The corde beinge plucked harde and cutt with a twytche lay at the church doore.

Forde, naturally, was suspect. He was found in bed, but that scarcely absolved him. After doing this good turn to his *alma mater*, his life was made a misery. He was railed at by masters and scholars and mugged at night in the town, though (according to a Catholic reporter) he did succeed in converting the head boy.[56]

The iconoclastic purges carried out under the direction of royal visitors early in the reigns of Edward VI and Elizabeth I swept away much of what reformers objected to as idolatrous "popish peltry." And at Elizabeth's accession, when the restored roods and saints' images of the intervening Catholic years challenged the indignation of returned exiles, Londoners again witnessed ceremonial public image-burnings not unlike those of 1538. By the time of the issue of the Second Book of Homilies in 1563, with

its long tripartite homily expounding the intolerable dangers of allowing any images to be set up publicly in churches, it might seem as if the iconoclasts had run their course: "Alas, gossip, what shall we now do at church, since all the saints are taken away, since all the goodly sights we were wont to have are gone, since we cannot hear the like piping, singing, chanting, and playing upon the organs, that we could before."[57] Churches surely looked bare, empty, denuded--"scoured of such gay gazing sights," as the homilist, here rebuking the "unsavoury" objections of tattling wives, scathingly put it. What remained for the iconoclasts to reform--apart from the fond memories and hoarded relics of the unconverted?

But the see-saw balance between public destruction and private enthusiasm was by no means over. Regional diversity apart, there still remained a range of objects that for long tested the initiative of committed purifiers. The imagery of church windows, crosses in churchyards and other public places, maypoles, and organs were all grist to the iconoclastic mill. We can briefly see how this process continued by looking at the development of cross-breaking.

Disputes over the use of the cross took place on various levels during the reign of Elizabeth. Besides all the controversy aroused by the use of the sign of the cross in baptism, there was a campaign of attrition against the freestanding crosses in churchyards and other public places. Such monuments were defaced or destroyed officially on the grounds that they were sources of idolatry. For instance, in October 1571 rural deans in the diocese of York were ordered "to se that no reliques of crosses remayne in

any churche or chaple yard within there severall Deanryes." Seven years later reports in the diocese of Chester suggest considerable lack of uniformity, some parishes still having their churchyard crosses while in others these had been reduced to stumps or headless monuments.[58] Discrepancies of this kind maddened the purists, and a number of open-air crosses were defaced or felled by individuals who took the law into their own hands.

At Durham, Neville's Cross was destroyed by nocturnal iconoclasts in 1589. This "most notable famous and goodly larg cross" had been erected to commemorate the victory of 1346 at which the Scots had lost to Lord Neville and the English their celebrated black rood, and its carvings included a Crucifixion as well as the four evangelists and Neville's arms. It apparently remained intact until thirty years after Elizabeth's accession when "in the nighte tyme the same was broken downe and defaced."[59]

Other less conspicuous activists went to work on parish crosses. In 1603 charges were brought in the quarter sessions at Chester against a group of offenders in Bishop Matthew's diocese. Seven men were accused, and confessed that they had one Sunday thrown down with staves a stone cross standing in the churchyard of Wharton, Cheshire, and the same night two of them had broken panels of glass representing St. Andrew and Lazarus in the chancel window at Tarvin some ten miles away. These nocturnal iconoclasts were the servants of John Bruen, who earned praise for his reform of "painted puppets and popish idols" in the church at Tarvin. Doubtless it was the example set by this leading light of the godly in Cheshire that was being followed.[60]

Particularly celebrated examples of cross-breaking were those of Banbury and Cheapside. There could hardly be a more focal Puritan center than Banbury (whose fame became linked with its cross), but even here iconoclasm was divisive and its proponents, aware of the contentiousness of the issue, tried to present the town with a *fait accompli*. Two stonemasons were set to work to hew down the Banbury High Cross at first light on the morning on 26 July 1600. This dawn endeavor was halted by a townsman who disliked the project, and before long a crowd of over a hundred had assembled, demonstrating for and against the work. There were enough supporters to see the demolition work completed, but also enough opponents to result in a case against a clique of the town's aldermen being taken to Star Chamber.[61]

The example of Cheapside Cross is illuminating. As one of the best-known crosses in the country, cherished and restored by generations of Londoners and a focal point in all city processions, it long withstood a battery of objections. This central public monument came to be viewed by some as the central idol in the land, and there were voices calling for its reform more than two generations before this was finally accomplished. One such advocate made known his view of the matter in a very well-read text.

The *Short Catechism for Householders* by John More and Edward Dering, issued in many editions between 1572 and 1634, was one of the more influential texts of its kind in the period. Edward Dering wrote the preface to this *Brief and necessary instruction, very needful to be known of all householders,*

invoking readers to purification from "the idolatrous superstition of the elder world."[62] It was the world of popular literature he specifically had in mind: the dangerous "spiritual enchauntmentes" and "dreames and illusions" of the past that readers found in the tales of Robin Hood, Bevis of Hampton, and Arthur of the Round Table as well as saints' lives and satanic texts "Hell had printed"--the chapbooks stocked by peddlers and chapmen alongside more edifying texts, those "pleasant histories" which, as Margaret Spufford has shown, perpetuated the old world of monks and friars and priests with a timeless disregard for the changes effected by the Reformation.[63] We have seen how St. George lived on in this literature, attached to some of the assumptions of medieval iconography. Dering's solution was simple. All such books, with songs and sonnets, fables and tragedies, should be burned as publicly as possible in London's main thoroughfare so that (as he put it) "the chiefe streete might be sanctified with so holy sacrifice. The place it selfe doth crave it, and holdeth up a gorgeous Idoll, a fyt stake for so good a fire."[64] A bonfire of vanities at Cheapside Cross: Dering's wish was to be granted, but not during his lifetime.

Whatever the inspiration on Dering's readers there were individuals who tried to do something about the egregious idol, Cheapside Cross. The first serious attempt took place in 1581. John Stow described what happened one midsummer under cover of darkness: "The 21 of June in the night, certaine young men, drawing ropes thwart the streete, on both sides the Crosse in Cheape, to stop the passage, did then fasten ropes about the lowest

Images of the said Crosse, attempting by force to
have plucked them downe, which when they could
not doe, they plucked the picture of Christ out of his
mothers lap, whereon he sate, and otherwise defaced
her, and the other Images by striking off their
armes."[65] Despite the issue of a proclamation of-
fering a reward for identification of the offenders,
these iconoclasts were not discovered. But the
matter was taken to the highest authority. On 4
July the city aldermen appointed a committee who
were forthwith to "conferre togeather and consyder
what course ys best to be taken concerninge the
repayringe of the great crosse in Cheapesyde." They
were to take advice from the bishop of Salisbury or
some other learned divine on the repairs and also
"for thanswearynge of her majesties commaunde-
ment in that behalfe." Five days later a deputation
of aldermen had to keep a Sunday morning appoint-
ment at court "touchinge the crosse in Cheape
syde."[66] The queen was evidently concerned about
the state of the city monument, though Stow's ac-
count suggests that it was a long time before some
perfunctory restoration to the damaged Virgin and
Child was completed.

The City authorities were in no hurry to improve
their ancient monument, and differences of opinion
between them and Queen Elizabeth became all too
clear at the turn of the century. The removal of the
crucifix at the top of the Cheapside monument, on
the grounds of its dangerous state of decay, led to
troubles over its replacement. Bishop Bancroft
thought that a cross should be put back, and he had
the queen behind him. Others, who had the support
of the vice-chancellor of Oxford, George Abbot, were

wholly opposed to this and thought that a religiously neutral object, such as a pyramid, should take the place of the deposed crucifix. In the end, Cheapside Cross got back its cross, despite the iconomachs' learned censures. But only twelve days afterwards the nocturnal iconoclasts struck again, once more defacing Virgin and Child.[67]

Crosses and crucifixes were very much in the news after the opening of the Long Parliament--thanks in part to their increased visibility in the 1630's. Crosses came under attack from many directions, and the monument in Cheapside became the topic of a small library of pamphlets in 1642-43. Most of them aimed at its demise, and it comes as no surprise to find that the final destruction of the cross was the work of private as well as public iconoclasts. In January 1642 surreptitious image-breakers launched a new attack, scaling the iron railing that had enclosed the monument since 1603 and breaking several statues, including the figure of Christ. After this, trained bands were set to keep nightly watch on the cross, though it was clear to some that it could not last long.[68] Its obsequies were penned and published. The end came on 2 May 1643 when, with an attendant force of mounted horse and foot companies, with drums beating and trumpets sounding, in the presence of a huge crowd of spectators, Cheapside Cross was finally haled to the ground. A print by Wenceslaus Hollar (fig. 10) commemorated this dramatic occasion, and play was made with the coincidence of date with the Invention of the Holy Cross (3 May) in the Catholic calendar.[69] It was an event comparable to the scenes of 1538. Once again, despite the alteration of circumstance and the

changed conception of the source of idolatry, Rome, spectacular official iconoclasm was a great propagandist rite of dismissal. The vanquishing of the "idol" was a declaratory ceremony designed to sweep idolators into the purified space created by the destroyers.

Ironically--and somewhat inconsistently, given their own view that God was no respecter of places-- the iconoclasts dedicated the site of the demolished idol to further ceremonies of the same kind. Hollar delineated the burning of the Book of Sports "in the place where the Crosse stoode" beneath his etching of its destruction. Both in 1644 and 1645, on days of public thanksgiving, ceremonial bonfires of popish books, pictures, and crucifixes took place on the empty site of Cheapside Cross.[70] Edward Dering would have been delighted.

Extremist purifiers, aiming to free believers from the religious clutter that had endangered their forebears, found spiritual meaning in blank walls and silence. The militant iconoclasts who, in the course of a century, managed to annihilate so much of England's artistic heritage, in the shape of religious sculpture, painting, stained and painted glass, organs, bells, plate, and vestments, may only have been a small minority of activists. Their influence was none the less for that. As Sir Thomas Gresham's agent reported of the destruction in Antwerp on the night of 20-21 August 1566, it was incredible that "so few pepell durst or colde do so much."[71] Overnight image-breaking by the few could alter the course of reform and affect the future beliefs of the many. Such actions played a critical part in the politics of

reformation, and through this physical alteration, separating the faith from so much familiar scenery, Christians were ushered into a reshaped spiritual world. God was to be heard, not seen. In learning to live by the Word, people gradually learned to find in their Bibles the compensation for that huge deprivation of their century, the enforced withdrawal of the "goodly sights" that had accumulated over generations. Many had regrets, but those schooled in the meaning of defilement increasingly found themselves at home in their bared and whitened churches. Some felt cleansed and were thankful, even able, like a preacher to Parliament in 1645, to echo the Elizabethan homilist:

> I am glad for my part, they are scoured of their gay gazing, and I marvelled a great while since, how, and why the Organs grew so many and blew so loud, when the very Homilies accused them for defiling God's house.[72]

Notes

[1]Earlier versions of this paper were delivered in 1980 at the London University Seminar of Michael Hunter and Bob Scribner, and in 1984 at Keith Thomas' graduate seminar in Oxford. I am grateful for the comments offered on both occasions, and also thank Susan Brigden for allowing me to cite her unpublished doctoral thesis.

[2]For the continental experience, see Carlos M. N. Eire, "Iconoclasm as a Revolutionary Tactic: The case of Switzerland 1524-1536," *Journal of the Rocky Mountain Medieval and Renaissance Association*, 4 (1983), 77-96, and *War Against the Idols: The Reformation of Worship from Erasmus to Calvin* (Cambridge: Cambridge Univ. Press, 1986).

[3]René Bornert, *La réforme protestante du culte à Strasbourg au XVIᵉ siècle (1523-1598): approche sociologique et interprétation théologique* (Leiden: Brill, 1981), p. 88, considering this danger of creating "un blocage contre la réforme," cites Capito's *Was man halten und antwurten soll* (of October 1524).

[4]The indulgence which vividly describes this event survives in a single copy in the British Library (STC 14077 c. 68), and is printed in facsimile in K. W. Cameron, *The Pardoner and His Pardons: Indulgences Circulating in England on the Eve of the Reformation* (Hartford, Conn., [1965]), p. 49. I have investigated its context in a forthcoming article, "Iconoclasm at Rickmansworth, 1522: Troubles of Churchwardens."

[5]John Foxe, *The Acts and Monuments*, ed. J. Pratt, 3rd ed. (London: G. Seeley, 1853-68), IV, 707.

[6]Ibid., IV, 706-07.

[7]Ibid., VIII, 581-90. This account was first published in the 1576 edition of the *Acts and Monuments*. In 1538 Thomas Rose made a name for himself as a reformer. He received a handsome testimonial (sent to Cromwell, whose chaplain he was, according to Foxe) for a preaching tour in Lincolnshire, and was invited to preach in London, where it became known that Mass was being celebrated in English at his old parish of Hadleigh. *Letters and Papers, Foreign and Domestic, of the Reign of Henry VIII*, ed. J. S. Brewer, J. Gairdner, and R. H. Brodie (London: Stationery Office, 1862-1932), XIII, Pt. 1, Nos. 704, 1492, pp. 267, 552; *Wriothesley's Chronicle*, ed. W. D. Hamilton, Camden Soc., n.s. 11, 20 (London, 1875-77), p. 83; Susan Brigden, "The Early Reformation in London, 1520-1547: The Conflict in the Parishes," unpubl. Ph.D diss. (Cambridge, 1979), p. 158.

[8]John F. Davis, *Heresy and Reformation in the South-East of England, 1520-1559* (London: Royal Historical Society, 1983), pp. 111-12; *Miscellaneous Writings and Letters of Thomas Cranmer*, ed. Edmund Cox, Parker Soc. (Cambridge: Cambridge Univ. Press, 1846), p. 280; John Strype, *Memorials of Archbishop Cranmer* (Oxford: Ecclesiastical History Society, 1848-54), II, 369, 374-76; Jasper Ridley, *Thomas Cranmer* (Oxford: Clarendon Press, 1962), pp. 88-89. Possibly Rose was placed in the bishop of Lincoln's custody at the time of Warham's death; despite Foxe's report (*Acts and Monuments*, VIII, 582), he seems to have regained the living at Hadleigh for a time.

[9]*Letters and Papers*, VII, No. 523, pp. 208-09: PRO SP6/1, No. 14, fol. 64[r]. The development of the case against images in this decade is examined in Margaret Aston, *England's Iconoclasts*, I (Oxford: Clarendon Press, 1988), chap. 5.

[10]Foxe, *Acts and Monuments*, IV, 627, Appendix vi (unpaginated), from Reg. Tunstall, Guildhall Library, London, MS. 9531/10, fol. 133[v]; Davis, *Heresy and Reformation*, p. 49. Bilney denied the charge as worded (*negat ut ponitur*).

[11]Foxe, *Acts and Monuments*, IV, Appendix vi; Reg. Tunstall, fol. 133[v].

[12]Davis, *Heresy and Reformation*, p. 82; Davis, "The Trials of Thomas Bylney and the English Reformation," *Historical Journal*, 24 (1981), 785.

[13]Foxe's phrase for the Dovercourt iconoclasts (*Acts and Monuments*, IV, 706).

[14]Recent helpful discussions of these events include Robert Whiting, "Abominable Idols: Images and Imagebreaking under Henry VIII," *Journal of Ecclesiastical History*, 33 (1982), 30-47; Ronald Hutton, "The Local Impact of the Tudor Reformations," in *The English Reformation Revised*, ed. Christopher Haigh (Cambridge: Cambridge Univ. Press, 1987), pp. 114-38.

[15]*Wriothesley's Chronicle*, I, 83.

[16]British Library MS. Add. 21,481, fol. 10^v, records under 29 July 1509: "Item for the kinges offring at the Roode of grace 6s 8d." See also MS. Harl. 433, fol. 293; *Letters and Papers*, II, Pt. 2, No. 4333, p. 1336 (Campeggio, on this first visit to England, stayed at Boxley on the night of Monday, 26 July, having spent the weekend seeing the sights of Canterbury); Ronald C. Finucane, *Miracles and Pilgrims: Popular Beliefs in Medieval England* (London, 1977), pp. 208-10. I have benefited from the critical assessment of J. Brownbill, "Boxley Abbey and the Rood of Grace," *The Antiquary*, 7 (1883), 162-65, 210-13. The movements attributed to the rood grew in the telling. See also Davidson, "The Devil's Guts," below, p. 95-97.

[17]*Wriothesley's Chronicle*, I, 75-76. Wriothesley reports that the image "was made of paper and cloutes from the legges upward; ech legges and armes were of timber," and it seems that during Hilsey's sermon it was placed where his auditors could inspect it for themselves. The account sent to Cromwell by his agent Geoffrey Chambers, who arranged the exposure of the rood at Maidstone, two miles away, described "certen ingynes and olde wyer, wyth olde roton stykkes in the backe of the same," which (like Wriothesley) does not suggest recent use (*Original Letters Illustrative of English History*, ed. H. Ellis [London, 1824-46], III, Pt. 3, 168-69).

[18]*Original Letters relative to the English Reformation*, ed. H. Robinson, Parker Soc. (Cambridge, 1846-47), II, 607. Finch's report (unlike Wriothesley's) was far from first hand; he had the news from a German merchant who had English contacts. Other such relations also stressed popular indignation against the impostures of monks and priests. See *Original Letters*, ed. Robinson, II, 604, 609-10, for those of William Peterson and Nicholas Partidge, sent respectively to Conrad Pulbert and Bullinger; for John Hoker of Maidstone's rhetorical letter to Bullinger, see Gilbert Burnet, *The History of the Reformation of the*

Church of England, ed. N. Pocock (Oxford: Clarendon Press, 1865), VI, 194-95; see also the account given by Henry VIII's representatives to the Marquis of Berghen (*Letters and Papers*, XIII, Pt. 2, No. 880, p. 366). On John Finch of Billericay, see C. H. Garrett, *The Marian Exiles* (Cambridge: Cambridge Univ. Press, 1938), p. 153, postulating a possible connection with John Finch, a tiler of Colchester, who abjured Lollard heresies, including "that no maner of worship ne reverence oweth to be do to ony ymages," in 1431; *Heresy Trials in the Diocese of Norwich, 1428-31*, ed. Norman P. Tanner, Camden Soc., 4th ser., 20 (London, 1977), pp. 181-89, esp. p. 185.

[19]*Original Letters*, ed. Robinson, II, 607; cf. p. 609.

[20]William Lambarde, *A Perambulation of Kent* (London, 1576), pp. 181-89, gives a disparaging account of the practices at Boxley, including the deceptions of the image of St. Rumwold, "a preatie shorte picture of a boy sainct, . . . small, hollow, and light" in itself, but capable of being fixed immovably in place by means of a wooden pin. Lambarde (b. 1536) had no first-hand knowledge, but based his report on what was "yet freshe in mynde to bothe sides."

[21]A. van Gennep, *The Rites of Passage* (London: Routledge and Kegan Paul, 1977), pp. 113-14. For examples of evangelical desecration of the previously holy by ritual inversion in profane space, see R. W. Scribner, "Ritual and Reformation," in *Popular Culture and Popular Movements in Reformation Germany* (London: Hambledon Press, 1987), pp. 103-22.

[22]Lambarde, *Perambulation of Kent*, pp. 182-85.

[23]He was curate of St. Benet, Gracechurch Street, and the parishioners who accused him of preaching contrary to the injunctions surmised that he made the remark about Augustine because "it grevede hym to see the Rode of Ungrace with soche other not with out good consideracyon broken in peces of late at paules and abolisshede" (*Letters and Papers*, XIII, Pt. 1, No. 1111, pp. 406-07; PRO E36/120, p. 214; SP 1/132/218).

[24]*York*, ed. Alexandra F. Johnston and Margaret Rogerson, Records of Early English Drama (Toronto: Univ. of Toronto Press, 1979), I, 55; *The York Plays*, ed. Richard Beadle (London: Edward Arnold, 1982), p. 196; *Records of Plays and Players in Lincolnshire, 1300-1585*, ed. Stanley J. Kahrl, Malone Soc. Collections, 8 (1974), pp. xiii-xiv, 26-27; *Records of Plays and Players in Kent, 1450-1642*, ed. Giles E. Dawson, Malone Soc. Collections, 7 (1965), pp. 192-93.

[25]See notes 18 and 20, above, for Hoker and for Lambarde on St. Rumwold. For an example of such an Easter Sepulchre, see my discussion below; but see also Pamela Sheingorn, "No Sepulchre on Good Friday," below, pp. 145-63. Jonas Barish, *The Anti-Theatrical Prejudice* (Berkeley and Los Angeles: Univ. of California Press, 1981),

considers the growth of suspicions of the theater in England, but see also Davidson, "The Devil's Guts," below.

[26]*Jacob's Well*, ed. Arthur Brandeis, EETS, o.s. 115 (London, 1900), p. 16. For the church's ruling on publication, see William Lyndwood, *Provinciale, (seu Constitutiones Angliae)* (Oxford, 1679), p. 355.

[27]Stanford E. Lehmberg, *The Reformation Parliament, 1529-1536* (Cambridge: Cambridge Univ. Press, 1970), p. 91; *Statutes of the Realm*, III, 283; 21 Henry VIII, cap. I, vii.

[28]Samuel Y. Edgerton, Jr., *Pictures and Punishment: Art and Criminal Prosecution during the Florentine Renaissance* (Ithaca and London: Cornell Univ. Press, 1985), pp. 47-58, and the same author's "The Last Judgment as Pageant Setting For Communal Law and Order in Late Medieval Italy," in *Persons in Groups: Social Behavior as Identity Formation in Medieval and Renaissance Europe*, ed. Richard C. Trexler, Medieval and Renaissance Texts and Studies, 36 (Binghamton, N.Y., 1985), pp. 89-90.

[29]M. R. James and E. W. Tristram, "The Wall Paintings in Eton College Chapel and in the Lady Chapel of Winchester Cathedral," *Walpole Society*, 17 (1928-29), 1-43, esp., for this scene, Pls. XIV, XXI. In both cases the source is given in the accompanying inscriptions, that at Eton reading "Qualitas ymago filii beate virginis a perfidis percussa sanguinem dedit. Vincentius"; for the story "De imagine que percussa sanguinem reddidit," see *Speculum Historiale Fratris Vincencii ordinis predicatorum* ([Strasbourg], 1483), Vol. I, Book viii, cap. cx. The two series of paintings are related. For a sermon by the Durham Benedictine Robert Rypon, countering the Lollard case against images and the early iconoclastic example of Epiphanius, see G. R. Owst, *Literature and Pulpit in Medieval England* (Oxford: Basil Blackwell, 1961), pp. 139-40.

[30]An apocryphal scene in the life of Christ which was frequently depicted in medieval art (and which allowed artists to express their ideas of pagan idols) was a miracle that took place on the Flight into Egypt: as Christ and his parents entered an Egyptian city, all the idols fell and broke (fulfilling a prophecy of Isaiah). This story, deriving from the *Liber de Infantia* or *Gospel of Pseudo-Matthew*, passed into popular sources including the *Golden Legend* and the *Meditations on the Life of Christ* attributed to St. Bonaventure, and was illustrated in many places, including church windows (Great Malvern still has an example) and Bible pictures. See M. R. James, *The Apocryphal New Testament* (Oxford: Clarendon Press, 1953), p. 75; Gordon McN. Rushforth, *Medieval Christian Imagery as Illustrated by the Painted Windows of Great Malvern Priory Church, Worcestershire* (Oxford: Clarendon Press, 1936), p. 287; Sandra Hindman, *Text and Image in Fifteenth-Century Illustrated Dutch Bibles* (Leiden, 1977), pp. 55-56, fig. 21.

[31]John Mirk, *Festial*, ed. Theodor Erbe, EETS, e.s. 96 (London, 1905), Pt. I, p. 265.

[32]*The Eclogues of Alexander Barclay*, ed. Beatrice White, EETS, o.s. 175 (London, 1928), p. 100.

[33]Jacobus de Voragine, *The Golden Legend* (Westminster: William Caxton, 1483), fols. clvi[v]-clvii[v]; *Three Lives from the Gilte Legende*, ed. Richard Hamer, Middle English Texts, 9 (Heidelberg: Universitätsverlag, 1978), pp. 65-74; *The Life of St. George by Alexander Barclay*, ed. William Nelson, EETS, o.s. 230 (London, 1955), pp. 12-13, 90, 106; STC 22,992.1.

[34]*Speculum Sacerdotale*, ed. Edward H. Weatherly, EETS, o.s. 200 (London, 1936), pp. 129-33. This account reverses the *Golden Legend* order and places the burning of the idols before the dragon-killing; see p. 130 for St. George's prayer at which "there come downe a fyre fro heuen and sodeynly brande the temple with alle the godis and the maistris."

[35]Gordon McN. Rushforth, "The Windows of the Church of St. Neot, Cornwall," *Exeter Diocesan Architectural and Archaeological Society Transactions*, 15 (1937), 175-76, Pl. xlvi.

[36]*The Life and Death of St. George, The Noble Champion of England* (London, [1750?]), p. 13. For the Pepys text (of which there were several editions between 1660 and 1689, his being possibly of 1685), I cite from the copy in the Pepys Library, Magdalene College, Cambridge (Penny Merriments, II [6], p. 123), on which see Margaret Spufford, *Small Books and Pleasant Histories* (London: Methuen, 1981), pp. 227-31. I am most grateful to Margaret Spufford for lending me a copy of this chapbook. St. George's image-breaking also featured in a work which was in print for the best part of a century after its first appearance in 1596. In Richard Johnson's *The Most Famous History of the seven Champions of Christendome* (London, 1608), p. 23, the Persians' solemn sacrifice to their pagan gods "so mooved the impatience of the English Champion, that he tooke the ensignes and streamers whereon the Persian Gods were pictured, and trampled them under his feete."

[37]Lynette Muir, "The Saint Play in Medieval France," in *The Saint Play in Medieval Europe*, ed. Clifford Davidson, Early Drama, Art, and Music, Monograph Ser., 8 (Kalamazoo: Medieval Institute Publications, 1986), p. 159. The idol in this Bourges *Actes des Apôtres* was capable of special trick effects. Cf. Clifford Davidson, "The Middle English Saint Play," in *The Saint Play in Medieval Europe*, pp. 37, 40, 48, on the possible dramatic role of idols in English plays of SS. Eustace, Lawrence, and Catherine. Destruction of the entire pagan temple with its idol of "mament" is one of the spectacular effects of the Digby *Mary Magdalene*; see *The Late Medieval Religious Plays of Bodleian MSS*

Digby 133 and e Museo 160, ed. Donald C. Baker, John L. Murphy, and Louis B. Hall, Jr., EETS, 283 (1982), p. 76. The destruction by fire that would have been called for in this scene was also encountered in dramatic presentations of Doomsday; see *Coventry*, ed. R. W. Ingram, Records of Early English Drama (Toronto: Univ. of Toronto Press, 1981), p. 230, including a 1565 payment at Coventry for "Settynge the worldes on fyre."

[38]*Letters and Papers*, XIII, Pt. 2, No. 1280, pp. 529, 535; Finucane, *Miracles and Pilgrims*, p. 205. Cf. *Letters and Papers*, II, Pt. 2, pp. 1442, 1449, and British Library MS. Add. 21,481, fols. 23v, 51r, 52v, for earlier payments for the king's candle and his priest singing before Our Lady of Walsingham (costing £4 13s 4d and £10 a year respectively) and for the king's offerings there in 1520.

[39]*Letters and Papers*, VI, No. 1255, p. 514, for the views of Richard Panemore (1533) on Latimer's reported preaching that church images should be pulled down and that the *Ave Maria* was no prayer; J. F. Davis, "Lollards, Reformers and St. Thomas of Canterbury," *Birmingham Historical Journal*, 9 (1963), 13.

[40]Aston, *England's Iconoclasts*, pp. 225-36, attempts to explain the situation at this time rather more fully than was done by John Phillips, *The Reformation of Images: Destruction of Art in England 1535-1660* (Berkeley and Los Angeles: Univ. of California Press, 1973), pp. 58-62.

[41]*Wriothesley's Chronicle*, I, 79-81; *Hall's Chronicle* (London, 1809), pp. 825-26; *Original Letters*, ed. Ellis, III, Pt. 3, 194-95, cf. I, Pt. 2, 82-83. This affair is discussed in M. Aston, "Iconoclasm in England: Rites of Destruction by Fire," in the forthcoming collection of papers delivered at the Herzog August Bibliothek, Wolfenbüttel, conference of September 1986: *Bilder und Bildersturm im 16. Jahrhundert,* ed. Bob Scribner.

[42]*Wriothesley's Chronicle*, I, 78-79; *Letters and Papers*, XIII, Pt. 1, No. 1043, p. 385; Ridley, *Thomas Cranmer*, pp. 160-61. Forest was hanged before being burned.

[43]*Wriothesley's Chronicle*, p. 81; John Stow, *A Survey of London*, ed. C. L. Kingsford (Oxford: Clarendon Press, 1905), I, 209-10.

[44]Foxe, *Acts and Monuments*, V, 28, 32. The king offered 6s 8d to the rood in 1511 (*Letters and Papers*, II, Pt. 2, p. 1449; British Library MS. Add. 21,481, fol. 52v).

[45]Corporation of London Rec. Office, Repertory 10, fol. 34v: "as they say M' Cromer reportyd by the report of ye bysshopp of Worceter that ye lorde prevy seales [commaundet?] that ye seid Image shuld be removyd." I owe this reference to Susan Brigden, "The Early Reformation in London," pp. 198-99. The matter was of immediate concern to the

MARGARET ASTON

court of aldermen, who, as patrons of the living, had two months earlier
presented John Grene. He held St. Margaret Pattens until July 1542,
when he resigned (Repertory 10, fols. 25ᵛ, 267ᵛ; cf. *Letters and Papers*,
XIII, Pt. 1, No. 866, p. 319; PRO, SP 1/131/242, for a John Grene who
petitioned Thomas Wriothesley for advancement to a living, having
failed in his expectation of promotion through service to Chancellor
Audley).

⁴⁶The outcome of these proceedings is not known, but Gough was
very much in business a few years after and was imprisoned in the
Fleet for printing seditious books in 1541; see Margaret Aston, *Lollards
and Reformers: Images and Literacy in Late Medieval Religion* (London:
Hambledon Press, 1984), pp. 229-30, 242, 251, and *England's Icono-
clasts*, p. 203.

⁴⁷*Original Letters*, ed. Ellis, III, Pt. 3, 112-15. This letter was
dated 12 October (*Letters and Papers*, XIII, Pt. 2, No. 596, 232).
Barclay, who had preached the previous day in honor of the Virgin, was
under pressure from Dynham who was determined to exploit the
situation. Stow (*Survey of London*, I, 209-10) reports the fire in the
parish of St. Margaret Pattens on 27 May 1538: "amongst the basket-
makers, a great and sudden fire happened in the night season, which
within the space of three hours consumed more than a dozen houses,
and nine persons were burnt to death there."

⁴⁸There is a problem over the meaning of the word 'delay,' for
which the *OED* and *MED* do not give obvious analogous examples, the
temporal meaning of the word (related to the Latin *differre* and English
defer) being dominant. Ann Nichols suggests that since 'delay' and
'defer' could be used synonymously with the sense of "postpone" (*OED*
gives example from John Palsgrave's *Lesclarcissement de la Langue
Francoyse* [1530], "I delaye one, or deferre hym, or put hym backe of his
purpose"), possibly 'delay' could be used synonymously for 'defer' in the
meaning of "to put on one side, set aside" (*OED* cites Lydgate, *Minor
Poems*: "Grace withe her lycour cristallyne and pure / Defferrithe
vengeaunce off ffuriose woodnes"). The word 'defer,' with this obsolete
non-temporal sense of set aside, carry down, convey away, was synony-
mous with another obsolete form, 'delate' (derived from the Latin
deferre). An example cited in the *MED* of the verb 'delaien' used in this
same sense is the Wycliffite Bible's translation of Psalm 21.20 (*Tu
autem Domine ne elongaveris auxilium tuum a me*) as "But thou, Lord,
delaie not thin help fro me." It seems likely that the injunction's 'delay'
bore such a meaning (*elongare*, to remove, make distant), and this
interpretation is supported by the proclamation of November 1538
against Becket imagery, ordering it to be "put down and avoided" from
churches. See *Visitation Articles and Injunctions of the Period of the
Reformation*, ed. W. H. Frere and W. M. Kennedy, Alcuin Club Collec-
tions, 14-16 (1910), II, 38; *Tudor Royal Proclamations*, ed. Paul L.
Hughes and James F. Larkin (New Haven and London: Yale Univ.
Press, 1964-69), I, 276; Aston, *England's Iconoclasts*, p. 227; and

Davidson, "The Devil's Guts," below, pp. 128-29.

[49]Aston, *England's Iconoclasts*, pp. 230-32. Possibly this image, which held the host, was an Easter Sepulchre image: cf. H. J. Feasey, *Ancient English Holy Week Ceremonial* (London: Thomas Baker, 1897), pp. 134-37, and, especially, Pamela Sheingorn, *The Easter Sepulchre in England*, Early Drama, Art, and Music, Reference Ser., 5 (Kalamazoo: Medieval Institute Publications, 1987), pp. 58-59.

[50]*Letters and Papers*, XVIII, Pt. 2, No. 546, p. 295.

[51]Ibid., XVIII, Pt. 2, 297. On John Crosse, see A. B. Emden, *A Biographical Register of the University of Oxford A.D. 1501 to 1540* (Oxford: Clarendon Press, 1974), p. 153. For affairs in Kent at this time, see Michael L. Zell, "The Prebendaries' Plot of 1543: A Reconsideration," *Journal of Ecclesiastical History*, 27 (1976), 241-53; Peter Clark, *English Provincial Society from the Reformation to the Revolution: Religion, Politics and Society in Kent 1500-1640* (Hassocks: Harvester Press, 1977), pp. 38-66.

[52]Corporation of London Record Office, Repertory 11, fol. 349.

[53]Brigden, "The Early Reformation in London," p. 199; PRO, SP1/135, fol. 247; *Letters and Papers*, XIII, Pt. 2, No. 209, p. 81; *Wriothesley's Chronicle*, I, 84. A call for this action was sent to Cromwell a month earlier by George Robinson, who in a letter of 16 July described how he had visited St. Paul's: "I went to powlles where I ffound sent Uncombre stonddyng in hyr old place and state with hyr gay gowne and sylver schews on and a woman kneelyng beffore hyr at xi of the cloke." It was for the king to be Josiah and take all such images away (*Letters and Papers*, XIII, Pt. 1, No. 1393, p. 515; PRO, SP 1/134/183).

[54]*Chronicle of the Grey Friars of London*, ed. J. G. Nichols, Camden Soc. (London, 1852), p. 55; *Wriothesley's Chronicle*, II, 1.

[55]*Wriothesley's Chronicle*, II, 1; Millar MacLure, *The Paul's Cross Sermons, 1534-1642* (Toronto: Univ. of Toronto Press, 1958), pp. 40-41; Sheingorn, *The Easter Sepulchre*, p. 61. The second of these images belonged to the execrated class of moving figures, like the Boxley one; "the resurrection of our Lord made with vices, which putt out his legges of sepulchree and blessed with his hand, and turned his heade." See also Sheingorn, "No Sepulchre on Good Friday," below, pp. 153-54.

[56]*Narratives of the . . . Reformation*, ed. J. G. Nichols, Camden Soc., 77 (London, 1859), pp. 29-30; Emden, *Biographical Register of Oxford 1501 to 1540*, pp. 208-09; Nicholas Sander, *Rise and Growth of the Anglican Schism*, trans. D. Lewis (London: Burns and Oates, 1877), pp. 207-08. "Golden gods" (a scriptural phrase) would have been especially provocative; see Aston, "Gold and Images," in *The Church and Wealth*,

ed. W. J. Sheils and D. Wood, *Studies in Church History*, 24 (1987), pp. 189-207.

[57]*Certain Sermons or Homilies appointed to be read in Churches* (Oxford: Oxford Univ. Press, 1844), p. 311, from the Homily of the Place and Time of Prayer.

[58]*Tudor Parish Documents of The Diocese of York*, ed. J. S. Purvis (Cambridge: Cambridge Univ. Press, 1948), pp. 177, 202.

[59]*Rites of Durham*, ed. J. T. Fowler, Surtees Soc., 107 (Durham, 1903), pp. 27-28. This regretful account, outspoken in its condemnation of the "lewde and contemptuous wicked persons" responsible for this deed, was written about 1593, and gives a full description of the cross.

[60]R. C. Richardson, *Puritanism in North-West England* (Manchester: Manchester Univ. Press, 1972), pp. 122-23, 158. (Since there is no Warton within range of Tarvin, I have taken the reference on p. 123 to relate to Wharton, Cheshire.)

[61]P. D. A. Harvey, "Where was Banbury Cross?" *Oxoniensia*, 31 (1966), 83-106; William Potts, *Banbury Cross and the Rhyme* (Banbury, 1930); *A History of the County of Oxford*, ed. Alan Crossley, Victoria History of the Counties of England (London: Oxford Univ. Press, 1972), X, 7-8, 23, 98.

[62]*A briefe & necessary Instruction, Verye needefull to bee knowen of all Housholders* (London, 1572), sigs. Aii[r]-Aiii[r]. On this work (STC 6679-6682.3, 6710.5-6724.5), see Patrick Collinson, *Godly People: Essays on English Protestantism and Puritanism* (London: Hambledon Press, 1983), pp. 297-98, 321-22.

[63]Spufford, *Small Books and Pleasant Histories*, pp. 219-20, 240-41, 250-51. Dering's proscribed books would have included lives of St. George like those mentioned above.

[64]*A Briefe & necessary Instruction*, sig. Aiii (with reference to the "zealous Ephesians" of Acts 19).

[65]John Stow, *Annales, or, A Generall Chronicle of England* (London, 1631-32), p. 694; cf. Stow, *Survey of London*, ed. Kingsford, I, 266, and II, 331, which records the lowest tier of images as including the Resurrection, the Virgin Mary, and King Edward the Confessor.

[66]Corporation of London Record Office, Repertory 20, fol. 216.

[67]Stow, *Survey*, ed. Kingsford, I, 266-67; [G. Abbot], *Cheapside crosse censured and condemned* (London, 1641); *Acts of the Privy Council of England*, n.s. 1542-1631 (London: Rec. Office, 1890-1964), XXX, 27, and XXXI, 44.

[68]*The crosses case in Cheapside* ([London,] 1642), pp. 1-2; *Calendar of State Papers, Domestic, 1641-43* (London: HMSO, 1887), I, 274.

[69]John Vicars, *A Sight of y^e Transactions of these latter yeares* (London [1646]), p. 21; *True information of the beginning and cause of all our Troubles* (London, 1648), p. 17; Richard Pennington, *A Descriptive Catalogue of the Etched Work of Wenceslaus Hollar, 1607-1677* (Cambridge: Cambridge Univ. Press, 1982), p. 75 (No. 491A).

[70]Vicars, *A Sight*, p. 21; Bulstrode Whitelocke, *Memorials of the English Affairs* (Oxford, 1853), I, 326, 482.

[71]J. W. Burgon, *The Life and Times of Sir Thomas Gresham* (London, 1839), II, 139; cf. II, 137.

[72]Thomas Thorowgood, *Moderation Justified, and the Lords Being at Hand Emproved* (London, 1645), p. 16; quoted by R. W. Ketton-Cremer, *Norfolk in the Civil War* (London: Faber, 1969), p. 262.

"The Devil's Guts":
Allegations of Superstition and Fraud
in Religious Drama and Art
during the Reformation

Clifford Davidson

I

On Ascension Day in the year following that in which Queen Elizabeth I was crowned, a religious procession commemorating the feast day near St. Paul's Cathedral in London was disrupted by a young man whose actions and iconoclastic fervor were described by the Venetian ambassador, Il Schifanoya. The iconoclast was said by the ambassador to be "a rascally lad-servant of these new printers against the Catholics," and if this description is accurate he may be associated not only with Protestantism but with the visual code that is the printed text--in other words, a champion by his chosen vocation of the Word rather than the sacred image.[1] Il Schifanoya, writing on 10 May 1559 to the Castellan of Mantua, noted that the young man "violently and publicly took the cross out of the hand of the bearer, and struck it on the ground two or three

times, breaking it into a thousand pieces." Disturb-
ingly, he was not stopped by anyone, though some
older men chided him with the words "Begone, you
scoundrel." Finally, "he took a small figure from the
said cross, and went off, saying, as he showed it to
the women, that he was carrying away the Devil's
guts (horrible and wicked words)."[2] What to the
Venetian ambassador was sacrilege instead was
regarded by the young man as an attack on supersti-
tion and fraud, for actions against images--and
certain ceremonies such as processions--must have
been seen by him to be meritorious acts, efforts to
achieve a cleansing from the filth associated with the
polluted eye.

Less than a year previously, while Queen Mary
was still on the throne of England, John Feckenham,
the last abbot of Westminster, had repaired the
desecrated shrine of St. Edward the Confessor and
with considerable ceremony had replaced his relics in
the place where they had previously been deposited.[3]
Though this shrine, since it represented a monument
of an English king, would remain located in its place
in Westminster Abbey in the future (fig. 11), the
attempt to return to Catholic practices focusing on
relics, images, and ceremony was to fail, and the
prevailing view was to be that of the two armed men
who barred a religious procession at a London church
and swore "that the ecclesiastics should not carry
such an abomination" (presumably a processional
crucifix).[4] By the end of August of 1559, on the feast
of St. Bartholomew, the fires of Smithfield burned
against the wooden roods, with their figures of Mary
and St. John, and also against "odur emages" that
had been replaced in Queen Mary's time, and ac-

cording to Henry Machyn these images "bornyd with
gret wondur."[5] Queen Elizabeth, who chose to have
a crucifix in her own chapel,[6] could not control the
tide of iconoclasm directed against the visual arts.
Pressure for progress in removing images from
churches came from her bishops, who insisted that
"images [are] not expedient for the church of Christ"
and are offensive,[7] though the Articles of 1559 had
already included prohibitions against priests who
might extoll "vague and superstitious religion,
pylgrimages, reliques, or ymages, or lyghtynge of
candelles, kyssinge, knelynge, deckynge of the same
ymages."[8] Then in 1563 was published *The Second
Tome of Homilies* which contained "An Homilie
agaynst perill of Idolatry and Superfluous deckyng of
Churches" (fols. 12r-83v). While images in them-
selves are "thynges indifferent" (fol. 21), they must
not be worshipped, and to prevent the devotional use
of such images they are to be set aside as supersti-
tious and fraudulent. The argument that images are
"laye mens bookes" is confuted, for "we see they
teache no good lesson . . . but all errour and wicked-
nes. Therfore God by his word, as he forbyddeth any
Idolles or Images to be made or sette vp: so doth he
commaunde, suche as we finde made and set vp, to
be pulled downe, broken, and destroyed" (sig. 18v).

The Protestant iconoclasm of the early period of
the reign of Elizabeth I may be described as the third
great wave of such destruction, the first occurring at
the time of the dissolution of the monasteries under
King Henry VIII. During the first phase, iconoclasm
was officially directed against abused images which
had been the object of allegedly superstitious venera-
tion, including ritual acts such as censing, kneeling

before, and saying prayers to images.[9] The documents of Cromwell's Commissioners put into practice a stern and unbending interpretation of the official position. At Bury St. Edmunds, the Commissioners reported that they had "founde a riche shryne whiche was very comberous to deface";[10] thus they began the process which would eventually result in the total destruction of the pilgrimage site dominated by the relics of St. Edmund, the East Anglian king and martyr. In another instance, Dr. John London wrote to Cromwell that he had "pullyd down the image of our lady at Caversham, wherunto wasse great pilgremage." This action significantly was directed against the cult of Mary so hated by the early English Protestants, and not surprisingly he "also pullyd down the place sche stode in, with all other ceremonyes, as lightes, schrowdes, crowchys, and imagies of wex, hangyng abowt the chappell, and have defacyd the same thorowly in exchuyng of any farther resortt thedyr."[11] At Hyde Abbey and St. Mary's the Commissioners determined "to swepe awaye all the roten bones that be called reliques," though here there was registered a protest that they were more interested in "treasure then . . . [in the] avoiding of thabomynation of ydolatry."[12]

The Commissioners and the more zealous Protestant clergy went to great lengths to produce evidence that fraud, deception, and greed were to be discovered behind relics and behind those images especially which had been the object of devotion. One of the best-known examples is, of course, the case of the Rood of Grace from the Cistercian abbey at Boxley near Maidstone which is also discussed by Margaret Aston in her essay in the present volume.

While numerous miracles had been reported at Boxley and King Henry VIII himself had visited there as a pilgrim in 1510, the rood was to become a prime vehicle for iconoclastic propaganda seeming to prove the fraud exhibited by images.[13] Early notice by the Commissioners was expectedly unfavorable: "The idolle that stode there, in myne opynyon a very monstruous sight."[14] However, when it was seen that the Rood of Grace involved a mechanical contrivance, the abbot was charged with fraud and the rood was eventually taken to London where it was shown at Paul's cross during an sermon by Bishop Hilsey of Rochester on the subject of idolatry. From the most reliable account of the rood by Charles Wriothesley, we learn that it was designed so that the eyes and lips might be moved by concealed "stringes of haire" as if miraculously.[15] At first it was taken to Maidstone where it was set up in the market-place "and there shewed openlye to the people the craft of movinge the eyes and lipps, that all the people there might see the illusion that had been used in the sayde image by the monckes of the saide place of manye yeares tyme out of mynde, whereby they had gotten great riches in deceavinge the people thinckinge that the sayde image had so moved by the power of God, which now playnlye appeared to the contrary."[16]

The story as told later in the century by William Lambarde in *A Perambulation of Kent* explains that people then still remembered the "imposture, fraud, Iuggling, and Legierdemain" by which "the sillie lambes of Gods flocke were (not long since) seduced by the false Romish Foxes at this Abbay."[17] Lambarde, who claimed rather implausibly that the

Rood of Grace was "compacted of wood, wyer, paste and paper," must also have exaggerated when he claimed a large repertoire of gestures and movements for it: he insisted upon its ability to bow, to move hands and feet, to nod, to move its eyes, "to wag the chaps," and ultimately "to represent to the eie, both the proper motion of each member of the body, and also a lively, expresse, and significant shew of a well contented or displeased minde" in response to the prayers of pilgrims.[18] In actuality, the Rood of Grace was not unique in possession of a mechanism, however limited its actual repertoire of movements might have been.[19] Robert Shrimpton, who died when he was more than a hundred years old in c.1608, remembered an image at St. Albans: a "hollow image erected near St. Alban's shrine, wherein one being placed to govern the wires, the eyes would move and head nod, according as he liked or disliked the offering. . . ."[20] Reference to feigned miracles associated with images, to weeping statues, and to trickery made possible by a devout and gullible people prior to the Reformation will be found in the influential Elizabethan Homily against Idolatry added to the *Book of Homilies* in 1563.[21]

The second wave of iconoclasm, which affected the parish churches more directly than the first, came during the reign of Edward VI and involved an official campaign to remove images and other marks of medieval "superstition" but only following a strong popular movement which aimed at "cleansing" places of worship, most enthusiastically in the cities where Protestantism had taken a foothold.[22] As we learn from a report of 5 December 1547 to the Emperor's Council of State,

> The great crucifix which was on the altar in Saint Paul's
> Church was a few days ago cast down by force of
> instruments, several men being wounded in the process
> and one killed. There is not a single crucifix now
> remaining in the other churches. . . . As there is, of
> course, no lack of people who complain of these pro-
> ceedings, a bishop has recently preached a sermon
> explaining the reasons that have moved them to abolish
> the images. In order to persuade the people he pro-
> duced and showed them certain figures artificially made
> to move their heads, arms and legs, these, he said,
> having been visited and venerated as miraculous.[23]

It was during this period, therefore, that we find
churchwardens' accounts generally making note of
the removal of the rood, images, vestments, painted
cloths, and so forth, though sometimes, as in St.
Michael, Spurriergate, York, some of these items
were merely locked away with the expectation that
better times would return before long.[24] At St.
Bride, Fleet Street, London, the King's Commis-
sioners wrote that some goods had been sold by the
churchwardens to provide funds "for that there was
no money then in the Churche boxe wherewith to
reforme the seide Churche of the Idolatrous Images
and monumentes then standyng therein and to
garnyshe the same Churche with Scriptures accord-
yng to the appoyntment and commaundement of the
Kynges maiesties visitor. . . ."[25] At St. Stephen,
Coleman Street, even some new glass was purchased
since the extant "Imagerye was contrarye to the
Kinges proceedinges,"[26] while at St. John Zachary
the cloth that covered the images was described as
"the lynone banor clothes that couered the yeddolles
in lente."[27] Fairly typical of change in churches
located in towns would seem to be Ludlow, where

payments were recorded in 1548 for "takynge downe of the roode and the images" while receipts were noted in payment for "the image of saynt George that stode in the chapelle" and for other images, which had included Jesus, St. Margaret, and St. Catherine. In 1551 the Lady Altar was removed, and in 1552 the walls of the church were whitewashed.[28] Curiously, in the chapel of Merton College, Oxford, there is record of the whitewashing of both walls *and* *windows* in 1549-50.[29]

With the coming of Queen Mary to the throne, the churchwardens' accounts generally record the return of the rood to its place over the chancel arch and often the replacing of images in the churches, though obviously much of the damage that had been done could not be undone. At Ludlow, for example, the rood was replaced in 1554, and from the 1559 accounts which record its removal, it would appear that a standing figure of the Virgin had been replaced in the Lady Chapel.[30] In spite of the repressiveness of Queen Mary's regime, however, the fury of the iconoclasm could not even then be entirely stemmed, for Machyn records that on 17 February 1555 "at bowt mydnyght ther wher serten lude feylous cam unto sant Thomas of Acurs [College of St. Thomas of Acon, or Mercers' Chapel, in Cheapside, London], and over the dore ther was set the ymage of sant Thomas [of Canterbury], and ther thay brake ys neke and the tope of ys crosier, the whyche was mad of fre-ston; with grett sham yt was done."[31] Another act of vandalism against the same image in which his neck was broken and his arms fractured was recorded by Machyn less than a month later.[32] Doubtless in these instances the acts of iconoclasm

were in part motivated by hatred of St. Thomas Becket, who had become for the English Protestants a symbol of the allegedly illegitimate power of Rome over England. Henry VIII in his Proclamation of 16 November 1538 had declared Becket to be no martyr and instead "to be esteemed to have been a rebel and a traitor" with the result "that his images and pictures through the whole realm shall be put down. . . ."[33] Those who broke his statue at the Mercers' Chapel in Cheapside nevertheless were apprehended, and were found to be a mariner, a shoemaker, and a butcher from Dover.[34] At the beginning of the next reign, such men engaged freely in iconoclastic acts for a time as the smoke rose from the burning of images at Cheapside and Smithfield in London.[35] At Merton College, Oxford, the chapel would now undergo "drastic" changes[36]--changes of the type which also would occur across the country in many parishes at this time. Under Elizabeth I, another and very damaging period of iconoclasm had begun.

In what appeared to be a happier time, John Weever surveyed the iconclasm of the Reformation in England in his *Ancient Funerall Monuments* (1631): during the reigns of Henry VIII and Edward VI, "certaine persons" were designated

> to pull downe, and cast out of all Churches, Roodes, grauen Images, Shrines with their reliques, to which the ignorant people came flocking in adoration. Or any thing else, which (punctually) tended to idolatrie and superstition. Vnder colour of this their Commission, and in their too forward zeale, they rooted vp, and battered downe, Crosses in Churches, and Church-yards, as also in other publike places, they defacd and

brake downe the images of Kings, Princes, and noble estates; . . . they crackt a peeces the glasse-windowes wherein the effigies of our blessed Sauiour hanging on the Crosse, or any one of his Saints was depictured; or otherwise turned vp their heeles into the place where their heads vsed to be fixt; as I haue seene in the windowes of some of our countrey Churches. They despoiled Churches of their copes, vestments, Amices, rich hangings, and all other ornaments wherevpon the story, or pourtraiture, of Christ himselfe, or of any Saint or Martyr, was delineated, wrought, or embroidered, leauing Religion naked, bare, and vnclad. . . .[37]

The idea of a Church of England as a middle way, between the nakedness of Calvinism and the gaudiness of Rome, was, of course, the ideal of Archbishop Laud, and it was an ideal best expressed perhaps in George Herbert's poem "The British Church": "A fine aspect in fit aray,/ Neither too mean, nor yet too gay,/ Shows who is best." Official iconoclasm was in abeyance but only temporarily.

Nevertheless, there remained strong currents of iconoclasm which surfaced from time to time. The most sensational, and for our purposes the most revealing, act of iconoclasm occurred at Salisbury in St. Edmund's Church, a Puritan stronghold, in 1630. A vestry order of January 1630 had approved the removal of a painted glass window illustrating the Creation of the World, which was to be replaced with white glass, since the glass "is somewhat decayed and broken, and is very darksome, whereby such as sit near the same cannot see to read in their books."[38] The Bishop of Salisbury, however, decreed that the window should not be removed, and the Recorder of Salisbury, Henry Sherfield, thereupon engaged in an act of ecclesiastical disobedience that

would lead ultimately to his trial in the Star Chamber.[39] Sherfield borrowed the keys of the church, and with his pike-staff broke the window. His objections to the window which emerged during the trial were that the depiction was inaccurate, illustrating God as like an old man and otherwise distorting the story of the Creation as told in *Genesis*:

> The painter, to represent God the Father, had depicted the forms of diverse little old men, barefooted, and clothed in long blue coats: that in setting forth the six days' work of the creation, he had placed one such figure in six several places, joining near them the likeness of some created thing, to denote what was made in each of the six days. To shew the third day's work, he had painted the sun and the moon, which were created the fourth day; and he had placed in the hand of one of these figures, representing God the Father, the similitude of a carpenter's compass, as if he had been compassing the sun, to give the true proportion thereof. For the fourth day's work he made the likeness of fowls, flying up from God, the maker, whereas God created them on the fifth day. To express the fifth day's work, he painted the similitude of a naked man, lying on the earth as it were asleep, and so much of the similitude of a naked woman, as from knees upward, seeming to grow out of the side of the man, whereas God did create man on the sixth day; neither did the woman grow out of the man's side, but God took a rib from the man, and made it a woman. To represent the seventh day's rest, he painted the picture of a little old man, in the same habit as the rest, but sitting.[40]

Neither Sherfield's literalism nor his charges concerning the alleged falseness of the painted glass were challenged directly in the Star Chamber trial, but instead his disobedience to ecclesiastical author-

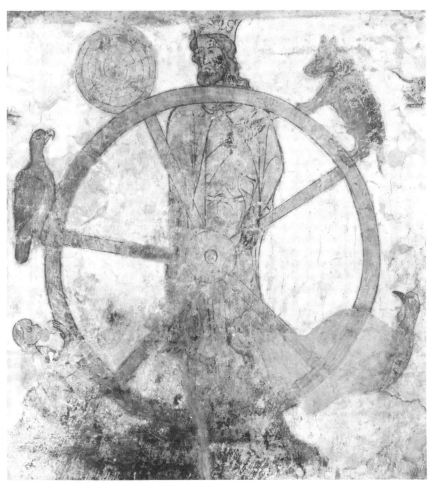

1. Wheel of the Senses showing cock as representative of Sight. Wall painting, Longthorpe Tower, Northamptonshire. Courtesy of the Royal Commission on the Historical Monuments of England.

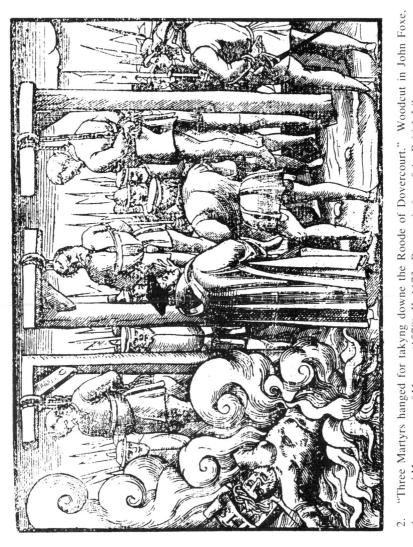

2. "Three Martyrs hanged for takyng downe the Roode of Dovercourt." Woodcut in John Foxe, *Actes and Monumentes of Martyrs* (1570). II, 1173. By permission of the British Library.

3. Miracle of the wounded image. Late fifteenth-century wall painting, Eton College Chapel. A woman kneels devoutly before a statue of the Virgin and Child (barely visible to right) in the niche of a church facade. Behind, a soldier in laced doublet and hose raises his arm to throw a stone and then falls dead. Courtesy of *Country Life*.

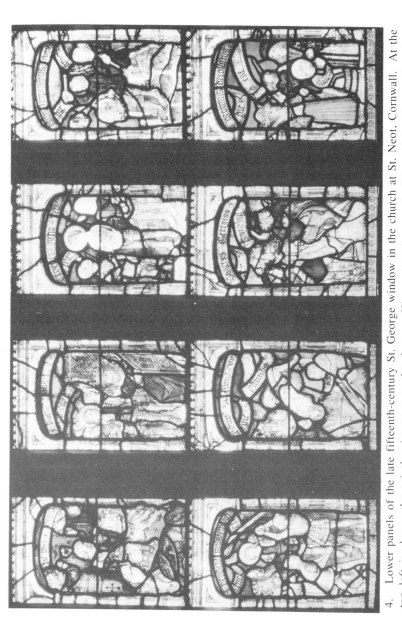

4. Lower panels of the late fifteenth-century St. George window in the church at St. Neot, Cornwall. At the top left is shown the saint's victory over the dragon (*Hic mactat draconem*), followed by his stand against idolatry and scenes of his torture and martyrdom. Courtesy of the Royal Commission on the Historical Monuments of England.

5. St. George depicted in a ballad of c.1695, which tells how "While he in *Persia* abode,/ He straight destroy'd each Idol-god." By permission of the British Library.

6. Princess Sabra, saved by St. George from being "the Dragon's next meal," introduces him to the king her father, who receives the champion "with all the gratitude imaginable." *The Life and Death of St. George* (?1750), p. 11. By permission of the British Library.

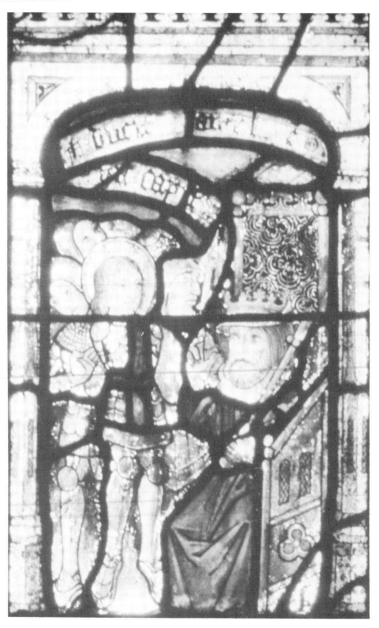

7. St. George, arrested for denouncing pagan idolatry, is brought before the king (*Hic capitur et ducitur ante regem*). Panel of St. George window, St. Neot, Cornwall. Courtesy of the Royal Commission on the Historical Monuments of England.

8.　St. Wilgefortis or Uncumber.　Early sixteenth-century statue in Henry VII's Chapel, Westminster Abbey.　According to legend, she was saved from marriage by the growth of her beard, but then was crucified by her pagan father.　English women were rebuked by Thomas More for believing that for a peck of oats "she will not fail to uncumber them of their husbands." Courtesy of the Dean and Chapter, Westminster Abbey.

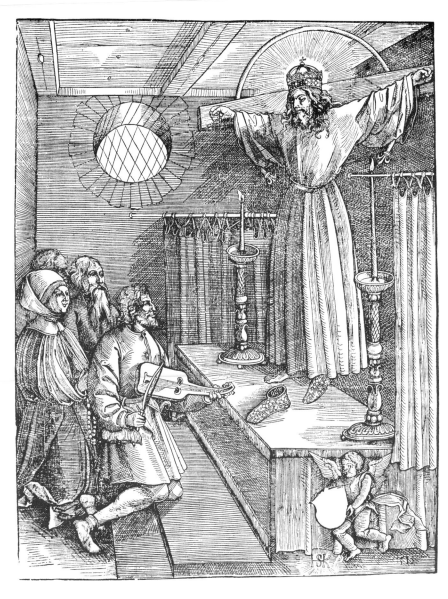

9. St. Wilgefortis and the Fiddler. Woodcut by Hans Springinklee (1513), illustrating the story of how an image of the saint shed a golden shoe to assist a destitute fidel player. Courtesy of the British Museum.

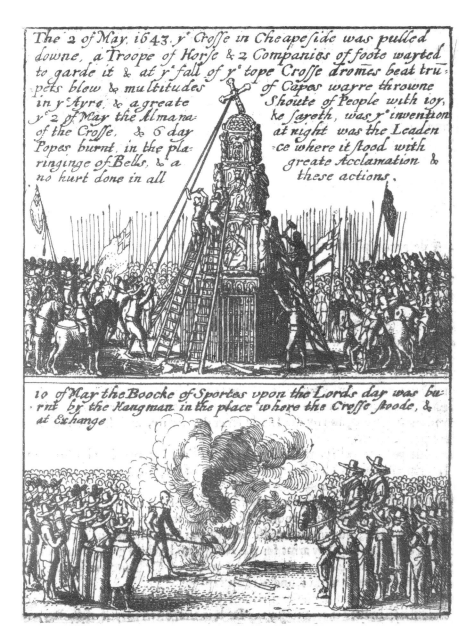

The 2 of May. 1643. y⁺ Croſſe in Cheapeſide was pulled downe, a Troope of Horſe & 2 Companies of foote wayted to garde it & at y⁺ fall of y⁺ tope Croſſe dromes beat tru: pets blew & multitudes of Capes wayre throwne in y⁺ Ayre, & a greate Shoute of People with ioy, y⁺ 2 of May the Almana- ke ſayeth, was y⁺ invention of the Croſſe, & 6 day at night was the Leaden Popes burnt, in the pla- -ce where it ſtood with ringinge of Bells, & a greate Acclamation & no hurt done in all theſe actions.

10 of May the Boocke of Sportes vpon the Lords day was bu: ·rnt by the Hangman in the place where the Croſſe ſtoode, & at Exhange

10. Destruction of the Cheapside Cross and the burning of the *Book of Sports* on the same site in May 1643. Etching by Wenceslaus Hollar. By permission of the British Library.

12. Coronation of the Virgin. Boss (modern copy of the original) at the entrance to St. Mary's Hall, Coventry. Courtesy of the City Council of Coventry (photograph: Jennifer Alexander).

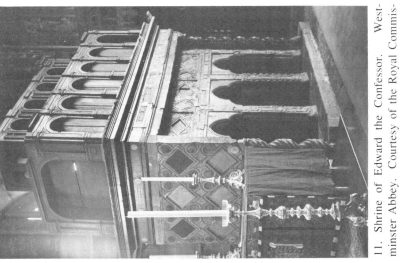

11. Shrine of Edward the Confessor. Westminster Abbey. Courtesy of the Royal Commission on the Historical Monuments of England.

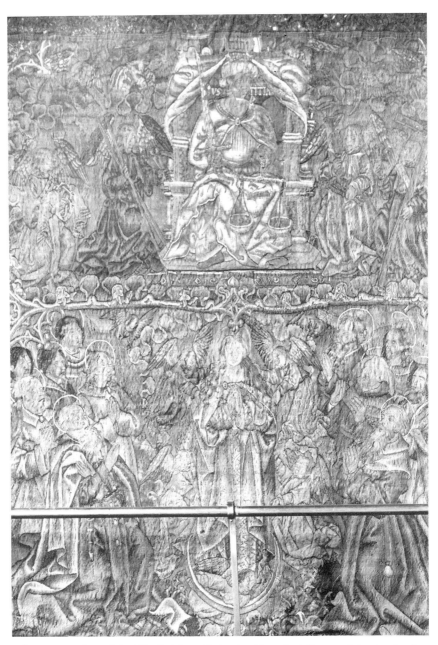

13. Assumption of the Virgin Mary (below); allegorical figure of Justice (replacement), above. Coventry Tapestry (detail). Courtesy of the Royal Commission on the Historical Monuments of England.

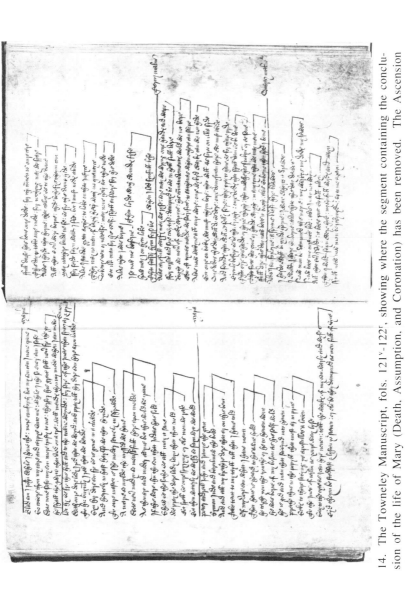

14. The Towneley Manuscript, fols. 121ᵛ–122ʳ, showing where the conclusion of the segment containing the conclusion of the life of Mary (Death, Assumption, and Coronation) has been removed. The Ascension play breaks off at the bottom of fol. 121ᵛ, while at the top of 122ʳ the beginning of the Judgment play is missing. By permission of the Huntington Library.

15. Scene from Miracles of the Virgin series. *Queen Mary's Psalter* (MS. Royal 2 B VII), fol. 225[r]. By permission of the British Library.

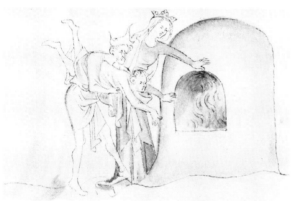

16. Jewish boy being thrown into an oven. Scene similar to sculpture in Lady Chapel at Ely Cathedral. Miracles of Virgin series. *Queen Mary's Psalter*, fol. 208[r]. By permission of the British Library.

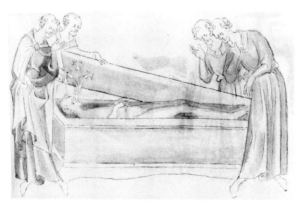

17. Burial of Knight who wanted to become a Cistercian. Features of this story are similar to another story illustrated in Lady Chapel sculpture at Ely Cathedral. Miracles of the Virgin series. *Queen Mary's Psalter*, fol. 222[r]. By permission of the British Library.

18. Meeting of Joachim and Anne at Golden Gate of Temple. Sculpture, Lady Chapel, Ely Cathedral. Courtesy of the Dean and Chapter, Ely Cathedral.

19. Virgin Mary as a child climbing the steps to the Temple. Sculpture, Lady Chapel, Ely Cathedral. Courtesy of the Dean and Chapter, Ely Cathedral.

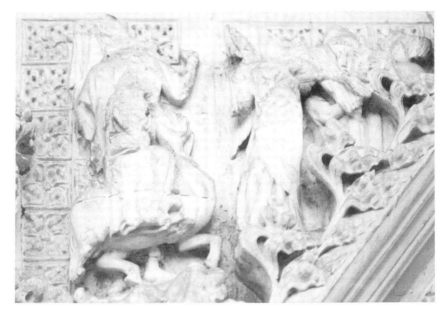

20. Journey to Bethlehem. Sculpture, Lady Chapel, Ely Cathedral. Courtesy of the Dean and Chapter, Ely Cathedral.

21. Herod giving orders for Massacre of Innocents. Sculpture, Lady Chapel, Ely Cathedral. Courtesy of the Dean and Chapter, Ely Cathedral.

22. Assumption of the Virgin. Sculpture, Lady Chapel, Ely Cathedral. Courtesy of the Dean and Chapter, Ely Cathedral.

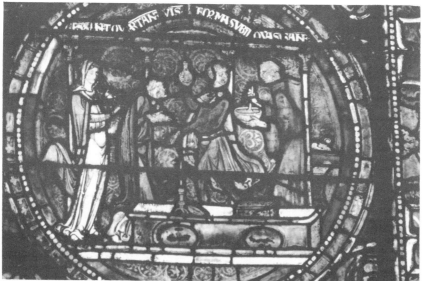

23. Miracle at shrine of St. Thomas Becket: healing of Etheldreda. Painted glass, Canterbury Cathedral. Courtesy of the Dean and Chapter, Canterbury Cathedral.

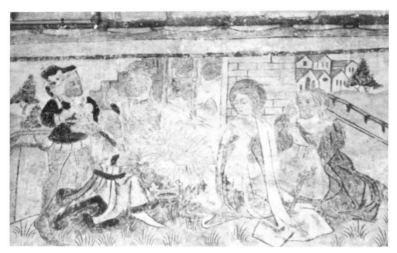

24. Nativity (Brigittine), with Adoration of the Christ Child. Wall painting, Church of St. Thomas of Canterbury, Salisbury.

25. St. Thomas Becket. Painted glass, Church of St. Thomas of Canterbury, Salisbury.

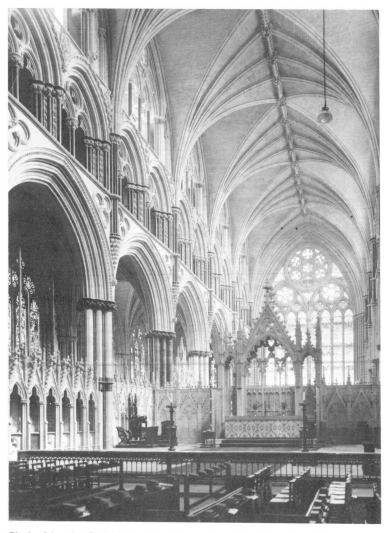

26. Choir, Lincoln Cathedral. The Easter Sepulchre is at the left under the first arch. Three carvings of soldiers as if asleep remain in place. By courtesy of the Royal Commission on the Historical Monuments of England.

27. Resurrection. Detail of Easter Sepulchre. Patrington, Yorkshire. Courtesy of the Royal Commission on the Historical Monuments of England.

28. Resurrection (mutilated). Detail of Easter Sepulchre. Fledborough. Courtesy of the Royal Commission on the Historical Monuments of England.

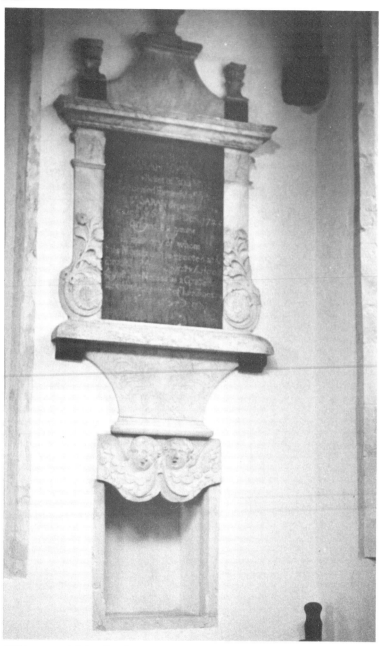

29. 1724 memorial in the Church of St. Mary, Cratfield, to octogenarian Sarah Minne incorporating the aumbry in the north wall; raised by her two nieces "as a grateful acknowledgement of her favours to them at her death." By courtesy of the vicar and churchwardens of Cratfield.

31. Confirmation. The bishop stands at center, the figure to left holds a swaddled infant; traces of a butterfly headdress (worn by woman at right) and of sacramentary (held by acolyte *supra* right). Church of St. Mary, Cratfield. Courtesy of the vicar and churchwardens of Cratfield (photograph: Elizabeth Nichols).

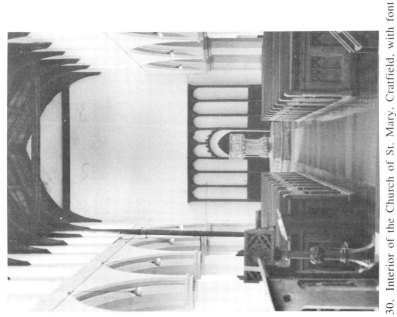

30. Interior of the Church of St. Mary, Cratfield, with font and screen at west end of nave. The pews of 1887 are in the foreground. By courtesy of the vicar and churchwardens of Cratfield.

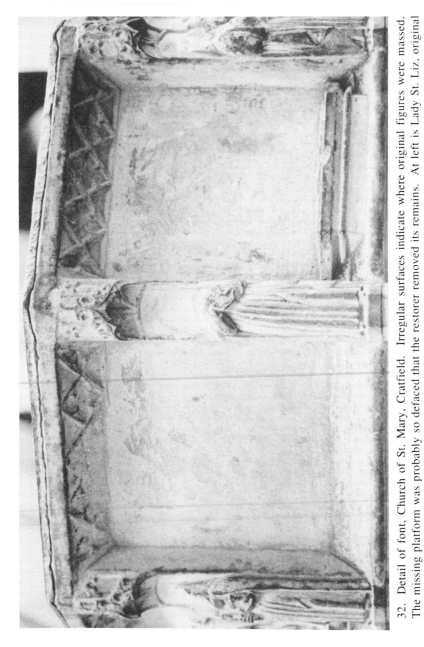

32. Detail of font, Church of St. Mary, Cratfield. Irregular surfaces indicate where original figures were massed. The missing platform was probably so defaced that the restorer removed its remains. At left is Lady St. Liz, original owner of the manor. Courtesy of the vicar and churchwardens of Cratfield (photograph: Elizabeth Nichols).

33. 1569 churchwarden record of font removal: "Item payed to Godbold and <. . .> for takyng downe of the fonte viij d." Suffolk Record Office FC 62/A6/50. By permission of the Suffolk Record Office and the vicar of Cratfield.

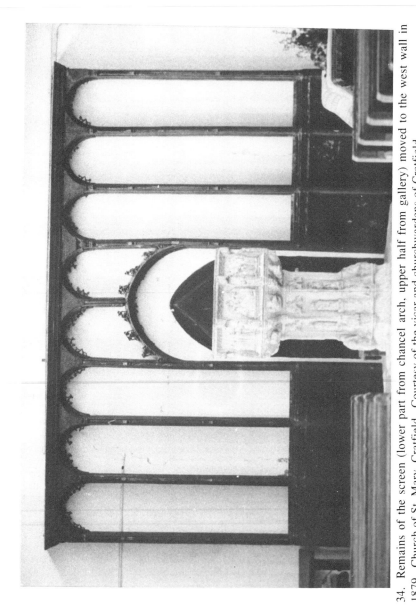

34. Remains of the screen (lower part from chancel arch, upper half from gallery) moved to the west wall in 1879. Church of St. Mary, Cratfield. Courtesy of the vicar and churchwardens of Cratfield.

ity was made the central issue in the proceedings. Laud in his testimony for the prosecution argued in favor of the propriety of certain images--of Christ, but not of the Father--and yet in the main attempted to define the case as one centered on the question of the authority of bishops in ecclesiastical matters--a violation in this case all the more serious because the offender was a justice of the peace.[41]

Sherfield's arguments, which to the literary scholar will be reminiscent of certain charges leveled by his contemporaries against the theater which was also criticized for its alleged distortion of reality and its essential falseness (*"the proper name of Player,"* according to Prynne, *"is* hypocrite"[42]), are a foreshadowing of the iconoclastic deluge that was to come in 1642 and in the years immediately thereafter. Most infamous during that period was the notorious William Dowsing, who, claiming authority from the Earl of Manchester, Queen Elizabeth's Injunctions, and the Elizabethan Homily against Idolatry,[43] went about Cambridgeshire and East Anglia "like a Bedlam, breaking glosse windowes . . ."[44] and otherwise doing the work of iconoclasm and sacrilege. Fortunately, the "I: thousand Superstitious Pictures" against which he fulminated at King's College, Cambridge,[45] were not destroyed, though elsewhere in Cambridge there was much destruction at this time with the result that today such Cambridge churches as Great St. Mary's retain none of their medieval iconography. Even Laudian or medieval inscriptions, including, for example, the name of Jesus in capitals on the roof of the church at Benacre, were not exempt from Dowsing's iconophobic fury.[46]

Thus what began as an attack on medieval modes of devotion and deceptive appearances in the writings of Erasmus, who in his colloquy "A Pilgrimage for Religion's Sake" (1526) had ridiculed such relics as the milk of the Virgin at Walsingham and the extant relics of the True Cross which "if the fragments were joined together" would fill a seagoing vessel,[47] culminated in very widespread destruction and desecration of the remnants of the visual arts still remaining in English churches in the 1640's (e.g., an image of the Virgin Mary and angels, presumably an Assumption, removed from St. Mary Woolnoth Haw)--a time when the theater, both religious and secular, was also effectively suppressed and when the Word, preached from the pulpit, officially supplanted things visual within the Church.

II

At first during the Reformation in England certain ceremonies of a highly visual and quasi-dramatic nature were not disturbed. The Palm Sunday procession, the rites of *Depositio* and *Elevatio* on Good Friday and Easter, and perhaps the less common dramatic *Visitatio Sepulchri* were not widely affected until the reign of Edward VI, when they were suppressed.[49] As Wriothesley noted, these rites were returned under Queen Mary,[50] but then were banned under Elizabeth I as examples of "Popish" practices not to be allowed. The official view came to be synonymous with the harsh and hostile satire of Barnabe Googe's *The Popish Kingdome* (London, 1570), which was a translation of a

work by a violently Protestant continental writer, Thomas Kirchmeyer's Latin *Regnum Papisticum* of 1553. *The Popish Kingdome* abounds in description of medieval pageantry as "foolish," as idle and dangerous, as idolatrous, and therefore as fraudulent, "wicked," and demonic.[51] To look upon such "Idolatree" as that which was offered under the rubric of ceremony and liturgical drama was to be blind and foolish.[52] Googe's translation, like Kirchmeyer's original poem, was intended to desecrate the memory of the rites, which some remembered with fondness and a deep sense of loss. Nevertheless, as late as 1593 the anonymous writer of *The Rites of Durham* remembered the "goodly large CRUCIFIX, all of gold, of the picture of our Saviour Christ nailed uppon the crosse" used in the Good Friday ceremonies at the Abbey Church of Durham, and he also spoke of the "marvelous beautifull IMAGE OF OUR SAVIOUR, representing the resurrection, with a crosse in his hand, in the breast wherof was enclosed in bright christall the holy Sacrament of the Altar" which was brought to the altar with the singing of *Christus resurgens* early on Easter morning.[53]

In contrast to drama and quasi-dramatic ceremonies of a devotional sort which were suppressed, polemical drama with religious content became a weapon in the Protestant arsenal. John Bale's contributions to the theater are well known,[54] and such Protestant dramas as the saint play of *The Life and Repentaunce of Marie Magdalene* by Lewis Wager would attempt to redefine the understanding of a biblical heroine in non-Catholic terms. Wager's Mary Magdalene is an exemplar of Christian penitence and, following her conversion, of virtue--rather

than, as had been the case of the protagonist in the medieval Digby play of *Mary Magdalene*, someone worthy of veneration.[55] For Wager and other Protestants, a saint is not a figure to whom prayers may be directed. In other words, polemical drama of this period was intended to correct errors in Catholic practice which had incorporated the cults of various saints and had developed specific modes of worship that would no longer be tolerated under Protestantism.

Following the reign of Queen Mary, Il Schifanoya, writing on 6 February 1559, complained that plays are invented daily "in derision of the Catholic faith of the Church, of the clergy, and of the religion, and, by placards posted at the corner of streets, they invite people to the taverns, to see these representations, taking money from their audience."[56] In the following May, another Italian letter writer reported plays in inns and taverns which, while officially prohibited by the Queen, were "so vituperative and abominable that it was marvellous they should so long have been tolerated, *for they brought upon the stage all personages whom they wished to revile, however exalted their station, and amongst the rest, in one play, they represented King Philip, the late Queen of England, and Cardinal Pole, reasoning together about such things as they imagined might have been said to them in the matter of religion; so that they did not spare any living person, saying whatever they fancied about them.*"[57]

While we know that the conventional Catholic saint play, immensely popular in the pre-Reformation period, was doomed by the advent of the New Religion,[58] such would not immediately be the fate of

the famous civic biblical drama, which had the support of the guilds and the civic authorities in various locations in England. Plays on such saints as Thomas Becket, anathama to the regime, were officially banned at an early point,[59] but otherwise the Catholic saint play also on the whole found itself in an extremely hostile environment under Protestantism. It is thus very hard to believe that the Digby play of *Mary Magdalene*, as John Coldewey has suggested, might have been included in the repertoire of summer theater at Chelmsford in 1562.[60] On the other hand, the civic biblical drama survived, as we know, into the reign of Elizabeth. Of course, as we might expect, it would appear that in periods when Protestantism was in the ascendant certain changes were made in the plays, at least in some cities. For example, the York House Books indicate that in 1575 certain of the city's playbooks were in the custody of the Archbishop of York, who was asked to "apoynt twoe or thre sufficiently learned to correcte the same wherein by the lawe of this Realme they ar to be reformed."[61] This document is an important one, since it indicates how pressure against the plays tended to come from officials such as the bishop or archbishop, while the plays remained popular even for a long time among people who otherwise found images and scenes in the visual arts to be anathema. In the first part of the sixteenth century Lollard objections, which had much earlier been voiced in *A Tretise of Miraclis Pleyinge*,[62] were not shared even by all Lollard sympathizers--indeed, in Coventry the only bequest to the civic pageants found in a will by the editor of the dramatic records of that city is contained in the

will of William Pysford, mayor in 1501 and a man
sympathetic to the Lollard cause[63]--and there is
evidence that early Protestant citizens distinguished
between the visual arts and the religious theater,
which might serve to educate onlookers in the bibli-
cal story. Citizen pressure for the right to present
the civic plays is documented by the dramatic
records, as at York in 1580 when "the Commons did
earnestly request of my Lord Mayour" and the
Corporation "that Corpus christi play might be
played this yere, wherapon my Lord Mayour an-
swered that he and his bretherin wold considre of
their request."[64] The ephemeral nature of the acted
scene (as opposed to a similar scene in sculpture or
painting), however, eventually came to be seen as an
equal threat, and the great cycle drama and other
plays which expressed medieval piety were put down
on account of their allegedly fraudulent content.
Like the window illustrating the Creation at St.
Edmund, Salisbury, which would be defaced by
Henry Sherfield, the plays were felt to distort the
biblical story and otherwise were objectionable
because they included representations of God the
Father, probably as in the Salisbury glass shown as
an old man with a beard.

In 1609, David Rogers, transcribing the banns of
the Chester plays which summarized their action in
his *Breviary*, added the following comment:

> And thus muche of the Banes or breife of the whitson
> playes in Chester for if I shoulde heare resite the whole
> storye of the whitson playes. it woulde be tooe tediose
> for to resite in this breauarye. As also the beinge
> nothinge profitable to anye vse excepte it be to showe
> the Ignorance of oure forefathers: And to make us theire

offspringe vnexcusable before god that haue the true
and *sincere* worde of the gospell of oure lord and
sauioure Iesus Christe. if we apprehende not the same
in oure liffe and practise to the eternall glorie of oure
god the saluation and comforte of oure owne soles.[65]

By implication, the plays are believed by Rogers to
have presented a telling of the Gospel story that was
less than "sincere." The official prejudice against
religious plays would eventually filter down, there-
fore, to the citizens, who would lose their enthusiasm
for civic religious drama in the face of official dis-
approval which labeled the plays as inauthentic and
less than accurate in their portrayal of the sacred
stories.

At Coventry, Hox Tuesday was temporarily
suppressed in 1561 on account of "the zeal of certain
. . . Preacherz: men very commendabl for their
behauiour and learning, & sweet in their sermons,
but sumwhat too sour in preaching awey theyr
pastime."[66] The reason seems to have been the
general Puritan dislike of recreation, since this event
was apparently untainted by Roman Catholicism.
But, when the Coventry Corpus Christi plays were
put down in 1580, the reason seems to have been a
more specific hostility to the visual scene as dis-
played in the streets of that city. Thomas Sharp
noted in his monograph on the Coventry plays: "The
temper of the times was hostile to such exhibitions of
sacred subjects, especially among the Clergy, the
higher orders of society who had embraced the
Protestant Religion, and men in power; and although
no official circumstance has been discovered, there
can be little doubt that as the Pageants of all the
Companies whose Accounts have been preserved

were not played during those years, the discontinuance was occasioned by an interdiction from authority."[67] Such too is the conclusion of Father Gardiner[68] with respect to the civic religious drama in general, and his opinion has on the whole been widely accepted, though the pattern of anti-theatrical suppression is perhaps more complex than he realized, as we shall see. It is also important, therefore, not to ignore entirely the role of the popular opposition to the theater that developed in the latter part of the sixteenth century.

At Chester, strong resistance to the popular Whitsun plays developed in the years immediately prior to 1575, when Mayor John Savage was charged with having authorized them without proper authority. In contrast to the comment in the Mayor's List for 1567-68 that "In this yeare the [Whitsun] Playes were playde & well set forthe,"[69] by 1571-72 they were reported as played but "to the dislike of many."[70] In 1575, though transferred from Whitsuntide to Midsummer and presented with certain alterations and omissions in order to leave out segments thought to contain superstition, the plays nevertheless stirred the wrath of the Archbishop of York and the Earl of Huntingdon, who was then Lord President of the North, and caused them to bring Savage before the Privy Council to explain his actions.[71] Consensus with regard to the presentation of the plays had evaporated in Chester, and a strong minority were clearly unhappy about the effort to stage them, especially in apparent defiance of higher authority. The struggle in Chester seems indeed to have been one of authority, as in the case of Henry Sherfield in Salisbury but with the majority of the

citizens poised on the other side of the issue--i.e., in favor of showing the scenes of biblical history, in this instance theatrically in the streets. Nevertheless, the "popish plaies of Chester"[72] which had been presented when Savage was mayor were doomed, and they were doomed for the same reason that had been fatal for the sacred iconography of England in its medieval art.

Rogers' *Breviary*, in commenting on the last performance of the Chester plays, uses language that is very similar to that which was utilized in Protestant commentary on the scenes shown in the visual arts--commentary which, as we have seen at the beginning of this essay, saw images in terms of the demonic and even the scatological. "And we haue all cause to power [i.e., pour] out oure prayers before god that neither wee. nor oure posterities after us. maye neuar *see* the like *Abomination of Desolation*, with suche a Clowde of Ignorance to defile with so highe a hand. the moste sacred scriptures of god."[73]

Protestantism began forcing some changes on the York cycle in 1548 when, according to the memorandum in the House Books, the Corpus Christi play was to be played except for "Certen pagyaunt*es* . . . That is to say / the deyng of o*u*r Lady / assumpc*i*on of o*u*r Lady / and Coronac*i*on of o*u*r Lady."[74] The first of these plays, known at York as *Fergus* from the name of the character who tries to disrupt the funeral procession of the Virgin, was not entered in the Register and probably had not been played regularly before this date for reasons aesthetic as well as doctrinal.[75] The other two plays represented visually defined scenes that had been extremely popular in York art[76]--scenes which particularly upset persons

with strong Protestant views since there was no biblical warrant for them. Further, as plays associated with the cult of the Virgin, whose role in the Church was demoted under the New Religion,[77] it is not surprising to learn that these dramas, along with representations of her Assumption and Coronation in the visual arts, would be proscribed early in the reign of Edward VI. Lumiansky and Mills believe that the Chester Wives' Assumption was also suppressed in the same year as the York plays on the conclusion of Mary's life.[78]

III

We may also assume, I believe, that a play on the Death, Assumption, and Coronation of the Virgin was suppressed at Coventry long before the Corpus Christi cycle there was abandoned. Such a play was conjectured by Hardin Craig in connection with the Coventry Mercers,[79] and yet it is impossible to believe that this subject could have been continued after the Reformation, especially after the accession of Elizabeth I to the throne. The Coventry annals,[80] as expected, report some Protestantizing in 1538, when "Pilgrimages [were] forbidden, Images pulled in pieces, Monasteries suppressed." However, a more serious wave of iconoclasm came to Coventry, as to other cities and towns in England, in 1547, when "The Lord Protector & the rest of the Counsell sent Commissioners into all parts of the Realme willing them to take all Images out of their Churches for the avoiding of Idolatry, with them were sent divers Preachers to persuade the people from their beads & such like ceremonies, & at that time the

going in procession was forbidden to be used, & the Gospell & the pistle were read in English."[81] During the time of Queen Mary, who at first had received the support of the people of Coventry, the persecution of Protestants there was particularly fierce, and even involved the direct intervention of the Crown in local politics. Mary at one point imposed a Catholic mayor on the city, while Richard Hopkins, one of the elected sheriffs in 1555, "was put out for Religion, & fled the land for a time."[82] However, only in the 1580's and 1590's did the local political winds turn decisively against the religious drama,[83] though the plays must have been cleansed of any overtly un-Protestant scenes fairly early, probably to some extent during the reign of Edward VI but surely more thoroughly at the beginning of Elizabeth's rule. We can, I believe, assume that these changes had broad support in Coventry, where Protestantism took early root in part because of earlier sympathy there for the Lollards.

The Mercers, along with the Drapers, dominated the Coventry Corporation.[84] They had been established as Gild Merchants in the city since 1268, and their chapel was opposite the Drapers' Chapel in St. Michael's Church in the place of honor at the east end within that building.[85] The significance of the guild's play may be guessed merely from the great importance of the guild within the city, as determined by entries in civic documents and by the order of the guilds in the Corpus Christi procession: though the Drapers were in the place of honor at the end, immediately before them were the Mercers.[86] Furthermore, the Mercers' play did not require (as in the case of all the other guilds' productions except

the Drapers') help from contributory guilds.[87] Even in the last year in which the Coventry cycle was played prior to its suppression, the amount spent on the Mercers' play was considerable[88]--an amount which would have indicated an expensive production that would have been regarded as a significant contribution to the civic cycle as a whole and, indirectly, to the spiritual and economic health of the city. In any case, when the guild's play gear, recorded as "pagant stufe," was sold in 1588, it brought 59s 4d--again an indication of a production that was designed to be impressive and worthy of a cycle that was famous throughout the realm.[89]

There are only two pre-Reformation references in the Coventry records to the pageant of the Mercers, and one of these occurred in the will of William Pysford the Elder (probated 2 March 1518), himself a Mercer, who in support of "the laudable customes of the Citie" left a "lyned scarlet gowne without ffurre" and a "Scarlet Cloke" to be used by his guild "in their said paionde the tyme of the playes."[90] The second pre-Reformation reference in the dramatic records occurs in the city annals under the year 1526:

> Henry Wall Weaver Mayor, the Lady Mary Came to Coventry & Lay att the Priory, the Mercers Pageant Gallantly trimed stood in the Cross Cheaping. . . .[91]

If the Mercers' pageant at that time indeed had illustrated the Assumption, it would thus, as Craig recognized,[92] have been considered a highly appropriate compliment to the eleven-year-old Princess Mary, whose mother, Catherine of Aragon, had been especially devoted to the Virgin Mary and had particularly shown devotion to her Assumption and

Coronation as Queen of Heaven. At Coughton Court in Warwickshire there is among the relics of recusancy a cope with embroidery attributed to Queen Catherine of Aragon that thus illustrates on its back the scene of the Assumption of the Virgin.[93] In this example, which almost may be taken as an emblem of the Catholic resistance to Protestantism, the Virgin, who wears a mantle over her garment, is crowned and appears with a nimbus, while she holds her hands together in the late medieval gesture for prayer as she is given support by angels.

Craig accurately points up a connection between the iconography of the Assumption and the Mercers, whose arms were "gules, a demy Virgin Mary with her hair disheveled crowned, rising out and within an orb of clouds, all proper; motto *Honor Deo*."[94] The fourteenth-century ordinances of the Mercers indicate that their annual meeting shall take place on the feast of the Assumption, when all the brothers and sisters of the guild are to appear "clad . . . in livery suits at their own cost, and others in hoods at the common cost of the guild."[95] The guild chapel, located, as noted above, in St. Michael's Church (later Cathedral), continued to be used after their St. Mary's Guild was merged with the Holy Trinity Guild.[96] The ordinances of the amalgamated guild also retained the Assumption as one of the its four annual feasts.[97] The nearby Merchants' meeting place of St. Mary's Hall, built in the fourteenth century, was, of course, also dedicated to the Virgin Mary. That the local cult of Mary included special devotion to the Assumption and Coronation is further suggested by iconographic evidence. The centrally located roof boss of c.1390 (replaced by a

modern copy in the late nineteenth century [fig. 12])
in the gate house of St. Mary's Hall showed the
Virgin, with long hair, on the left, and joining her
hands in prayer while the bearded deity on the right
placed the crown on her head.[98] There was also a
misericord of c.1465 picturing the Assumption in St.
Michael's (unfortunately destroyed by bombing in
World War II) which illustrated the Virgin within an
aureole and wearing a long robe and mantle. She
was attended by a four-winged angel at her left, and
further four-winged angels appeared on the sup-
porters.[99]

However, another example of Coventry iconog-
raphy pertains more directly to the Pre-Reformation
devotional concerns of the Mercers, to their change
to Reformed ways of thinking about things spiritual,
and to the manner in which iconoclasm at first
affected the plays as well as the visual arts when
these played an important civic function. This
example is contained in the so-called "Coventry
Tapestry" in St. Mary's Hall. The tapestry includes
the Blessed Virgin Mary supported by angels and
encircled with clouds (fig. 13). The scene is an elab-
orate one, with the Virgin in prayer and appearing
with the twelve apostles arranged on each side of
her. She wears a blue mantle over a patterned
garment, and has the traditional long hair. Four
angels give direct support, and two additional angels
appear beyond the clouds. She also stands upon the
shoulders of yet another angel who is holding a
crescent moon. The tapestry, which is extant and
recently has undergone a restoration, includes the
figures of Henry VII and his queen, Elizabeth. The
best estimate of its date is c.1510.[100] Designed for

the merchants' hall of St. Mary, it had originally contained at the top an image of the Trinity, in honor of the powerful Trinity Guild with which St. Mary's Guild had become amalgamated, just as the scene of the Assumption in the tapestry was designed to honor the St. Mary who served as the second patron of the guild. Interestingly, while the scene of the Assumption was not removed (though it did depict a scene which Protestant iconoclasts would have found deceptive and even dangerous, as in the instance of "our ladie"[101] removed in 1568 from the altar cloth in Great St. Mary's, Cambridge, as cited above), the image of the Trinity at the top was eventually re-garded as too offensive to be allowed to remain; in the early seventeenth century the Trinity was re-moved from the tapestry. The replacement was a figure of Justice which was probably added by the Sheldon workshops in Warwickshire, but the Hebrew inscription indicating "Jehovah" and the angels with the signs of the Passion above suggest that the segment removed from the tapestry was a Trinity of the "Throne of Grace" or the "Corpus Christi" type with the body of the slain Son held by the Father.[102]

Craig believed that the Mercers' play would most likely have included the scene of the Death of the Virgin as well as her "appearance to Thomas." He cites a 1493 inventory as well as expenses of the Corpus Christi Guild in 1539 which "indicate a pageant of the Assumption in the Corpus Christi procession."[103] The inventory, however, only speci-fies two girdles, including one "of rede silk"--hardly proof of the Virgin's appearance to Thomas[104]--while the payments from 1539 and subsequent years refer to the religious procession which indeed did include a

scene of the Death of the Virgin. Further, we may doubt whether this guild--i.e., the Guild of Corpus Christi--ever had anything whatever to do with the play presented by the Mercers of Coventry. The tableau, which presented the apostles, Mary, and Gabriel with the lily, also included other characters (e.g., St. Catherine and St. Margaret) that would not have been appropriate in a play about the Death of the Virgin and her Assumption. Nor, of course, would such a play have included torch bearers, cross bearers, and men to bear "the Canape ouer the sacrament."[105]

It is, to be sure, significant that references in the records to a tableau showing the conclusion of the life of the Virgin should terminate with the suppression of the feast of Corpus Christi and indeed of the amalgamated Corpus Christi Guild itself. The last years for the inclusion of references to the tableau were 1545 and 1546, both plague years when the plays were not performed.[106] Yet since the Trinity Guild had been amalgamated with the Corpus Christi Guild in 1535,[107] the presentation of the tableau here, as in the case of the Assumption in the Coventry tapestry which was designed to recognize guild associations, might not be without meaning. It should also be remembered that one of the relics in the Cathedral of St. Mary in Coventry prior to the Reformation was "A pece of Owre ladyes Tombe Closyd in Copper"[108] and that Coventry as a typical English city was generally strongly attached to the cult of the Virgin prior to the middle of the sixteenth century.[109] The cultic and iconographic associations thus do indeed tend to corroborate Craig's belief that the Mercers' play was a dramatization of the Death

and Assumption of the Virgin, but, as indicated above, this could hardly have been the case after the Reformation. While the scene of the Assumption was not removed from the Coventry tapestry in St. Mary's Hall, scenes illustrating the final portion of the life of the Virgin could not be tolerated in the streets where they would allegedly mislead the common people. The legendary history of the Virgin not only had lost its great popularity but also had become genuinely suspect when the cult of the Virgin was suppressed, though the presentation of the mysteries continued for a time at Coventry before they too were put down.

In the early part of the century, the play cycle at Coventry was not even then a static or fixed entity, but rather had been undergoing change as it presumably had done throughout its history. For example, in 1519 the city annals cited by Sharp noted "New Plays at Corpus Christi tyde which were greatly commended."[110] The dramatic records further provide considerable evidence of new play books or new copies of plays being made in the middle of the century and in the early years of Queen Elizabeth's reign. Hence the Drapers recorded new play books in 1568, when Francis Pynnyng was paid five shillings "for a playe," and in 1572, when someone was paid five shillings "for wryttyng the buck."[111] In 1563, the Smiths paid Robert Croo "for ij leves of ore pley boke,"[112] in this instance probably a revision involving changes necessitated by the new religious climate.

Mary Dormer Harris has conjectured that there was a new and different play being offered in Protestant times by the Mercers on the topic of the arch-

angel Michael.[113] The change would have taken
place, if this theory is correct, not long after the end
of the reign of Queen Mary. In a way, the suggestion
is not entirely implausible, since in order to retain
their place at the end of the cycle immediately before
the Drapers the Mercers would have needed a play
on the end of history (e.g., on Antichrist or some
other eschatological motif), while at the same time
such a topic would have allowed them to relinquish
their unplayable drama on the Virgin Mary with its
Catholic content.

I have chosen to survey at some length the prob-
lem of the Coventry Mercers' play because placing
that drama in the context of Protestant iconoclastic
attitudes will establish some limits that critical and
scholarly writing must take into account. Further,
the Coventry plays have a particular importance for
us, since these productions very likely were witnes-
sed by the great William Shakespeare, whose satiri-
cal presentation of amateur actors in *A Midsummer
Night's Dream* may well reflect the conditions of such
playing in this city which was located so near to his
native Stratford-upon-Avon.[114] The Mercers were
still repairing their pageant house in Gosford Street
in 1599,[115] which would suggest that the guild had
not yet abandoned its interest in play production.
However, it is unlikely that there would then have
been much support at the turn of the century in such
a strongly Protestant city as Coventry for returning
to the old Corpus Christi cycle, even if that cycle
were divested of its more Catholic pageants, dia-
logue, and iconography. It should thus come as no
surprise that by 1602 the company had leased the
house to one Richard Bankes,[116] presumably a sign

that the pageant wagon which had been stored in the pageant house had now been disposed of and also a signal that, twenty-three years after the last performance of the mystery plays, the mysteries were to be regarded as permanently abandoned. The relics which had played such an important role in medieval religion had been swept away along with the practice of pilgrimage. Images too, even when not "abused," had largely fallen victim to iconoclasm in Coventry and elsewhere. The religious civic drama, first purged of its more Catholic elements, was finally to be entirely laid aside as a theater that reflected a spirituality of the past that was now to be seen as false, deceptive, and perhaps even demonic by many in the community, although others, we may imagine on the basis of the evidence, still remembered the Corpus Christi pageants with great fondness. As Sharp had believed, the impetus for its suppression may have come initially from the higher clergy and the secular government, but quite clearly pressure informed by the anti-visual prejudice eventually came also from the ordinary citizens of the city.[117]

IV

The Towneley manuscript, frequently but unconvincingly associated by modern scholars with the town of Wakefield in West Yorkshire,[118] provides further evidence of the suppression of sensitive portions of the play cycle. In Play XIX, which treats the story of the Baptism of Christ, one stanza, noted in a different hand as "corectyd & not playd," was canceled "because," as the note to the Early English Text Society edition explains, "Seven Sacraments are

named."[119] However, a more striking instance of censorship in the manuscript has been observed by Martin Stevens, who noticed that the incomplete Ascension play, which is missing its conclusion, and the Last Judgment play, that lacks its beginning (fig. 14), provide evidence of "editorial tampering" which presumably removed a play or plays on the conclusion of the life of the Virgin.[120] In other words, this portion of the cycle was excised on account of its content, which presumably involved the sensitive matter of the non-biblical story of the death, Assumption, and Coronation of Mary the Mother of God and Queen of Heaven. The mutilation of the manuscript is analogous surely to the practice of mutilating painted glass, which might be done by knocking out the head of a saint, or of defacing sculpture, which often illustrated even such seemingly non-controversial subjects as the Virtues and Vices (as in the vestibule of the Chapter House at Salisbury).[121] However, as we have seen, the matter of the Blessed Virgin was hardly non-controversial in the sixteenth century or in the first half of the next century. Such "abused" images as Our Lady of Walsingham were among the earliest representations of the Virgin to be removed, in this case on 14 July 1538 or less than a month prior to the suppression of the shrine itself,[122] but the destruction became very widespread indeed as Protestantizing progressed in England.

The fate of iconographic programs focusing strictly on the life of the Virgin would seem to be typified by the sculpted reliefs (figs. 18-22) in the Lady Chapel at Ely where even M. R. James had to confess failure to recognize many of the mutilated

scenes.[123] The reliefs, placed on three walls of the Lady Chapel after being carved *ex situ* in the mid-1320's,[124] were badly damaged by iconoclasm in the sixteenth century, most probably in the time of Edward VI. Thomas Goodrich, Bishop of Ely from 1534 to his death in 1554, issued Injunctions ordering the destruction of images, relics, and shrines in his diocese as early as 21 October 1541, but these Injunctions were directed at icons which had been the object or vehicle of veneration and not yet directly at such examples as the Ely Lady Chapel reliefs.[125] Nevertheless, by the second or third year of the reign of the next monarch, Edward VI, the damage to the reliefs was probably already done. The stone on which the reliefs are carved is soft and easily broken; in fact, some of the reliefs had been damaged during their installation in the fourteenth century.[126] The figures appear as though the iconoclast had taken a staff of some kind, probably of metal, and had gone around the chapel knocking at them, possibly from floor level. Heads in particular are knocked away, and sometimes one simply cannot identify the nature of the figure, not even determining whether it is male or female. Arms are broken away so the gestures which are so essential to our knowledge of the meaning of the scenes are missing. Also, with the passage of time, the reliefs also have been denuded of most of their paint, and hence their present appearance is far different from what must have been a fine work of art and a useful devotional aid prior to the Reformation. Yet as a narrative of the life and miracles of the Virgin, the reliefs stand in importance beside the remarkable series of miniatures on the subject in *Queen Mary's*

Psalter (British Library, MS. Royal 2 B.vii, fols. 204ᵛ-232 [see figs. 15-17]).[127]

The series begins at the east end of the south wall with illustrations of the miracles of the Virgin, beginning with an unidentifiable scene with worshippers and figures possibly kneeling in confession. In another relief, an angel is scourging a man (very mutilated) and on the right is the seated figure of the Virgin Mary, possibly witnessing punishment for some kind of offense against her but not otherwise identifiable. The series, however, does include scenes which seem to tell the story of Theophilus who sold his soul to the devil but was saved nevertheless because of his devotion to the Virgin.[128] The reliefs in this segment of the sculptural program tend to be problematic because the iconoclasm was often very thorough, and also the miracles are not traditionally arranged in some particular order so that they can be identified even when the principal figures are missing or heavily mutilated. Identification is much easier, of course, from the point when the subject matter of the birth of the Virgin is introduced. The rejection of Joachim's offering, though very damaged, nevertheless is recognizable (the high priest behind the altar uses a gesture to repulse him), as is the annunciation to Joachim--a scene which includes shepherds and their sheep as well as an angel. So too do we recognize the meeting at the Golden Gate (the Immaculate Conception [fig. 18]), in spite of the bashing of the tops of the two figures, and the birth of the Virgin, the latter scene showing St. Anne in bed, a midwife beside her, another midwife at the right, and a bath supported by the legs of a trestle. Typically, not only the heads in the

Birth of the Virgin scene have been knocked off by the iconoclast, but also the bath! In better condition, in spite of the loss of the heads, is the presentation of the Virgin in the temple (fig. 19); the young girl walks up the fifteen steps to the temple while her parents stand by, St. Anne having her hand on her daughter's shoulder. At the top of the steps is a priest of the temple by an altar.

The scenes which follow include two of the Virgin as a young girl in the temple, her marriage to Joseph, the Annunciation (cut down flat against the wall when a tablet was installed) and Visitation, the reconciliation of Joseph and the Virgin, possibly the administration of the water of jealousy to the Virgin,[129] the journey to Bethlehem (fig. 20), including, if James' conjecture is correct, an angel identifying laughing and weeping people as Jews and Gentiles,[130] and scenes associated with the Nativity. The final relief sculpture on this wall at the southwest corner illustrates the Virgin showing the Child to kneeling figures, who may be the Magi, and also, around the corner, verifiably the Magi on horseback.

The West wall contains scenes which are some of the most familiar in religious iconography since they treat the story of Mary's Son Jesus from the Flight to Egypt to the Ascension (and possibly Pentecost), and yet there are puzzles here as well. One scene, which has been almost entirely knocked away, may illustrate the angel's warning to Joseph to escape from Herod's wrath. While we are able to recognize Herod ordering the massacre of the Innocents (fig. 21), the scene which should be the actual illustration of the massacre is unclear. There are three figures, two of which, according to James, "seem to be strug-

CLIFFORD DAVIDSON

gling."[131] A niche, now empty, above probably held a
statue of the Blessed Virgin and the Child. In spite
of heavy damage to the torsos of the figures and to
the horse which Mary is riding (the Child is totally
destroyed), the Flight to Egypt is easily recognizable,
however, and as part of this scene in the foreground
two dragons are emerging from holes, apparently
dragons coming out of caves to do obeisance to
Christ.[132] In the next scene there is a large dragon
near a tree along with the figures of an angel and a
lamb, possibly a continuation of the previous
scene.[133] But there is a further problem in the next
relief, which shows the Virgin Mary apparently
standing on a devil which has a very good face that
was missed by the iconoclasts--a scene which, along
with the following three groups of scenes, was un-
clear to James.[134] The Baptism of Christ is not at all
ambiguous, but otherwise not even the scenes which
should be seen to represent the Deposition, Ascen-
sion, and Pentecost can be identified with cer-
tainty[135] on account of the destruction wrought by
the iconoclasts. A Crucifixion was probably placed
on the niche above these figures.

On the North side, beginning from the West end,
the series continues to present the life of the Virgin,
again including some scenes which cannot be identi-
fied with certainty but definitely including the Death
of the Virgin, her funeral procession, and the
Assumption. The Assumption (fig. 22) is very
damaged, with the head and body of the Virgin
apparently struck repeatedly by the iconoclast, who
also knocked away one side of the aureole, which is
supported by an angel below. We can, I believe, be
sure that originally a Coronation of the Virgin would

126

have been present as the culmination of this series, and it would have been placed on the now-empty niche above the Assumption. After this point, the sculptures turn again to additional miracles of the Virgin, with some of the scenes again on account of the thoroughness of the iconoclast defying identification with any certainty.

In all, James could not identify twenty-two scenes in the relief as it was placed against three walls in the Lady Chapel, and many of these were simply battered beyond recognition. However, the identification of many of the other seventy-one groups is not entirely certain in every case,[136] though he is able to provide at least some explanation. To be sure, the iconoclast who originally smashed this sculpture presumably would have been concerned to see that it should not any longer include recognizable forms, for these, especially the stories of the miracles of the Virgin, were obviously thought to have no place in a church or chapel. The iconoclast would thus have been attempting to destroy or to desecrate the sculpture so that the chapel would be as if never decorated with these scenes of the life of the Virgin. While we cannot know the individual motives that came into play (we can only guess), the iconoclasm was an event which nevertheless almost inevitably was designed to help set aside and to neutralize medieval iconography, especially that associated with the Virgin Mary. Such a purpose was also applied, as we have seen, to the cycle plays, which after 1547 had to set aside the plays of the Death, Assumption, and Coronation of the Virgin.

Examples of desecration and iconoclasm in England during the Reformation could be extended

infinitely, of course. Relics, images, wall paintings were everywhere removed or covered over, as in the instance of the great shrine of Becket (fig. 23) with its relics of the saint at Canterbury Cathedral which was taken down in 1538, or of the well-known fifteenth-century wall painting of the Last Judgment (restored, unfortunately, in the nineteenth century using oils[137]) at the Church of St. Thomas of Canterbury, Salisbury. The latter, located over the chancel arch in a church with a congregation that was apparently much less dominated by the Puritan element than St. Edmund's in the same city, was nevertheless whitewashed over at least by 1593,[138] if not earlier, possibly in 1560-61 when texts are noted as having been painted on the walls.[139] The same fate befell the wall paintings, now uncovered and not subjected to repainting in restoration, showing the Annunciation, Visitation, and Brigittine Nativity (fig. 24) on the north wall of the Swayne chapel in the south chancel in St. Thomas' Church,[140] while the original medieval painted glass in the windows is limited to three figures (showing St. Christopher, St. Thomas Becket [fig. 25], and possibly St. Francis) which were preserved only because the glass was formerly placed in the vestry.[141] Fortunately, at Canterbury Cathedral the glass was left more or less intact with numerous extant panels showing miracles at the shrine, though portraits of St. Thomas Becket himself were destroyed except for one small figure in the north-west transept.[142] The same window had once contained a much more impressive portrait of the saint as well as other subjects prior to a famous act of iconoclasm which took place in December 1642. The well-known description of this

act from Culmer's *Cathedrall Newes from Canterbury* (c.1643) explains:

> the Commissioners fell presently to work on the great Idolatrous window, standing on the left hand, as you goe up into the Quire: for which window (some affirm) many thousand pounds have been offered by Out-landish Papists. In that window was now the picture of God the Father, and of Christ, besides a large Crucifixe, and the picture of the Holy Ghost, in the form of a Dove, and of the 12. Apostles; and in that window were seven large pictures of the Virgin Marie, in seven several glorious appearances, as of the Angells lifting her into heaven, and the Sun, Moon, and Stars under her feet, and every picture had an inscription under it, beginning with gaude Maria: as *gaude Maria sponsa dei*, that is, Rejoyce Mary thou Spouse of God. There were in this window, many other pictures of Popish Saints, as of St. George &c. But their prime Cathedrall Saint--Arch-Bishop Thomas Becket was most rarely pictured in that window, in full proportion, with Cope, Rocket, miter, Crosier, and all his Pontificalibus. And in the foot of that huge window, was a title, intimating that window to be dedicated to the Virgin Mary. *In laudem &c. honorem beatissime Virginus Maria matris dei, &c.* . . . But as that window was the superstitious glory of that Cathedrall; as it was wholy superstitious, so now it is more defaced than any window in that Cathedrall.[143]

Thus had the commissioner, mounting on a ladder and using his pike, succeeded in "ratling down proud Beckets glassy bones."[144]

At Lincoln Cathedral (fig. 26) in the Middle Ages the inventories of items belonging to the fabric listed great variety and wealth of images, relics, shrines, vestments, and plate. On 6 June 1540 King Henry VIII signed a letter which indicated that "there ys a certayn shryne and di*verse* fayned Reliquyes and Juels in the Cathedrall church of Lyncoln with

[which] all the symple people be moch deceaved and broughte in to greate supersticion and Idolatrye to the dyshonor of god and greate slander of this realme and peryll of theire own soules. . . ."[145] Among the many images in the cathedral that had been noted four years earlier had been the following statue:

> a grett Image of owr lady syttyng yn a chaire sylver and gylte with iiij poles ij of them havyng armes yn the toppe before havyng upon her hede a crowne sylver and gylte sett with stones and perles and one bee with stones and perles abowte hir neke and an owche dependyng therby havyng yn hir hand a septer with one floure sett with stones and perles and one bird yn the tope therof and hir chyld syttyng opon hir knee with one crown of his hede with a diademe sett with perles and stones holdyng a ball with a crose sylver and gylte yn his lyft hand and at ayther of his fete a scochon of Armes with Armes of the gyft off master mason Chantor.[146]

The shrines and "abused" images were desecrated and taken away in 1540, with further images removed in 1547-48. In spite of the attempt to renew Catholic worship under Queen Mary, in 1565-66 the Queen's Commissioners could report in their survey of ornaments of Lincoln Cathedral: "Images--none remayning."[147]

The decade of the 1560's also presumably saw the end of the medieval drama in Lincoln. In 1564-67 was presented a two-day "staige play of the Storye of Tobye" for which the list of properties is highly reminiscent of the staging of medieval plays throughout England. There was a hell mouth "with a neithere Chap," a prison, the cities of Ninevah and Jerusalem, "a fyrmament with a fierye clowde," and

various palaces and houses.[148] But there are hints that the play was a transition drama with Protestant overtones, as one additional stage property may indicate: "Item a greate Idoll with a Clubb."[149] Idols were held to deceive the people, and, by identifying devotional images--and later all images of a religious import--with the claim that they are deceptive, the authorities, often acting in the wake of popular outbursts of iconoclasm, enforced a Protestantism that eventually also suppressed the medieval religious drama that had taken root in the cities and towns of the realm.

It is significant that the "Order of Council for the Removing of Images" issued in 1548 identified images as not necessary and as "dead"; further, since the only "quietness" in the realm is where images have been taken away, it would be best if churches were to divest themselves of all such items.[150] We may be reminded of the Wycliffite who recalled the way in which painted images were said to be less well retained by the mind than religious plays, "for this is a deed bok, the tother a quick."[151] Neither, however, could ultimately satisfy those who insisted that the image must conform to the visible reality of the thing presented. Imagination, which had been considered a necessary function of the mind for salvation in Franciscan thinking of the late Middle Ages,[152] was ultimately so distrusted that visible re-creations of sacred persons and events must be seen as incorrect, wrong-headed, and fraudulent whether these were present in the form of examples of the visual arts or of theatrical presentations. Stripped of specific visual features, the biblical

narrative and sacred ideas could instead only accurately be absorbed by the mind, it was felt, through language, especially by the preacher whose purpose was, as John Donne indicated, "to convey and usher the true word of life into your understandings and affections (for both these must necessarily be wrought upon) . . . for the word of God to enter and triumph in you."[153] Finally, as the Word of God must be seen as cleansing to the soul, so also, at least to those involved in iconoclasm from an ideological standpoint, the images and scenes in churches and on scaffolds and pageant wagons must be identified with defilement of pure religion and hence with dirt and excrement[154]--qualities associated with the demonic. The small image identified by the young man as "the Devil's guts" on Ascension Day in 1559 may thus serve as an emblem of the feeling which informed the iconoclastic effort that would put down the religious visual arts in the churches and then, eventually, on the stage.

Protestantism had introduced a new classification scheme in which sacred objects and scenes have been desacralized. These will now be regarded as polluted and polluting--and hence as highly dangerous. Purification, through destruction and fire, is believed to be a requirement in order to achieve safety from the danger and to reform the ritual practices of the Middle Ages. But this reformation was in fact a revolution which would establish new practices that were in fact identified by their opposition to the highly visual religion of the past with its rich display of wall paintings, painted glass, images of stone and wood, vestments, processions, ceremonies, and theatrical spectacles. That which had been regarded as

food for the soul now was to be seen in terms of excrement, filth, and defilement.[155]

Notes

[1]Cf. Ernest B. Gilman, *Iconoclasm and Poetry in the English Reformation: Down Went Dagon* (Chicago: Univ. of Chicago Press, 1986), p. 44.

[2]*Calendar of State Papers, Venetian*, VII (London, 1890), No. 71 (p. 84).

[3]Henry Machyn, *The Diary*, ed. John Gough Nichols (London, 1848), p. 130. For the history of the shrine, see J. Charles Wall, *Shrines of British Saints* (London: Methuen, 1905), pp. 223-35.

[4]*Cal. of State Papers, Venetian*, VII, No. 71 (p. 84).

[5]Machyn, p. 207. The significance of the burning of images is taken up by Margaret Aston in her paper "Iconoclasm in England: Rites of Destruction by Fire," read at the International Congress on Medieval Studies in 1986. The images were regarded by extreme Protestants as "idols" and hence were seen as deserving to be treated in the manner prescribed for idols in the Old Testament.

[6]John Strype, *Annals of the Reformation* (Oxford: Clarendon Press, 1824), I, Pt. 1, 259-62.

[7]Ibid., I, Pt. 1, 330-32. M. R. James' *Description of the Manuscripts in the Library of Corpus Christi College, Cambridge* (Cambridge: Cambridge Univ. Press, 1912), I, 203, identifies a "Letter from the bishops to queen Elizabeth for the removal of images out of churches" (MS. 105).

[8]Article 9; see also Article 45.

[9]*Articles devised by the Kynges Highnes Maiestie* (1536), sig. C4.

[10]*Three Chapters of Letters Relating to the Suppression of the Monasteries*, ed. Thomas Wright, Camden Soc., 26 (London, 1843), p. 145.

[11]Ibid., pp. 221-22. See also C. Haigh and D. Loades, "The Fortunes of the Shrine of St. Mary of Caversham," *Oxoniensia*, 46 (1981), 62-72.

[12]Ibid., p. 219.

[13]See Margaret Aston, "Iconoclasm in England," above, pp. 56-60, and also John Phillips, *The Reformation of Images* (Berkeley and Los Angeles: Univ. of California Press, 1973), pp. 73-74; Aylmer Vallance, *Greater English Church Screens* (London: Batsford, 1947), pp. 10-12.

[14]*Three Chapters of Letters*, ed. Wright, p. 172.

[15]Charles Wriothesley, *A Chronicle of England during the Reigns of the Tudors, from A.D. 1485 to 1559*, ed. William Douglas Hamilton, Camden Soc. (London, 1875), p. 74. For a possible source for the iconography of the Rood of Grace, see the description of a miracle involving a notary before the image of the crucifix associated with the true cross in the "chirche of saint sophye" in Byzantium (*Golden Legend*, trans. William Caxton [1493], fol. cxxxi[r]). In this case, the crucifix moved its eyes so that it continued to look at the guilty man.

[16]Wriothesley, *Chronicle*, p. 74.

[17]William Lambarde, *A Perambulation of Kent*, rev. ed. (London, 1826), p. 205.

[18]Ibid., p. 206. See also J. Brownbill, "Boxley Abbey and the Rood of Grace," *The Antiquary*, 7 (1883), 164.

[19]J. Lewis André, "Boxley Abbey," *The Antiquary*, 7 (1883), 279.

[20]Francis Grose, ed., *The Antiquarian Repertory*, III (1808), 349-50.

[21]*The Seconde Tome of Homilies*, fol. 56.

[22]W. K. Jordan, *Edward VI: The Young King* (Cambridge: Harvard Univ. Press, 1968), pp. 182-86; John Foxe, *The Acts and Monuments*, introd. George Townsend (rpt. New York: AMS Press, 1965), V, 717-18. For the "Order of Council for the Removing of Images," see Gilbert Burnet, *The History of the Reformation of the Church of England* (Oxford: Clarendon Press, 1865), V, 191.

[23]*Calendar of State Papers, Spanish*, IX (1912), 222. Were the images used as visual aids in this instance similar to the Boxley Rood, or were these images designed for use in the Holy Week and Easter ceremonies? For Protector Somerset's explanation of the removal of the cross, see ibid., p. 219, and, for further comment on the significance of this event at St. Paul's, see Aston, "Iconoclasm in England," above, p. 71, and for a 1552 inventory which lists imagery that remained in St. Paul's up to this time, see H. B. Walters, *London Churches at the Reformation* (London: SPCK, 1939), pp. 73-85.

[24]Clifford Davidson and David E. O'Connor, *York Art*, Early Drama, Art, and Music, Reference Ser., 1 (Kalamazoo: Medieval

Institute Publications, 1978), pp. 2, 15; E. Brunskill, "Two Hundred Years of Parish Life in York," *Annual Report and Proceedings of the Yorkshire Architectural and York Archaeological Society, 1950-51* (York, 1951), p. 32. See also the complaint of the "Order of Council," in Burnet, *History*, V, 191, that "in some places also the images, which by the said injunctions were taken down, be now restored and set up again." The reluctance to dispose of images in many parts of the country was also evident following the change in the religious climate upon the accession of Queen Elizabeth I; for example, Great St. Mary's in Cambridge did not dispose of its Marian acquisitions for an entire decade, finally in 1568 selling its Marian vestments, books, "the crosse of Copper with Images of mari & John," pax, bell, "the Image of our ladie which was taken of blewe velvet alter clothe bi the comaundement of the archdeacon," etc. (*Churchwardens' Accounts of Great St. Mary's, Cambridge, 1504-1635*, ed. J. E. Foster, Publications of the Cambridge Antiquarian Soc., 35 [Cambridge, 1905], p. 164).

[25]H. B. Walters, *London Churches at the Reformation* (London: SPCK, 1939), p. 223.

[26]Ibid., p. 603.

[27]Ibid., p. 310.

[28]*Churchwardens' Accounts of the Town of Ludlow*, ed. Thomas Wright, Camden Soc., 92 (London, 1869), pp. 33, 36-37, 46, 50.

[29]John M. Fletcher and Christopher A. Upton, "Destruction, Repair and Removal: An Oxford College Chapel during the Reformation," *Oxoniensia*, 48 (1983), 122-27.

[30]*Churchwardens' Accounts of the Town of Ludlow*, ed. Wright, pp. 94, 98.

[31]Machyn, *Diary*, p. 82.

[32]Ibid., pp. 82-83.

[33]*Tudor Royal Proclamations*, ed. Paul L. Hughes and James F. Larkin (New Haven: Yale Univ. Press, 1964-69), I, 276.

[34]Strype, *Annals of the Reformation*, I, Pt. 1, 70.

[35]Ibid., I, Pt. 1, 260-61.

[36]Fletcher and Upton, "Destruction, Repair and Removal," pp. 126-27. In 1564-65, further attempts to cleanse the chapel are noted when a painter was hired to "deform" the pictures in the chapel, and even the organ was sold in 1567 (ibid., pp. 126-28).

CLIFFORD DAVIDSON

[37]John Weever, *Ancient Funerall Monuments* (London, 1631), p. 50.

[38]Robert Benson and Henry Hatcher, *Old and New Sarum*, in Richard Colt Hoare, *The History of Modern Wiltshire*, VI (London, 1843), 371.

[39]*Calendar of State Papers, Domestic, 1631-33*, pp. 267, 538-39; for the resolution of the matter, see *Cal. State Papers, Domestic, 1633-34*, p. 19.

[40]Francis Hargrave, *A Complete Collection of the State Trials*, I (1776), as quoted by Benson and Hatcher, *Old and New Sarum*, pp. 372-73. For a more complete report of the trial, I have consulted Hargrave's *Complete Collection of State Trials*, 2nd ed. (London, 1780), I, 377ff. See also Paul Slack, "Religious Protest and Religious Authority: The Case of Henry Sherfield, Iconoclast, 1633," in *Schism, Heresy and Religious Protest*, ed. Derek Baker, Studies in Church History, 9 (Cambridge: Cambridge Univ. Press, 1972), pp. 295-302.

[41]William Laud, "Speech in the Star Chamber, at the Censure of Henry Sherfield, Esq. . . . Feb. 8th, 1632," in *Works*, VI (Oxford: John Henry Parker, 1857), 17-20.

[42]William Prynne, *Histrio-Mastix* (London, 1633), p. 93.

[43]*The Journal of William Dowsing, of Stratford* (Woodbridge, 1786), p. 19; A. C. Moule, ed., *The Cambridge Journal of William Dowsing, 1643* (1926), p. 5.

[44]*Querela Cantbrigiensis* (1647), pp. 17-18, as quoted in Moule, ed., *The Cambridge Journal*, p. 3.

[45]Ibid., p. 6. For the view that these "Superstitious Pictures" did not include the iconography of the chapel glass, see Hilary Wayment, *The Windows of the King's College Chapel, Cambridge* (London: British Academy, 1972), p. 40.

[46]*The Journal of William Dowsing*, pp. 1, 12.

[47]Erasmus, *The Colloquies*, trans. Craig R. Thompson (Chicago: Univ. of Chicago Press, 1965), p. 295, but see also the summary of Erasmus' objection to taking shadows (images) for the true substance of religion, in Phillips, *Reformation of Images*, pp. 38-40. Especially pertinent is Erasmus' statement, in his *Enchiridion*, that he viewed "the entire spiritual life" to be a gradual turning "from those things whose appearance is deceptive to those things that are real" (quoted by Phillips, p. 39). But for his attitude toward iconoclasm, see Erwin Panofsky, "Erasmus and the Visual Arts," *Journal of the Warburg and Courtauld Institutes*, 32 (1969), 207-14.

[48]Charles Pendrill, *Old Parish Life in London* (London: Oxford Univ. Press, 1937), p. 26.

[49]See Pamela Sheingorn, "No Sepulchre on Good Friday," pp. 146-60, below, and, by the same author, *The Easter Sepulchre in England*, Early Drama, Art, and Music, Reference Ser., 5 (Kalamazoo: Medieval Institute Publications, 1987), pp. 60-62.

[50]Wriothesley, *Chronicle*, II, 1, as cited in Sheingorn, *Easter Sepulchre in England*, p. 61.

[51]See the selection from this work reprinted by Karl Young, *The Drama of the Medieval Church* (Oxford: Clarendon Press, 1933), II, 532-37.

[52]See also "The Anti-Visual Prejudice and the Holy Week Ceremonies on Good Friday and Easter," *EDAM Newsletter*, 9, No. 2 (1986-87), 6-8.

[53]*A Description or Briefe Declaration of All the Ancient Monuments, Rites, and Customes belonginge or beinge within the Monastical Church of Durham before the Suppression*, ed. James Raine, Surtees Soc. (London, 1842), pp. 9-10.

[54]See especially Peter Happé's Introduction to his edition of *The Plays of John Bale*, Tudor Interludes, 4 (Cambridge: D. S. Brewer, 1985), I, 1-25.

[55]See Peter Happé, "The Protestant Adaptation of the Saint Play," in *The Saint Play in Medieval Europe*, ed. Clifford Davidson, Early Drama, Art, and Music, Monograph Ser., 8 (Kalamazoo: Medieval Institute Publications, 1986), pp. 226-35. See also the commentary on Protestant drama by John N. King, *English Reformation Literature* (Princeton: Princeton Univ. Press, 1982), pp. 271-318.

[56]*Cal. State Papers, Venetian*, VII, No. 18 (p. 27).

[57]Ibid., VII, No. 69 (pp. 80-81).

[58]See Clifford Davidson, "The Middle English Saint Play and Its Iconography," in *The Saint Play in Medieval Europe*, ed. Davidson, pp. 31-122.

[59]Ibid., pp. 54-55.

[60]John C. Coldewey, "The Digby Plays and the Chelmsford Records," *Research Opportunities in Renaissance Drama*, 18 (1975), 103-21.

[61]*York*, ed. Alexandra F. Johnston and Margaret Rogerson, Records

of Early English Drama (Toronto: Univ. of Toronto Press, 1979), I, 378.

[62]See *A Middle English Treatise on the Playing of Miracles*, ed. Clifford Davidson (Washington, D.C.: Univ. Press of America, 1981).

[63]R. W. Ingram, *Coventry*, Records of Early English Drama (Toronto: Univ. of Toronto Press, 1981), pp. 112-13, 576.

[64]*York*, ed. Johnston and Rogerson, I, 392-93.

[65]*Chester*, ed. Lawrence Clopper, Records of Early English Drama (Toronto: Univ. of Toronto Press, 1979), p. 248 (italics mine).

[66]*Coventry*, ed. Ingram, pp. 215, 273.

[67]Thomas Sharp, *A Dissertation on the Pageants or Dramatic Mysteries Anciently Performed at Coventry* (Coventry, 1825), p. 39.

[68]*Mysteries' End, passim*.

[69]*Chester*, ed. Clopper, p. 86.

[70]Ibid., p. 97.

[71]Ibid., pp. 109-17; R. M. Lumiansky and David Mills, *The Chester Mystery Cycle: Essays and Documents* (Chapel Hill: Univ. of North Carolina Press, 1983), p. 193.

[72]*Chester*, ed. Clopper, p. 109.

[73]Ibid., p. 252 (italics mine); cf. Lumiansky and Mills, *The Chester Mystery Cycle: Essays and Documents*, pp. 265-66, 271.

[74]*York*, ed. Johnston and Rogerson, I, 291-92.

[75]See Mark R. Sullivan, "The Missing York Funeral of the Virgin," *EDAM Newsletter*, 1, No. 2 (April 1979), 5-7.

[76]Davidson and O'Connor, *York Art*, pp. 103-11.

[77]For a convenient summary of early writings, see *The Oxford Dictionary of the Christian Church*, ed. F. L. Cross, 2nd ed., revised by F. L. Cross and E. A. Livingstone (Oxford: Oxford Univ. Press, 1974), pp. 882-84.

[78]Lumiansky and Mills, *The Chester Mystery Cycle: Essays and Documents*, p. 190. Other alterations to the Chester cycle appear to involve the Last Supper, which also treated a subject very sensitive in the times of Edward VI and Elizabeth I; see ibid., pp. 190-91.

[79]Hardin Craig, ed., *Two Coventry Corpus Christi Plays*, 2nd ed., EETS, e.s. 87 (London, 1957), p. xvi, and Craig's *English Religious Drama of the Middle Ages* (Oxford: Clarendon Press, 1955), p. 286.

[80]Humphrey Wanley's *Annals*, British Library, Harley MS. 6388, fol. 31r.

[81]Ibid., fol. 33r.

[82]Ibid., fol. 34v.

[83]R. W. Ingram, "Fifteen seventy-nine and the Decline of Civic Religious Drama in Coventry," in *The Elizabethan Theatre VIII*, ed. G. R. Hibbard (Port Credit, Ontario: P. D. Meany, 1982), pp. 114-28.

[84]Mary Dormer Harris, "The Craft Guilds of Coventry," *Proceedings of the Society of Antiquaries*, 2nd ser., 16 (1895), 5.

[85]Charles Gross, *The Gild Merchant* (Oxford: Clarendon Press, 1890), II, 48-49.

[86]*Coventry*, ed. Ingram, pp. 16-17. It was, of course, traditional that the most important persons should appear at the end of the procession on account of the injunction in the Gospels that "the last shall be first" (*Matthew* 19.30). Matters of precedence in processions, etc., were regarded as of great importance in the structured society of the medieval city.

[87]Charles Phythian-Adams, *Desolation of a City: Coventry and the Urban Crisis of the Late Middle Ages* (Cambridge: Cambridge Univ. Press, 1979), pp. 100, 160; cf. Joan C. Lancaster, "Crafts and Industries," in *The Victoria History of the County of Warwick*, VIII, 155.

[88]*Coventry*, ed. Ingram, p. 292. Unfortunately, 1579 is the first year for which accounts of the Mercers are available; see ibid., p. xliv.

[89]For the reputation of the Coventry Corpus Christi play, see William Dugdale, *The Antiquities of Warwickshire* (London: 1656), p. 116; Sharp, *Dissertation*, p. 13.

[90]*Coventry*, ed. Ingram, pp. 112-13.

[91]Ibid., p. 125; cf. Sharp, *Dissertation*, p. 77; see also *Coventry*, ed. Ingram, p. 564. For this period in Princess Mary Tudor's life, see H. F. M. Prescott, *A Spanish Tudor* (1940; rpt. New York: AMS Press, 1970), pp. 13-14.

[92]Craig, ed., *Two Coventry Corpus Christi Plays*, p. xvi.

[93]Clifford Davidson and Jennifer Alexander, *Early Art of Coventry,*

Stratford-upon-Avon, Warwick, and Lesser Sites in Warwickshire, Early Drama, Art, and Music, Reference Ser., 4 (Kalamazoo: Medieval Institute Publications, 1985), p. 136.

[94]Craig, ed., *Two Coventry Corpus Christi Plays,* p. xvi, and *English Religious Drama,* p. 289; see also Diane K. Bolton, "Social History to 1700," in *Victoria County History of the County of Warwick,* VIII, 213.

[95]*English Gilds,* ed. J. Toulmin Smith (London, 1890), pp. 229, 231. Joan Lancaster has also noted three extant impressions of a fourteenth-century seal which may have been associated with the St. Mary's Guild; the seal depicts the Coronation of the Virgin, with Christ on the right and the crowned Virgin seated on the left ("Crafts and Industries," p. 156). However, neither the scene of the Assumption nor that of the Coronation appeared on the later seal of the amalgamated guild of the Holy Trinity, St. Mary, St. John the Baptist, and St. Catherine; see the Aylesford Collection: Warwickshire Churches, I, 262, in the Birmingham Reference Library.

[96]The mergers which ultimately united the merchants' St. Mary's Guild (founded 1340) and the guilds of St. John the Baptist and St. Catherine as well as the Holy Trinity Guild were completed by 1392; see Lancaster, "Trades and Industries," p. 156. The Holy Trinity Guild was the senior guild, while the Corpus Christi was the junior guild; see Phythian-Adams, *Desolation of a City, passim.*

[97]Dugdale, *Antiquities,* pp. 122-23.

[98]John Carter, *Specimens of the Ancient Sculpture and Painting now remaining in this Kingdom* (London, 1780), Pl. following p. 15.

[99]Mary Dormer Harris, "The Misericords of Coventry," *Transactions of the Birmingham Archaeological Society,* 52 (1927), 262, Pl. XXXI. Harris suggests that this seat was from a series which commemorated guild associations.

[100]A. F. Kendrick, "The Coventry Tapestry," *Burlington Magazine,* 44 (1924), 83-89.

[101]*Churchwardens' Accounts of Great St. Mary's,* ed. Foster, p. 164.

[102]Kendrick, "The Coventry Tapestry," pp. 84, 89.

[103]Craig, ed., *Two Coventry Corpus Christi Plays,* pp. xvi-xvii.

[104]For the legend of St. Thomas and the girdle of the Virgin, see Mrs. [Anna] Jameson, *Legends of the Madonna* (London: Longmans, Green, 1890), pp. 320-21. For an English example of this iconography, at Gloucester Cathedral, see the illustration by Charles Winston in

"THE DEVIL'S GUTS"

British Library MS. Add. 35,211, Pl. G.75-76.

[105]*Coventry*, ed. Ingram, pp. 152, 154-55, 162, 166, 170, 172-74.

[106]Reginald W. Ingram, "'Pleyng geire accustumed belongyng & necessarie': Guild Records and Pageant Production at Coventry," in *Proceedings of the First Colloquium*, ed. JoAnna Dutka (Toronto: Records of Early English Drama, 1979), p. 63; *Coventry*, ed. Ingram, pp. 172-74.

[107]Charles Phythian-Adams, "Ceremony and the Citizen: The Communal Year at Coventry," in *Crisis and Order in English Towns 1500-1700*, ed. Peter Clark and Paul Slack (Toronto: Univ. of Toronto Press, 1972), p. 79.

[108]British Library MS. Egerton 2603, fol. 26; *Coventry*, ed. Ingram, p. 487.

[109]See Dugdale, *Antiquities*, pp. 122-23. Relevant here is the image of the Virgin which was especially venerated at Coventry and which may serve as an indication of the popularity of her cult in this region. Located in the Lady's Tower on the city walls, the image and altar dedicated to her within this chapel were especially known to travellers, who would give offerings to this image--an image which would be regarded as in the "abused" category by the promoters of the Reformation and hence a prime target of iconoclasm. For the image, see W. G. Fretton, "Memorials of the Whitefriars," *Transactions of the Birmingham Archaeological Society*, [4] (1873), 72. R. W. Ingram has also called my attention to the significance of the dedication of St. Mary's Cathedral for stimulating the cult of the Virgin in Coventry.

For notice of the popularity of the practice of venerating Mary and praying the Office of the Virgin in England before the Reformation, see Pendrill, *Old Parish Life*, p. 163.

[110]Sharp, *Dissertation*, p. 11.

[111]*Coventry*, ed. Ingram, pp. 247, 260.

[112]Ibid., p. 225.

[113]Mary Dormer Harris, ed., *The Coventry Leet Book*, EETS, o.s. 134-35, 138, 146 (London, 1907-13), p. 857.

[114]See my "'What hempen home-spuns have we swagg'ring here?' Amateur Actors in *Midsummer Night's Dream* and the Coventry Civic Plays and Pageants," *Shakespeare Studies*, 17 (1987), 87-99.

[115]*Coventry*, ed. Ingram, p. 354.

[116]Ibid., p. 361.

[117]See Ingram, "Fifteen seventy-nine and the Decline of Civic Religious Drama in Coventry," pp. 114-28.

[118]See, for example, Martin Stevens, *Four Middle English Mystery Cycles* (Princeton: Princeton Univ. Press, 1987), p. 95; but see the definitive argument against Wakefield provenance by Barbara Palmer, "'Towneley Play' or 'Wakefield Cycle' Revisited," *Comparative Drama*, 21 (1987-88), 318-48.

[119]*The Towneley Plays*, ed. George England and Alfred W. Pollard, EETS, e.s. 71 (London, 1897), pp. 200-01.

[120]Martin Stevens, "The Missing Parts of the Towneley Cycle," *Speculum*, 45 (1970), 258-59.

[121]Rosalie B. Green, "Virtues and Vices in the Chapter House Vestibule in Salisbury," *Journal of the Warburg and Courtauld Insitutes*, 31 (1968), 148-58.

[122]J. C. Dickinson, *The Shrine of Our Lady of Walsingham* (Cambridge: Cambridge Univ. Press, 1956), pp. 65-66.

[123]M. R. James, *The Sculptures in the Lady Chapel at Ely* (London: D. Nutt, 1895).

[124]Nicola Coldstream, "Ely Cathedral: The Fourteenth-Century Work," in *Medieval Art and Architecture at Ely Cathedral* (British Archaeological Association, 1979), p. 42; Philip Lindley, "The Fourteenth-Century Architectural Programme at Ely Cathedral," in *England in the Thirteenth Century: Proceedings of the Harlaxton Symposium*, ed. W. M. Ormond (Woodbridge: Boydell Press, 1985), pp. 126-27.

[125]James Bentham, *The History and Antiquities of the Conventual and Cathedral Church of Ely* (Cambridge, 1771), p. 190; cf. Philip Lindley, "Appendix--Selective Iconoclasm: A Case Study," in "The Imagery of the Octagon at Ely," *Journal of the British Archaeological Society*, 139 (1986), 93-94.

[126]Lindley, "The Fourteenth-Century Architectural Programme," p. 127.

[127]See *Queen Mary's Psalter*, introd. George Warner (London: British Museum, 1912), Pls. 219e-238c.

[128]Alfred C. Fryer, "Theophilus, the Pentitent, as Represented in Art," *Archaeological Journal*, 92 (1935), 316-17.

[129]James, *The Sculptures in the Lady Chapel at Ely*, South Side, Pl. XVII.

[130]Ibid., South Side, Pl. XVIII.

[131]Ibid., West End, Pl. II, p. 35.

[132]See ibid.

[133]Ibid., West End, Pl. III, p. 36.

[134]Ibid., West End, Pls. IV-V, pp. 37-38.

[135]Ibid., West End, Pls. VI-IX, pp. 39-42.

[136]Ibid., p. 62.

[137]For a drawing made by a Miss Wickens from the wall painting before its restoration, see Benson and Hatcher, *Sarum*, fig. following p. 588; see also her description, p. 589.

[138]H. J. F. Swayne, ed., *Churchwardens' Accounts of S. Edmund and S. Thomas, Sarum, 1443-1702*, Wiltshire Record Soc. (1896), pp. 150, 280, 288.

[139]Ibid., p. 281.

[140]*Ancient and Historical Monuments in the City of Salisbury*, I, Royal Commission on Historical Monuments (London, 1980), p. 30, Pl. 43.

[141]Ibid., p. 29.

[142]Madeline Harrison Caviness, *The Windows of Christ Church Cathedral, Canterbury*, Corpus Vitrearum Medii Aevi, 2 (London: Oxford Univ. Press, 1981), p. 268, fig. 494.

[143]Quoted by Caviness, *The Windows of Christ Church Cathedral*, p. 253.

[144]Ibid.

[145]Christopher Wordsworth, "Inventories of Plate, Vestments, &c., belonging to the Cathedral Church of the Blessed Mary of Lincoln," *Archaeologia*, 53 (1892), 1-82.

[146]Ibid., p. 16.

[147]Ibid., p. 80.

[148]*Records of Plays and Players in Lincolnshire*, ed. Stanley Kahrl, Malone Society Collections VIII (1974), pp. 67-68.

[149]Ibid., p. 68.

[150]Burnet, *History*, V, 191.

[151]*A Middle English Treatise*, ed. Davidson, p. 40.

[152]See *Meditations on the Life of Christ*, trans. Isa Ragusa (Princeton: Princeton Univ. Press, 1961), p. 333; David L. Jeffrey, *The Early English Lyric and Franciscan Spirituality* (Lincoln: Univ. of Nebraska Press, 1975), *passim*. The implications for late medieval religious drama are discussed in my "Northern Spirituality and the Late Medieval Drama of York," in *The Spirituality of Western Christendom*, ed. E. Rozanne Elder (Kalamazoo: Cistercian Publications, 1976), pp. 133-36.

[153]*Fifty Sermons* (1649), Sermon 24, as quoted by John Coulson, *Newman and the Common Tradition: A Study in the Language of Church and Society* (Oxford: Clarendon Press, 1970), p. 7.

[154]Cf. the important article by Karl Wentersdorf, "The Symbolic Significance of *Figurae Scatologicae* in Gothic Manuscripts," in *Word, Picture, and Spectacle*, ed. Clifford Davidson, Early Drama, Art, and Music, Monograph Ser., 5 (Kalamazoo: Medieval Institute Publications, 1984), pp. 1-19. Calvin's comment on "idolaters" assumes a similar analogy between excrement and the false objects of worship; see Carlos M. N. Eire, *War against the Idols* (Cambridge: Cambridge Univ. Press, 1986), p. 220, who quotes a highly revealing passage from Calvin's works: "Just as a [latrine cleaner] mocks those who hold their noses [in his presence], because he has handled filth for so long that he can no longer smell his own foulness; so likewise do idolaters make light of those who are offended by a stench they cannot themselves recognize. Hardened by habit, they sit in their own excrement, and yet believe they are surrounded by roses."

[155]A useful anthropological study that may provide a background against which such patterns of religious behavior may be seen is Mary Douglas, *Purity and Danger: An Analysis of Concepts of Pollution and Taboo* (New York and Washington: Frederick A. Praeger, 1966).

"No Sepulchre on Good Friday": The Impact of the Reformation on the Easter Rites in England

Pamela Sheingorn

Although it is tempting to summarize the impact of the Reformation on art and ritual in England with sweeping generalizations, full understanding of that impact arises only through detailed examination of specific instances. Dramatic acts of destruction, such as the dismantling of the shrine of St. Thomas Becket at Canterbury Cathedral, and dramatic changes in ritual, such as the suppression of the Latin Mass in favor of the Protestant Eucharistic rite, come readily to mind. More mundane actions, such as the walling up of a niche like the Easter Sepulchre, along with the suppression of the rites that were celebrated there, were no less destructive of the fabric of religious life. Tracing the impact of the Reformation on the Easter Sepulchre and its rites from the early sixteenth century into the 1560's provides a sharply-focused glimpse into changes in ritual life at the level of the individual, whether monk, nun, priest, or parishioner.[1]

Essentially mimetic as well as commemorative,

the rites performed at the Easter Sepulchre re-enacted the burial and Resurrection of Christ on the appropriate days of the liturgical year. On Good Friday a cross and/or Host, representing the body of Christ, was carried in procession to the place symbolizing the Holy Sepulchre in Jerusalem where it was ritually buried to the accompaniment of suitable antiphons such as *Sepulto domino, In pace factus est,* and *Caro mea requiescet in spe.* This rite is called the *Depositio.* Lights placed at this sepulchre burned until Easter morning, at which time the removal of cross or Host from the sepulchre re-enacted the Resurrection in a rite called the *Elevatio,* and again there were appropriate chants, such as *Christus resurgens* and *Surrexit dominus de sepulchro.* A third rite, the *Visitatio sepulchri,* was rarely performed in England, though it was quite popular on the Continent. This rite re-enacted the Visit of the Holy Women to the Tomb.

Such ceremonies might involve more or less impersonation, might be more or less dramatic, and might be surrounded by more or less imagery. Their place of performance, the Easter Sepulchre, usually stood near the high altar on the north side of the chancel. Its form varied from a wholly temporary wooden structure draped with embroidered or painted cloths--the Easter Sepulchre at Cowthorpe, Yorkshire, is a rare surviving example--to a monumental sculptural ensemble that obviously remained in place throughout the liturgical year--e.g., the sepulchre at Heckington, Nottinghamshire.[2] Frequently a series of openings, or merely a simple niche in the north wall of the chancel, received the temporary embellishment necessary to transform the space into an Easter Sepulchre.

Although not required by medieval Catholic ritual, Easter Sepulchres were to be found in most churches in England, from the smallest parish churches to the largest cathedrals and monastic churches. Ample evidence from churchwardens' accounts, inventories, and wills demonstrates that the Easter Sepulchre was an object of considerable popular devotion. The imagery associated with it presented neither obscure episodes from the lives of local saints nor esoteric bits of intellectualized theology but rather a central event of salvation history: the resurrection of Christ (see fig. 27). The body of Christ lay enshrined in the Easter Sepulchre from Good Friday to Easter every year, and the great popularity of this practice in the late Middle Ages can surely be connected with increased devotion to the Eucharist within the context of the Catholic Mass. The Easter Sepulchre encouraged affective piety, emotional identification with Christ, as is clear from Richard Kieckhefer's description of an incident in the life of James Oldo, a fourteenth-century continental saint:

> A more vivid reenactment of Christ's experience was James Oldo's actually lying down in a sepulcher repre-senting that of Christ. He did so at first out of idle curiosity, to see "which of us is taller, Christ or I." No sooner did he lie down, though, than the Holy Spirit worked a transformation in his soul, "like white-hot iron in frigid water." He lost all his taste for the vanities of the world, and converted at once to a life of piety. This incident is a perfect example of the effect that devotional reenactment was meant to have: it transformed a sinner into a saint, or made the saint a more perfect one, precisely through subjective assimilation to Christ.[3]

With the success of the Reformation in England, opportunities for "devotional reenactment" such as this were irretrievably lost.

Let us begin with the situation that pertained in the first decades of the sixteenth century. The chancel of a parish church was the responsibility of the priest or vicar. Since the Easter Sepulchre stood within the boundaries of the chancel, wills of clerics sometimes include bequests of funds for repair of the sepulchre or for the building of a new one. The ongoing expense of lights, cloths, watchers, their food and drink was, by contrast, the responsibility of the parish and might be met in a variety of ways. Either the churchwardens held direct responsibility for these costs or they were assigned to special "light-wardens" appointed or elected; at Wing in Buckinghamshire they were called "lytemen to the blesyd sepulkur lytte." Such costs could also be assumed by guilds. In rural areas these groups might maintain a herd of cattle, the church herd. Profits from the increase in the size of the herd supported the functions of the parish. Lightwardens collected money for the sepulchre, sometimes on specific days. Small bequests of money, grain, wax, and even bee hives-- useful for all those lights--supplemented regular income. Larger gifts allowed for repairs and improvements. The cloths that decorated the sepulchre were often donations and had been made for other purposes. For example, in his will of 1500 Henry Willyams of Stanford on Avon, Northamptonshire, bequeathed his "coverled to the use of the sepulcre." Items for use in the sepulchre might also be provided by parishioners. In 1501 Hugh Brown, a grocer of

London, left to the church of St. Leonard, Eastcheap, a reliquary cross "of silver and gilt with a foot thereto all gilt, . . . and on every Goodfriday and Esterday in the morning at the Resurrection of the said cross to be occupied at the creeping of the cross, also that the said cross shall yearly be laid by and with the blessed sacrament in the sepulchere on every Goodfriday, to the great honour of God, and for the great dignity and preciositie of the same cross."

The Easter Sepulchre, which stood at the center of the celebration of the most important events in Christian history, was not remote from the central concerns of individual Christians. Parishioners revealed their understanding that their own funerary ritual, and also the hope that their souls would be received in heaven, were intimately connected with the ritual burial and resurrection of Christ conducted at the Easter Sepulchre. Thus in 1413 Sir John Cheyne of Bedford asked that one taper burn at his head and another at his feet during his funeral. What remained of the tapers was "to brenne to fore the sepulcre from good freiday in to Esterday by the morowen." Frequently wills asked that the deceased be buried near the Easter Sepulchre, or left money for a new sepulchre to be made that would combine the functions of Easter Sepulchre and tomb; of this type, the example from Hawton, Nottinghamshire, is the most elaborate surviving. John Saron, who died in 1519, was priest and parson of St. Nicholas Olave in London. He asked to be buried "before Seynt Nicholas, with a littell tombe for the resurrection of Ester Day." In St. John's, Hackney, Middlesex, the tomb of Christopher Urswyck, who died in 1522, was also intended for use as the Easter Sepulchre. A

portion of the black letter inscription on the tomb reads: *hic sepultus carnis resurreccionem in aduentu christi expectat* ("buried here, he awaits the resurrection of the body at the Second Coming of Christ").

We may conclude that the Easter Sepulchre was one of the standard appurtenances of the medieval English church, that English Christians perceived its maintenance as part of their religious responsibility, and that through their gifts to it they expressed their belief in the resurrection of the body at the Last Judgment.

The earliest evidence in England for the Easter rites comes from monastic settings, and documents such as the *Rites of Durham* describing practices at the end of the Middle Ages indicate that the monasteries continued these practices. Nonetheless the waning of the Easter Sepulchre began in 1536 with the Act of Parliament that dissolved the lesser religious houses--all those with an income of less than £200 per annum. The decision to dissolve all monasteries seems to have been taken soon thereafter, and by the end of March 1540 there were no monasteries left in England.[4]

Commissioners charged with the responsibility of confiscating monastic property for the Crown compiled inventories of lands, buildings, and goods owned by monasteries. For example, in 1538 the Commissioners' Inventory for the Benedictine Priory at Castle Hedingham in Essex listed sepulchre clothes of silk as well as a pair of sheets for the sepulchre. Although the dissolution brought an end to monastic celebration of the Easter rites, parish churches gained from the dissolution. The monu-

ment probably used as the Easter Sepulchre in the church of St. Michael at Stanton-Harcourt, Oxfordshire, consists largely of the pedestal of the shrine of St. Edburg from the Priory of Austin Canons at Bicester and was presumably brought to Stanton-Harcourt at the dissolution of the monastery.[5] Obviously the expectation was that Catholic ritual would continue in this parish church.

However, Cromwell's Injunctions of 1538 sharply limited the daily expression of Catholic ritual by stipulating that no lights were to be placed before images. Churchwardens' accounts indicate that the maintenance of lights before images of saints, of Christ, and of the Virgin had been one of the most regular expenditures of the parish church. Virtually every church housed numbers of such images, ten to fifteen not being an unusual figure. The Easter Sepulchre was excepted from this general directive, as the Injunctions of Archbishop Edward Lee for York Diocese indicate: "Nevertheless they may still use lights in the rood-loft, and afore the Sacrament, and at the sepulchre at Easter, according to the King's Injunctions."

Henry VIII's first move against chantries in 1545, followed by their dissolution in 1547, deprived Easter Sepulchres of some of their regular income. For example, a Chantry Certificate of 1545 from Quainton, Buckinghamshire, lists as income: "A rent goinge oute of certeine landes of the auncestres of one Taillour geven for maintenyng of ij tapers before the sepulchre within the said parishe worth by yere--iij pounde of wax." But by 1548 having an Easter Sepulchre had become a proscribed practice. Cranmer's Articles of Inquiry issued in that year

asked: "Whether they had upon Good Friday last past the sepulchres with their lights, having the Sacrament therein."

Now the advocates of reform turned their attention to the Easter rites. In a tract published in Switzerland in 1547, John Hooper, later Bishop of Gloucester, attacked the Catholic Easter rites:

> [Christ] hankyd not the picture of his body upon the crosse to theache them his deathe as our late lernyd men hathe donne. The plowghman, be he never so unlernyed, shalle better be instructyd of Christes deathe and passion by the corn that he sowithe in the fyld and likwyce of Christes resurrextion, then be all the ded postes that hang in the churche or pullyd out of the sepulchre withe, Christus resurgens. What resemblaynce hathe the taking of the crosse out of the sepulchre and goying à prossession withe it withe the resurrexcion of Christ: none at all, the ded post is as ded, when they sing, iam non moritur, as it was, when they buryd it, withe, in pace factus est locus eius. If ony precher would manifest the resurrexcion of Christe unto the sences. Why dooth he not teache them by the grayne of the fyld, that is rysyn out of the Erthe, and commithe of the ded corn, that he sawid in the winter.[6]

The especial object of Hooper's rage was the wooden image of Christ placed in the Easter Sepulchre on Good Friday and raised from it on Easter morning. Refusing to yield any didactic value to such a image, Hooper derisively calls it a "ded post."

Presumably a similar kind of image, a Resurrection puppet, was derided in an anti-Catholic sermon given in London in 1547. The chronicler Wriothesley notes: "The xxviith daie of November, being the first Soundaie of Aduent, preched at Poules Cross Doctor Barlowe, Bishopp of Sainct Davides, where he shewed

a picture of the resurrection of our Lord made with vices, which putt out his legges of sepulchree and blessed with his hand, and turned his heade. . . ." Wriothesley described the content of the sermon, which strongly advocated iconoclasm, and the reaction of the audience, which was to destroy the "idolls."[7] Although, perhaps understandably, no such puppets thus representing the risen Christ have survived in England, several other references indicate that they may have been used with some frequency in the Easter ritual. For example, William Lambarde, late in the sixteenth century describing the scene as it had been dramatized previously in "the Dayes of ceremonial Religion" at Witney, Oxfordshire, wrote that "the Preistes garnished out certein smalle Puppets, representinge the *Parsons* of Christe, the Watchmen, *Marie*, and others, amongest the which one bare the Parte of a wakinge Watcheman, who (espiinge Christ to arise) made a continual Noyce, like to the Sound that is caused by the Metinge of two Styckes, and was therof comonly called *Jack Snacker of Wytney*."[8] Such puppets may have served as inexpensive substitutes for mechanical devices of the type seen at Salisbury by a distinguished traveller from Bohemia, Leo of Rozmital, who toured Europe from 1465 to 1467. Calling the device "a splendid and praiseworthy thing to see," Leo's secretaries described "fine carved figures which were so worked with weights that they moved," showing "the angels opening the Sepulchre with Christ rising from the dead, holding a banner in his hand." Both this scene and one of the Adoration of the Magi were "so represented that they [did] not appear to be fashioned but alive and actually to be

moving before our eyes."[9] Certainly the representation of the resurrected Christ carved in relief on the Easter Sepulchre in Patrington, Yorkshire, bears a strong resemblance to a puppet (fig. 27). Christ is both lively and stiff--ungainly as if a jointed puppet. His appearance correlates with the description of the puppet displayed by Dr. Barlow: sitting up in his tomb, he turns his head to face outward, blesses with his hand, and throws his leg over the edge of the coffin.

By 1548 the church was clearly enforcing the new regulations, for in that year the curate at Sandhurst, Kent, deposed to the Consistory Court that "touching the setting up of the Paschall candle and sepulchre he was not of knowledge of the settyng up of them." In a narrative account of the Reformation, which he tellingly introduced with a quotation from Proverbs-- *Regnantibus impiis: ruina hominum*--Robert Parkyn, curate of Aldwick-le-Street near Doncaster, reported the new way of observing Good Friday in 1548. "And on Good Friday no sepulcre was preparide nor any mention mayde thatt day in holly churche of Christ Jesus bitter passion, death and beriall (as of longe tyme before was uside) the passion only exceptt, wich was redde in Englishe. All other ceremonyes, as creappinge before the crosse, 24 candylls, & disciplyne was utterly omittide."[10]

With the omission of the ritual, local church officials saw no need to maintain an inventory of no-longer-useful goods and thriftily disposed of many obsolete items. In 1552 the churchwardens at Goldhanger, Essex, sold "one trydyll of wax the whyche was the bachelars and the maydyns sepulkar lyght" for ten shillings. The churchwardens' accounts from

St. Lawrence, Reading, for 1549 preserve the following entry: "Received of Mr. Bell for the sepulcre & the frame for tapers thereto annexid xxs." Sometimes churchwardens carefully consulted the parishioners, thereby sharing the responsibility for the sale of goods, as at St. Ives in Huntingdonshire: "Solde by Thomas Sisson and Thomas Pallmer, church wardenes ther, with the assent of the most parte of the parochineres, a pillowe of vellvett, a sepulchre of woodde and one handebell for iiijs. viijd." The money gained thereby could be used to bring the church into compliance with the new ritual; at Streatham in Surrey income from the sale of the sepulchre cloths was "bestowed upon the whittyng of the church."

Once the property of the church was no longer sacrosanct, theft became a vexing problem. The 1547 inventory for St. Swithin, Woodbury, Devon, lists "thre olde sepulcure clothers whyte & rede · stolen." Thus it is not surprising that in the same year, in order to determine what property remained in churches and to hold churchwardens accountable for its value, the government made inquiries as to the goods owned by parish churches. This was followed early in 1549 by a commission for making inventories. In May of 1552 the Privy Council appointed commissioners for each county to inventory church possessions, and inventories survive for a number of counties. On the basis of these inventories a new commission issued in January of 1553 directed the seizure of all but the bare minimum required for the new ritual.

Such inventories could be quite complete: for example the inventory from Amersham, Buckinghamshire, included "a covyring of silke for the sepul-

ture a valens of silke a linen clothe to the sepulture a valens for the same of peynted clothe." But, as the commissioners' inventory for Wickham Bishops, Essex, reports, often the commissioners came too late: "Fynally ther was other thyngs wych did perteyne and belonge to ower church as . . . a veile cloth and other clothes belongyng to ye sepulture . . . and diverse other thyngs wych were stollen a wey when ower church was robbedd and by whom we can nott tell."

From the point of view of the visual environment of medieval Christianity, our most grievous losses resulted from the disappearance or deliberate destruction not only of stone sculpture (fig. 28), wall painting, and glass, but also of perishable objects such as painted or embroidered cloths. Pre-Reformation inventories list sepulchre cloths with imagery of the Passion or, most frequently, of the Resurrection. The handsome carving on the Easter Sepulchre at Lincoln Cathedral (fig. 26) was further embellished with "a whyte steneyd cloth of damaske sylke for the sepullcour with the passyon and the Resurreccion of owr lord." There is even some indication that a sequence of cloths was used, reflecting the sequence of ritual activity at the sepulchre. For example, Holy Trinity Church in Arundel, Sussex, listed in an inventory: "a sepulcre of dyverse peces . . . of the whiche oon pece is enbrowdid with a close tombe and an other with the resurrection." After the Reformation all such items disappeared from inventories.

A number of inventories reveal holdings of wooden sculpture that has been lost--for example, the angels that belonged to St. Margaret's, Southwark: "Item vi angelles of tre gylt with a tombe to

stande in the sepulture at Ester." The Reformation also did away with the jewelry and clothing frequently listed in inventories as belonging to statuary. Not only did statues of patron saints own elaborate clothing for feast days, but apparently the image of Christ used in the Easter rites might also amass a fashionable wardrobe. With such a figure, apparently altered in 1536 by a coppersmith and called "God Amyty" in the accounts of St. Alphege, London Wall, we must surely associate the "cotte for the resurexione at ester of rede sylke," for it is also called "God Amyty's Cotte."

It was finally intended that stone monuments share the fate of these more ephemeral objects. In 1552 Bishop Hooper of Gloucester and Worcester enjoined on the churches under his jurisdiction: "that none of you maintain . . . sepulchres pascal. that you exhort your parishioners and such as be under your cure and charge for the ministry of the church, to take down and remove out of their churches and chapels, all places, tabernacles, tombs, sepulchres, tables, footstools, rood-lofts, and other monuments, signs, tokens, relics, leavings, and remembrances, where such superstition, idols, images, or other provocation of idolatry have been used."

When the Roman Catholic Mary Tudor ascended to the throne in 1553, the situation was altered. As Claire Cross observes, "From the first Queen Mary made no attempt to hide her overriding desire to bring back the form of Catholicism she had known and loved in the days before her father had summoned the Reformation Parliament. The laity, as represented in the frequent Parliaments Mary held, countenanced the return of this traditional

pattern of services and ceremonial without too much unease. . . ."[11] The traditional pattern included the Easter Sepulchre and its rites. Suddenly efforts were made to locate items that had been removed from the church, as at St. Lawrence, Reading, in 1554: "Item for the valence about the sepulcre to know who hath it in kepyng."

Churchwardens' accounts after the accession of Mary record expenditures for mending of sepulchres or purchase of new ones, for cloths and for payments to watchers "according to custom." In 1557 the church at Devizes in Wiltshire paid four pence "for the Sextane watching at the Sepulcre." Again bequests appear in wills, as at Newton Bromswold, Northamptonshire, where a will of 1557 reads, "To sepulcher light a pownde of wax or els a torch." Such bequests, however, are not so frequent as before. Consistory Courts dealt with cases such as that of John Parker of Stodmarsh, Kent, who was faced with the charge that "he had awayd the sepulchre there." And an archdeacon's visitation to St. Mary's, Lydden, Kent, in 1557 resulted in an injunction "to provide a Sepulchre this side Easter."

The return to the Church of England under Elizabeth, who came to the throne in 1558, brought an end to Catholic ritual and thus to the Easter Sepulchre and its rites. By this time there was, perhaps, a certain exhaustion from so much change, for the new order was swiftly and rather smoothly adopted. As A. G. Dickens observes, "the majority of the people cannot possibly have been ardent or even convinced Catholics. Few religious revolutions have been more dramatic than that of 1558-59, yet none has encountered more feeble opposition."[12]

Most church records make no mention of the Easter Sepulchre after the accession of Elizabeth. There is some indication that the new expense added by the communion of the people in both kinds was met with funds previously used to support the Easter Sepulchre. The new ritual also required a communion table, which was occasionally fashioned from the old Easter Sepulchre, as at Healing, Lincolnshire: "the sepuwlker--was cotte and mayd a fryme for a commewneon taybell." Once more sepulchres and their cloths were sold or destroyed, as at Sherborne, Dorset, where the "Sepulker cloth" was sold in 1562. Permanent sepulchres that survived earlier iconoclasm were now converted to tombs or targeted for destruction, a process that took place over a number of years. In 1562 the church of St. Lawrence in Reading took down "the fframe where the sepulcher Lighte dyd stand." The church at Bearsted, Kent, was presented at Consistory Court in 1562 because "the hole [i.e., the recess] where the sepulchre was wont to lie is undefaced." Many blocked up recesses await discovery; some have been uncovered in modern restorations, such as that at South Throwleigh in Devon, found in 1938. In Lincolnshire, royal commissioners took inventory of churches in 1565 and 1566. Of the sepulchre, churchwardens reported a variety of fates: "cutt and putto other vses," "broken in peces and defaced and burnte," "Taken from the Church by the vicar and remayneth in his house," "broken in peces and geven to the pore," "burnte in melting lead for to mend our churche," "whearof wee made a bear [bier] to carrie the dead corps and other thinges," "sold . . . to william Storre and Robert Cappe who have made a

159

henne penne of it." At the end of each inventory the churchwardens signed a statement indicating that no items used in Catholic ritual remained in the church.

As D. M. Palliser observes, "The Reformation provides perhaps the earliest instance in English history of conflicts over beliefs and attitudes in which ordinary people not only took sides in large numbers but also left those choices on record for posterity."[13] Of course the final choices were those that became the teachings of the Church of England. Prominent among these was the rejection of the doctrine of transubstantiation and, with it, imaginative devotion focused on the body of Christ. A new sensibility won the day, one that rejected the spiritual efficacy of mimetic ritual.[14]

Oddly enough, focus on the doctrine of transubstantiation, attacked by Continental Protestants as well as by the Church of England, led to changes in the Easter Rites in the Roman Catholic Church as well. Neil C. Brooks quotes the explanation offered by the Congregation of Sacred Rites, stating that the Sacrament had indeed been enclosed in the sepulchre until the time of the Reformation, when heretics allegedly preached against the real presence in the Eucharist, but now, to oppose the Lutherans and to confirm the real presence, the Sacrament is instead exposed, placed above the Sepulchre in a ciborium or monstrance.[15] This "Exposition Rite" in effect replaced the *Depositio* and *Elevatio*, and there was no longer to be a *Visitatio sepulchri*, for the Council of Trent suppressed it.

Tracing the fate of the Easter Sepulchre during the course of the Reformation has provided a case

study concerning the impact of the Reformation on the religious sensibility of the English people. Yet it is important to remember that in England there were "years of uncertainty" lasting until quite late in the sixteenth century. In 1565 Bishop Bentham's Injunctions for Coventry and Lichfield Diocese mentioned the Easter Sepulchre and suggested that there were churches still using it: "and that you do abolish and put away clean out of your church all monuments of idolatry and superstition, as . . . sepulchres which were used on Good Friday." After so many changes of religion, why could it not change once more, or, as the Provost of King's College, Cambridge, put it in 1565, "That which hath been may be again." It did not happen, but the hope faded slowly and many an Englishman must have yearned for the time in which a man could write in his will as John Garyngton of Mundon, Essex, wrote in 1517: "I geve and bequeth to the churche of Mundon xxx ewes of iij yeres of age for ij Tapurs brennyng yerely afore the sepulchre at the fest of Easter as long as the worlde doth stonde."

Notes

[1] My book, *The Easter Sepulchre in England*, Early Drama, Art, and Music, Reference Ser., 5 (Kalamazoo: Medieval Institute Publications, 1987), is a comprehensive study of the Easter Sepulchre and its rites. Unless otherwise noted, quotations from records and texts of the rites are drawn from the catalogue included in this book.

[2] Ibid., figs. 27, 43.

[3] Richard Kieckhefer, *Unquiet Souls: Fourteenth-Century Saints and Their Religious Milieu* (Chicago: Univ. of Chicago Press, 1984), p. 116.

[4] For a general discussion of the dissolution and a useful selection of primary documents, see Joyce Youings, *The Dissolution of the*

Monasteries (London: George Allen and Unwin, 1971).

[5]Illustrated in Francis Bond, *The Chancel of English Churches* (London: Oxford Univ. Press, 1916), p. 225.

[6]John Hooper, *A Declaration of Christe and of his offyce* (Zurich, 1547), sig. Ei[v].

[7]Charles Wriothesley, *A Chronicle of England during the Reigns of the Tudors*, II, ed. William Douglas Hamilton, Camden Soc., n.s. 20 (1877), p. 1.

[8]See also the commentary in C[lifford] D[avidson], "Medieval Puppet Drama at Witney, Oxfordshire, and Pentecost Ceremony at St. Paul's, London," *EDAM Newsletter*, 9, No. 1 (1986), 15-16.

[9]*The Travels of Leo of Rozmital*, ed. Malcolm Letts, Hakluyt Soc., 2nd ser., 108 (Cambridge: Cambridge Univ. Press, 1957), 57, 61. I am grateful to Nicholas Rogers for this reference; see also his brief article "Mechanical Images at Salisbury," *EDAM Newsletter*, 11, No. 1 (1988), in press at the time of this writing.

[10]A. G. Dickens, "Robert Parkyn's Narrative of the Reformation," *English Historical Review*, 62 (1947), 67. I am grateful to Ann Eljenholm Nichols for calling my attention to this article.

[11]Claire Cross, *Church and People, 1450-1660: The Triumph of the Laity in the English Church* (Atlantic Highlands, N.J.: Humanities Press, 1976), p. 101. Some resistance was to be expected, of course. John Foxe reports that in 1554 on Easter day, "in the morning, at St. Pancras in cheap, the crucifix with the pix were taken out of the sepulchre, before the priest rose to the resurrection: so that when, after his accustomed manner, he put his hand into the sepulchre, and said very devoutly, 'surrexit; non est hic,'--he found his words true, for he was not there indeed" (*The Acts and Monuments* [rpt. New York: AMS Press, 1965], VI, 548).

[12]A. G. Dickens, *The English Reformation*, rev. ed. (London: Fontana, 1967), p. 401.

[13]D. M. Palliser, "Popular Reactions to the Reformation during the Years of Uncertainty 1530-1570," in *Church and Society in England: Henry VIII to James I*, ed. Felicity Heal and Rosemary O'Day (Hamden, Conn.: Archon, 1977), p. 35.

[14]See D[avidson], "Medieval Puppet Drama at Witney," pp. 15-16, but see also "The Anti-Visual Prejudice and the Holy Week Ceremonies on Good Friday and Easter," *EDAM Newsletter*, 9, No. 2 (1987), 6-8, which reviews the comments of Thomas Kirchmeyer (as translated by Barnabe Googe under the title *The Popish Kingdome*, issued in 1570) on

the Holy Week and Easter ceremonies, herein dismissed as idolatrous.

[15]"Usque ad saeculum decimum quintum SS. Sacramentum in Sepulchro inclusum fidelium adorationi expositum est. Cum autem tempore reformationis haeretici contra realem et essentialem praesentiam Christi in SS. Eucharistia absconditi vehementer prae- dicarent, eamque exprobrarent et omnino negarent, ac diem Parasceves pro sua confessione festum solemnissimum totius anni elevarent, factum est, ut, ad fideles in confessione verae fidei in Christum in SS. Sacramento vere, realiter et substantialiter praesentem conservandos et confirmandos et ad opponendam luthericae solemnitati die Para- sceves aliam catholicam festivitatem, SS. Sacramentum in Sepulchro non amplius includeretur, sed super Sepulchrum sive in calice sive in ostentorio velato Feria VI in Parasceve adorationi palam exponeretur" (quoted by Neil C. Brooks, *The Sepulchre of Christ in Art and Liturgy*, Univ. of Illinois Studies in Art and Literature, 7, No. 2 [Urbana, 1921], p. 45). See also Neil C. Brooks, "The Sepulchrum Christi and Its Ceremonies in Late Medieval and Modern Times," *PMLA*, 27 (1928), 147-61.

163

Broken Up or Restored Away: Iconoclasm in a Suffolk Parish

Ann Eljenholm Nichols

By East Anglian standards Cratfield is a relatively plain church.[1] In 1895 J. J. Raven described the parish as "about as unknown a place as one could well find,"[2] a description that is equally appropriate today. In the census of 1891 it had a population of 467, which has declined since then.[3] Yet hidden away as it is, the church is well worth finding. Today it largely reflects major changes made at the end of the nineteenth century, a period that prided itself on its neo-Gothic appreciation.[4] But it also preserves traces of other ages as well, as if each century of parishioners felt the need to imprint its peculiar religious sensibility on the fabric of the church. The 1724 memorial to Sarah Minne is a typical example of eighteenth-century funerary sculpture, a splendid example of adaptive reuse since it incorporates the north aisle aumbry into its design (fig. 29). The twenty pews with volute benchends are characteristic of the carefully proportioned woodwork of the seventeenth century. And no monument in the church speaks more clearly of the religious temper of the past than Cratfield's badly damaged baptismal

font, a visual homily on the violence of Reformation iconoclasm (figs. 30-32).

In addition to its own sermon in stone, Cratfield church also boasts unusually complete records, the churchwardens' accounts beginning in 1490.[5] The fullness of the early records makes the parish particularly important for the study of the reformation of parish life. The records indicate that Cratfield was radicalized early, wholeheartedly supported Edwardian reforms, and consistently strained at the leash of Elizabethan moderation. Furthermore, since Cratfield is a small country parish, it is a useful microcosm of Reformation history in rural East Anglia and more representative of the region as a whole than are better known churches in Norwich or Ipswich.[6]

Later records from the nineteenth century provide evidence for a different sort of "iconoclasm"--not the breaking of images, but rather the destruction that results from misguided renovation. The results were particularly harmful in the Cratfield chancel, as indeed they were generally in other churches as well. Ironically, the motivation for the changes wrought in the nineteenth century was, in part, identical with that in the sixteenth--liturgical reform. The end result was also identical: whether broken up or restored away, the work of the past was destroyed. Only the records enable us to reconstruct, however imperfectly, what was lost.

There are, to be sure, major difficulties in interpreting the early records. Sometimes the records are difficult to date. Thus, while those from 1490-1509 are stitched together, other accounts are on loose sheets, and these are not always dated. More diffi-

cult are problems stemming from the recording habits of churchwardens. Some worked in a meticulously detailed way, while others favored classifying items in maddeningly broad categories. Sometimes half a century will go by with never a penny entered for any type of cleaning material or labor; a new warden assumes his duties, and the cleaners use a brush a year. It is also clear that some churchwardens did not keep records in any very regular way. For example, the purchase of "olde Testamenys" occurs both in the year 1549 and in 1550, the first entry being crossed out. The churchwarden was apparently making out records for two years in 1550. Then there are the omissions and anomalies: an altar that was never removed is replaced; a rood never taken down, remounted. How are these contradictions to be resolved? Did reforming zeal account for the omission--the men who removed the offending furniture scorning pay? If so, the Edwardian zeal was short-lived, for the parish had to pay for the removal of the Marian altar. Finally there is the problem of handwriting. Sometimes the hand of a churchwarden deteriorates year by year until it is largely illegible. The fallible nature of the recorders reminds historians of their own fallibility

The earliest churchreeves' accounts make it possible to appreciate the artistic losses occasioned by the wave of iconoclasm that swept the church clear of its medieval furnishings. The 1490's were a busy decade at Cratfield. A local painter named Bollre was at work throughout the decade. He first appears in the records for 1491 when he submitted a bill for partial payment "pro pictacione imaginis,"[7] and in 1493 he was at work on the north aisle statue

of Mary. He was paid £2 13s 4d for painting "the image of owr lady" and £7 the next year for the tabernacle for the image.[8] At such a cost the tabernacle must have been particularly splendid but hardly inappropriate for a church dedicated to St. Mary.[9] By comparison, St. Edmund, whose chantry chapel was the oldest section of the church building, was not so liberally treated; in 1493 Bollre was paid only eight shillings for painting his tabernacle. However, five years later St. Edmund's shrine was renewed, Bollre submitting a bill for £8 6s 8d for "peyntyng of the image of Saynt Edmunde and the tabernacle." Other significant outlays for church furnishings include "horgans" in 1497 and gilding of the organ case two years later. Because of the fullness of the early accounts, we can assume that the lovely seven-sacrament font had been carved and erected before 1490. Given the extensive and costly work in the opening years of the 90's, it is tempting to hypothesize the magnificent gift of the font in the 80's, such a donation spurring the parish to renew and honor its other images.[10]

A 1528 inventory suggests the abundance of church goods--in addition to the usual censers, boats, chrismatories, and crosses, there were seven chasubles in a variety of colors and fabrics, over twenty linen altar cloths, not including stained cloths for the side altar, a banner of the martyrdom of St. Stephen, four elaborate hoods (apparently for the statue of Mary), and more than twenty service books, most written on vellum and bound in cloth. The 1555 inventory catalogued the losses. Only three altar cloths remained, two chasubles, and one cope; over half of the service books had disappeared. Where

there had been six corporal cases with corporals, only one remained with two cloths. Gone were the six stained frontals for the side altar, and no mention is made of the "box imbroyderyd of sylke and a corporas to bere in the holy sacrament to pepil lying syke."[1]

When did the devotional life of Cratfield church cease to be supported and stimulated by the sensory appeal of images and shift to a Reformed reliance on preaching? It is generally agreed that areas in East Anglia were among those reformed earliest,[12] and a number of iconoclastic incidents occurred in the early 1530's. Persecution of heresy under Henry VIII revealed a number of "new sect" men there, while Bishop Nykke in his often quoted letter of 1530 complained that merchants were importing heresy. Furthermore, a number of early iconoclastic incidents either occurred in Suffolk or were instigated by men who lived there. Eye, where a plot was hatched in 1532 against the great rood, is only about twelve miles west of Cratfield.[13]

There is no explicit evidence of iconoclasm in the early Cratfield records, but anomalies in a number of entries need to be considered. Item by item, the facts preserved are only suggestive; nevertheless, taken together they provide substantive evidence that Cratfield was a Reformed parish and that its reformation was early. The first isolated piece of evidence involves the sale of church goods. Symond Smyth and John Bateman certified in 1547 that three years earlier "Mr. June sold with the consent of town . . . a payre of Chalys a peyre of censers and a cross" for £20, of which £12 went for repair of the steeple; another £5 were used for leading the church

roof, the rest "remayg in the cherche box." Did the 1544 sale represent the dealings of practical men with too little money to meet parish expense, or did a reformist element already exist in the parish? John Charles Cox, in his study of churchwardens' accounts, comments that it was unusual for church plate to be sold before the Edwardian period.[14]

What about the images in Cratfield church? There is documentary evidence that three saints were honored: Stephen, represented only by a painted banner, Our Lady, and St. Edmund. (There was also a confraternity of St. John, but almost no information about it.) Evidence from the records suggests that the shrines to the two saints were situated in the north and south aisles respectively, and by the 1530's the Guyld of Saint Thomas the Martyr was using the former chapel of St. Edmund (now the vestry) for its chapel. Although there are no records of a statue of St. Thomas, it would be unusual for a guild as powerful as that at Cratfield not to have its own image or at least a stained cloth or banner. Since images were the litmus test for a Reformed congregation, it is essential to determine the parish attitude to their images. Unfortunately, the churchwardens left no record of when they removed the painted, gilded images. Indeed, no such record exists in any of the published churchwardens' records. Yet we know that by 1549 no parish investigated in the archdeaconry of Norwich admitted retaining any image.[15] Thus it is safe to assume that the Cratfield images had disappeared before then. Careful reading of the records provides some evidence for just when the removal may have occurred.

First, it is reasonable to assume official action

against two of the saints must have undercut their credibility at Cratfield. Both St. Edmund and St. Thomas had already been officially targeted in the early drive against relics. In 1535 John Ap Rice wrote to Cromwell that among the relics found at the shrine of St. Edmund at Bury were what were reputed to be nail parings from the East Anglian saint. In 1536 the shrine was defaced.[16] St. Thomas Becket was officially pronounced "a rebel and traitor to his prince" in a royal proclamation of 16 November 1538. The text of the proclamation is at pains to show that Thomas's death was "untruly called martyrdom," but rather occurred in a "fray" exacerbated by the violence of Thomas himself. The proclamation that stripped Becket of his martyr's crown also left the parish Guyld of Saint Thomas the Martyr without a patron. The proclamation also ordered that Becket's "images and pictures through the whole realm shall be put down and avoided out of all churches."[17] According to one estimate, only one-sixteenth of the medieval paintings of Becket have survived.[18] At North Walsham even the name Thomas in the title "fraternitatis sancti Thomae martyris" was savagely cut away from the screen given by the guild. Guild records for Cratfield are not complete, but it may be suggestive that in 1542 the guild chapel was being used as a storehouse for lead sheeting. Furthermore, 1541 seems to be the last year in which Guild chaplain John Smith was paid his salary.[19] Although guilds were not dissolved until 1546, it is tempting to hypothesize that a dissolution of the contract with Smith reflected a reformulation of guild function.

Second, the destruction of East Anglian shrines

in response to the 1538 Injunctions provided an official model for the removal of abused images.[20] These injunctions were primarily enforced against pilgrimage shrines targeted for destruction in Cromwell's attack on relics. Thacker confiscated the once-famous rood of Bromholm, and two important East Anglian shrines were among those stripped of their decked Marian images.[21] Removed to London, the statues of Our Lady of Walsingham and of Ipswich were burned in Chelsea in 1538. It was also possible, however, for parish images to be abused. Indeed one commissary in Kent so interpreted the Injunction.[22] Although there is no evidence that the Cratfield images had been "abused wih pilgrimages," there certainly had been "offerings . . . made thereunto."[23] Elsewhere clothing for images was cited as evidence of idolatry. For example, at Reading the commissioners cite three coats for the image of an angel, at Caversham "cotes of thys image, her cappe and here," and at an unidentified site "a coote of idolytrie with three frontlettes,"[24] frontlets being the facings that depended from headdresses. Perhaps the four hoods listed in the 1528 inventory condemned the statue of Our Lady at Cratfield as an abused image.

Images painted in glass frequently met the same fate as painted wooden images. In 1541 a glazier in Cambridge was paid to take off the bishop of Rome's head in the windows at St. Mary the Great. Is there any evidence for similar work at Cratfield? Two entries that at first seem innocuous provide a clue. The first entry involves payment of two shillings and eight pence to a Nicholas Goodale to mend "the glase wyndows abowght the churche & the clarystorye."

He was also reimbursed for three pounds of solder and a bushel of lime "he spent abowght them."[25] It was, of course, not unusual for a glazier to be working on windows, and three pounds of solder does not suggest major work. In contrast, a bushel of lyme would have been rather too much "cementing" mixture for repair of windows that required only three pounds of solder. Might Goodale have been whitewashing offending images in glass, perhaps of St. Thomas? We know that at St. Thomas of Acon in London "all the glaswindowes . . . that was of his story" were removed.[26] We know that elsewhere offending painted windows were whitewashed.[27] Such an interpretation would help to account for the relatively late removal of the imaged glass at Cratfield, for it was only in 1596 that a glazier from Laxfield "came and toke down the glas."[28] The date of Goodale's work is also suggestive, for in 1541 further official action was taken to enforce the 1538 Injunctions on images. The primary focus was on the non-conforming cathedrals--for example, Lincoln where images were removed. But Bishop Goodrich in the neighboring diocese of Ely directed attention specifically to parishes, targeting all ornaments and abominable monuments.[29]

A further seemingly innocuous entry in the Cratfield accounts for 1540-41 records the purchase of 100 pavement tiles, suggesting major work done on the church floor. Shrine altars had been removed elsewhere--for example, at Reading and Winchester.[30] If the statues at Cratfield, their tabernacles, and altars were removed with the violent efficiency suggested by those who complained of the "cumbrous" difficulties of defacing shrines, the floor at

Cratfield may well have needed filling and paving. Thus, the evidence from the 1530's and early 1540's, while not definitive, at least suggests that images were removed from Cratfield parish before the 1547 Injunctions required their removal and destruction.[31] If so, Cratfield had been swept clear at an early date of its visual ties to medieval devotion. One other piece of positive evidence suggests an orientation away from images. The records for 1540/41 include six shillings and twopence paid to the vicar for "two bybils," presumably the old and new testaments.[32]

The 1547 records permit us to do more than speculate about the temper of the parish. They indicate wholeheartedly prompt response to the changes required by the Injunctions of that year. A chalice was remade into a communion cup, and scriptural texts were lettered on the walls.[33] Not since the days of Bollre were the accounts so filled with details of stainers' bills: sixteen pence for boarding the stainers (no local man this time), twenty-one shillings for workmanship, two for a quart of gold, nineteen pence for gum, rosin, and bistre. Records from the Marian years indicate other Edwardian changes. A stainer, paid only two shillings "for makyng of the Roode," apparently was repainting the rood that had been removed but not destroyed. We also learn that the chrismatory had disappeared, as had the pulley for the sacrament and the Lenten veil.

Cratfield's commitment to reform is further suggested by its tardiness to implement Marian injunctions, though interpretation is hampered by the relative carelessness in dating records. An undated loose sheet contains payments for the

stainer making the rood and for fetching the altar "from the vycaryage bearne."[34] Another undated loose sheet records payments for candlesticks as well as for a pyx and "a Cloth to hang over yt." But dated sheets record that the chrismatory was not replaced until June 1556, and only in 1557 was a man paid sixpence "for help to have up the roode," probably in response to Pole's articles of visitation.[35] Perhaps this was done at Lent since a Lenten veil was also procured that year. In contrast, the 1559 records show an alacrity to continue the unfinished business of the Edwardian reform. A new communion book was purchased, and the altar was pulled down at the cost of four shillings twopence to be replaced by a new communion table costing six shillings eight pence.

Taken individually, the items from the records are not conclusive, but cumulatively they create the outline of a reformed parish. If the statues of Our Lady, Edmund, and Thomas remained until 1547, they were certainly destroyed or made away with at that time. There is no reference to their being replaced under Mary; they simply disappear from the records. If there was an outbreak of image-destruction when they were removed from the church, it is also possible that the images on the seven-sacrament font were destroyed at that time.[36] The Cratfield font (figs. 30-32), called by Cautley "the finest" of all the seven-sacrament fonts,[37] must have been particularly offensive, for it was indeed well adorned with offending images. In addition to those on the font panels, angels decorated the chamfer, and saints stood in crocketed tabernacles between the bowl panels and around the pedestal.

Bedell, who studied these figures early in this century, identified SS. Edmund, Peter, Paul, John, James, and Catherine.[38] These statues were all defaced and some disfigured as well, only the saints' symbols making them recognizable. Whoever defaced this font wholeheartedly agreed with Becon that images "do not adore, but deform; . . . not deck, but infect."[39]

In addition, two panels on the font bowl were totally destroyed (fig. 32). Not surprisingly, these panels represented the two sacraments most assailed by the Reformers, the Eucharist and Penance. The Eucharist panel would have depicted the elevation, the typical iconography for the East Anglian seven-sacrament fonts, and it was precisely the elevation that most exercised the reformers. The first *Book of Common Prayer* had forbidden the elevation, and episcopal injunctions regularly inquired about it and other popish practices.[40] Thus Hooper set out the following article in his 1551 visitation book: "Item, that none of you do counterfeit the popish mass, . . . shewing the sacrament openly . . . or making any elevation thereof, ringing of the sacring-bell, or setting any light upon the Lord's board."[41] Yet the font panel would have represented these very customs, vestments, candles, altar, kneeling acolytes, and perhaps a bell rope as well. Equally abhorrent to radicals was auricular confession.[42] As early as the 1536 Convocation, the lower house had paid special attention to a rite referred to as neither necessary nor beneficial. Auricular confession was described as "only a Practice to unlock a Man's Breast, and rob him of his Thoughts and Money."[43] Yet the Penance panel would have shown a penitent

kneeling before the priest to whom he unlocked his breast.

At least one man in the neighboring parish held radically anti-sacramental views. John Noyes was martyred under Queen Mary for just such a position. One of the articles which Noyes refused to accept concerned the real presence. He maintained at the stake: "They say they can make God of a piece of bread, believe them not."[44] Noyes was burned in 1557 in the adjoining market town of Laxfield--a burning that must have forged the anti-sacramental temper of many a neighbor.

It is impossible to know who was the moving spirit behind the changes made in any parish church, the vicar or strong-minded members of laity. Certainly in East Anglia, Reformed lay people played key roles in the reformation of parish religion.[45] Unfortunately, the records preserve little information about the vicars in the 40's and 50's. Robert Thyrketyll, vicar in 1533-48, was the last appointed by St. Neot's Priory. Since one of his relatives boarded the stainers in 1547, we can surmise the commitment to reform was shared by the vicar and some of his parish. It would be useful to know more of the religious persuasion of Mr. John Lany who nominated the later vicars. He was a lawyer at Ipswich, a town known for its reformist character since the early days when Bilney attacked images there in a dispute with Friar John Brusierd--a reputation which continued until its heyday as center of Protestant publications.[46]

In the Elizabethan period, however, details surface in the records that suggest something about the character of the Cratfield vicars. It is suggestive

that significant changes occur soon after the installation of new vicars. In 1561, for example, Syr Thomas Plumpton was instituted, the rood loft was removed, and his maid was paid "for maken clene the churche." In 1562, a commandment table was made, and in the next year the revised *Book of Homilies* was purchased. It is, however, during the long tenure of the next vicar (1566-1602) that evidence surfaces for action that cannot be interpreted simply as Elizabethan zeal for comeliness or obedience to rules issuing from the central government. In 1569 an event occurred that could not have taken place without the concurrence of Vicar Francis Eland. In that year John Godbold and an associate were paid eight pence "for takyng downe of the fonte" (fig. 33).[47] Such action was contrary to action taken by the Ecclesiastical Commission in 1561. The language of the orders taken on October 10 indicates that such novelty was widespread enough to require opposition: "Item, that the font be not removed from the accustomed place, and that in parish churches the curates take not upon them to confer baptism in basins, but in the font customably used."[48]

Perhaps the "takyng down" of the font was in response to the "Homilie agaynst perill of Idolatry and Superfluous deckyng of Churches." It is also possible that the font figures were destroyed at this time, though it seems more likely that the violence evidenced by the thorough defacement of the font would have occurred at the same time the other medieval images were removed from the church.

There is further evidence for a radicalized parish during the tenure of Francis Eland. Predictably, the organ and organ case were removed. More signifi-

177

cant, in 1582 the churchwardens were required "accordyng unto the commandement of the Commissary" to purchase eight yards of new Holland for a surplice. There can be no doubt that the surplice had been discarded. Apparently East Anglia was notorious for its nonuniformity in regard to the surplice. Accordingly, Parker set out to make an example of the Norwich diocese. As early as 1561 Cecil had complained of the laxness of Bishop Parkhurst, and Parker in his 1567 visitation of the diocese charged commissaries to enforce uniformity of dress.[49] In a letter Parkhurst complained of the vestment controversy: "O that at length these bickerings and quarrels may be laid to rest and buried."[50] Other evidence suggests that by the 80's Suffolkmen had a reputation for radical attitudes to vestments. When an Essex vicar was charged in 1589 for not wearing his surplice, he blamed the Suffolk people who had come with their minister who was to preach, whom he feared "would have liked hym the worse yf he had worne it."[51]

A further instance of the radicalization at Cratfield surfaces in 1586 when the records include payment for loaf bread in a context that indicates use for communion. Bishop Parkhurst's earlier correspondence with Parker had revealed his frustration over the issue of bread. In a 1574 letter to the Archbishop of Canterbury, he complained, "what contention and harteburning is kindled in many places, and what ernest disputacions are mayteyned abrode for brede. . . ."[52] In his reply later that month Parker said, "I trust that you meane not vniversallie in your dioces to commaund or winke at the lofe bread, but for peace and quietnes heare and theare

to be contented therwith."[53] It seems that Cratfield was one place in the Norwich diocese where the bishops continued to wink at loaf bread.

The records also make clear the central place that the Word of God had assumed in Cratfield. In 1583 the walls of the church were whitewashed and scriptural texts set up; in 1590 the purchase and installation of an hour glass reflects the importance of the sermon, preached not only by the vicar but also by visiting preachers. In 1599 two shillings were paid "for the skoote that preched hear," a indication of the sort of preaching preferred by Francis Eland. When Gabriel Eland succeeded his father in 1602, one detects the preaching zeal of Francis' son. The pulpit is repaired, and new binding is provided for the Bible. The official homilies had long since disappeared in favor of preaching, and in 1606 a fine was paid to the court at Blythborough "for want of no Homily Book in our Town." That same year a payment to a visiting preacher is recorded, such outlays continuing throughout Gabriel Eland's tenure. In 1642, for example, £20 was the annual fee paid to a Mr. Crosby. Eland thus may be added to the number of Suffolk ministers committed to the godly ministry of the Word, those men who attempted to model their parishes on that of John More in Norwich. The regular entries for bread and beer for visiting preachers suggests the atmosphere of the combination lecture. Although this clerical exercise is usually connected with market towns, one wonders if it did not have its roots at the parish level where vicar and preacher shared a meal and godly conversation.[54]

Gabriel Eland's commitment to Reformed preach-

ing is further indicated by costs recorded during his tenure. In 1617 a new pulpit cost £10, and in 1638 a faculty was granted to move the reading desk and pulpit; the accounts indicate that they were joined together. In 1633 desks were made for three books in the church, perhaps the three volumes of the *Book of Martyrs* purchased that year for £2 19s. Gabriel was also constant in directing works of charity; it is not surprising that in his first year of tenure, he collected relief for Geneva.[55] Arrangements in the chancel similarly reflect the temper of the congregation during these years. Cox has shown that most English churches had altar rails by the late Elizabethan period and that their acquisition after the Laudian visitation of 1633 suggests a puritanical parish.[56] Cratfield again meets the description: the 1636 injunctions from the bishop of Norwich called for rails, and that same year the parish paid for "fetching the rails" from neighboring Laxfield and setting them in place.

The Commonwealth period is commonly blamed for widespread iconoclasm in East Anglia. In Suffolk church notes, Oliver Cromwell and his commissaries are ubiquitously blamed for the destruction of church furnishings and art. At Cratfield, for example, the current church leaflet, like Bedell earlier in this century, blames "Mr. Dowsing and his Cromwellian friends" for the destruction of the baptismal font. Whatever Dowsing's destruction in Suffolk, he certainly cannot be blamed for the damage to the font. First, it is not at all certain that Dowsing visited Cratfield. Dowsing's editor tentatively suggested that the "Kayfield" listed in the parliamentary visitor's diary referred to Bedfield.[57] A study of

the geography of the area indicates that he was almost certainly correct. On 3 April, Dowsing visited "Kayfield," Beddingfield, Tannington, and Brundish, the latter three churches clustered not in the immediate vicinity of Cratfield but to the south and west. Bedfield, on the other hand, lies directly between Beddingfield and Tannington. Further study of Dowsing's intinerary indicates that he was circling north and east until he doubled back to Heveningham on 9 April. Second, the notation in the journal is so vague that it is impossible to know what was destroyed at Kayfield: "A Deputy broke down divers, which I have done."[58] (Another manuscript reads: "and I have done the rest.") Given Dowsing's "evident desire . . . to relate his doings very fully," his editor finds it significant that he does not explicitly claim to have destroyed baptismal fonts in this area.[59] Perhaps, as at Cratfield, the damage had already been done.

By the early nineteenth century, little remained of the zeal of the Reformation parishioners, for Suckling commented sadly that the noble architectural features of the church could only be glimpsed "through the dirt and neglect which miserably contrasts its present condition with its ancient splendor."[60] Apparently an episcopal injunction was needed to prompt the restoration of Cratfield church. In his initial specification of essential repairs in 1875, R. M. Phipson of Norwich noted that he had done his work at the order of the Lord Bishop of Norwich.[61] He then estimated costs at £121. During the next three years there was a groundswell for restoration. Printed appeals

launched a drive for a project that by 1879 was estimated by Phipson at £1200 (not including the chancel). Financing was complicated by the fact that the great tithes still belonged to a lay impropriator.

The large packet of estimates, receipts, and bills attendant on this project includes a number of 3x5 printed collecting books. The cover reads: "Collecting Card for RESTORATION of Cratfield Parish Church." Inside are the signatures of the small donors, with sums posted after their names. The packet also contains a number of rough drafts of appeals to the mighty and wealthy, presumably written by the vicar since they invariably begin: "I am hoping to restore my church. . . ." The official printed appeal cites the need to remove both the nave and south aisle roofs, with complete replacement of the latter. Complaints that the wind and rain were coming in seem not to have been exaggerated. In May 1879 articles of agreement were signed by George Grimwood, builder. The work was completed with dispatch, for the church was reopened for worship in November.

The major work done in 1879 was not renovation for the sake of taste; instead it was restoration essential to preserve the basic fabric of the church. Phipson's specifications are a model for historic preservationists. He noted, for example, that when reframing the nave roof all defective principals were to be replaced in oak to match the existing ceiling, that the original bosses were to be refixed and new ones made where necessary. Grimwood's work is equally to be praised. He cleaned and restored the stone moldings and doorway to the rood stairway. When the new floor of red tiles was laid to replace the uneven brick one, it was done in such a way as to

preserve an existing seventeenth-century tile below the chancel arch.

Other changes affected the furnishings of the church. Grimwood made a new pulpit and prayer desk from the old pulpit panels, oiling instead of painting the finished work. The construction involved making "one entire new Wainscot panel to match," and the new work is proudly dated. It was at this time that the roodscreen was removed from the chancel arch to its present position at the west end (fig. 34). The screen, decorated with tracery instead of with images, had at some time been painted an ochre-brown, as had some of the poppyhead pews; two bench ends remain in the northwest corner.[62] This happened sometime after the new pulpit was made in 1617, since the nineteenth-century builder who used the old pulpit to make a new one included in his bill costs for "cleaning off old paint from Panels."

The same careful records preserve the history of the original pews.[63] New benches were made for the nave, but fortunately the seventeenth-century pews were preserved: Grimwood reconstructed and refixed the seventeenth-century volute benchends in the north and south aisles.[64] One item in Grimwood's account tells us something about the fate of the original poppyhead pews. He refers to "labor and nails to making" up benches "out of old stuff." Whether this indicates the bench behind the reading desk or also includes the two rough benches in the west corner of the north aisle, the "old stuff" certainly referred to the original poppyhead benchends. These ends provide a further clue to the history of the church furnishings. Those on the

bench behind the reading desk were never painted, while those in the northwest corner were, their paint matching that on the roodscreen. The latter must, therefore, still have been in use in the nave when the screen was painted, while the unpainted benchends must have been relegated to a lumber room before the woodwork was painted. Fortunately, Grimwood did not strip the painted benchends, and thus it is possible to reconstruct their relationship to the rood screen.[65]

The most radical Victorian changes took place not in the nave but in the chancel. In Suckling's day, one could still see where the old altar had been, and an unclosed aumbry still existed with chains attached to wooden shelves--chains by which, Suckling assumed, the Bible had been once fastened. During the chancel restoration the floor was raised and the aumbry walled up. In 1889 the Victorian reredos was erected in memory of Emma Cautley by her son, who had formerly been a vicar of the parish. In 1925 the large Victorian window above the altar was erected as a thank offering for recovery from a serious illness.

Whatever changes the Victorians made at Cratfield, they are certainly minor when compared to the travesties committed elsewhere in the nineteenth century--e.g., tiling the lower walls with maroon and green encaustic tiles at North Tuddenham, repainting faces on roodscreens, destroying a remaining gilded rood beam. One cannot help but be bemused at the satisfaction of the Worstead curate, who wrote in 1838: "the two figures . . . on the panels had been defaced. . . . I then painted with my own hand, the Saviour and St. Paul to complete the series. What

figures had been there I cannot tell; what I supplied is by conjecture. W. T. S. Curate."[66] When the wheel of taste revolves, the zeal for renovation can prove equally as destructive as the religious zeal of the Reformation iconoclasts.

Still, the nineteenth-century renovators did preserve as well as destroy. For example, the rector responsible for the tiling at North Tuddenham can be credited with saving valuable medieval glass from a builder's yard in East Dereham.[67] It is also necessary to remember that periodization puts blinders on us all. The medievalist looks at changes in a rather different light than does the eighteenth-century or Victorian scholar. Thus the student of eighteenth-century church monuments will be charmed by the incorporation of an aumbry into a memorial tablet and mourn the loss of an eighteenth-century altarpiece as much as the medievalist regrets the loss of St. Mary's tabernacle at Cratfield.[68] On the other hand, we know what the Victorians thought about eighteenth-century cherubs and urns. One Norfolk writer complained in 1863: "How for instance, were . . . weeping cupids, urns, and the various forms of pagan sculpture pressed into the service of the Christian mourner?"[69]

Similarly, students interpreting the Victorian interpretation of the Middle Ages will be delighted by the 1889 reredos at Cratfield; the medievalist merely shakes a head in wonder at misinterpretation. Whatever our prejudices, however, we can all respect the artistic integrity of the architect and builder who worked on Cratfield church in 1879. These Victorians were restorers rather than renovators. Both kept admirable records of their work, and

the contemporary churchwardens were equally
meticulous in preserving an incredible amount of
paper connected with the project. As a result, we
have not only facts, but enough of them to enable us
to reconstruct the changes of the past. In contrast,
the early churchreeves of Cratfield church provide
only a tantalizing view through the dark mesh of
their spidery handwriting of the most radical change
of all, the reformation of the devotional life of a
parish.

Notes

[1]I have taken the phrase "broken up or restored away" in my title
from a chapter on stained glass in Edward S. Prior and Arthur Gardner,
Account of Medieval Figure Sculpture (Cambridge: Cambridge Univ.
Press, 1912), p. 137.

[2]William Holland, *Cratfield: A Transcript of the Accounts of the
Parish from A.D. 1490 to A.D. 1642 with Notes*, ed. John James Raven
(London: Jarrold and Sons, n.d.), p. 9; hereafter cited as *Cratfield
Parish Papers*.

[3]Cratfield, like so many small parishes, has been amalgamated
with neighboring ones, with Heveningham and Ubbeston (the church has
been sold and is a private residence) and with Huntingfield and Cookley.
Such "pluralities" were traditional; for example, three sixteenth-century
vicars were instituted at both Cratfield and Ubbeston, John Page
(1556/57-1561/62), Thomas Plumpton (1561/62-1563-66), and Francis
Eland (1566-1602) (F. Freeman Bullen, "Catalogue of Beneficed Clergy
of Suffolk, 1551-1631," *Proceedings of the Suffolk Archaeological Institute*,
22 [1934-36], pp. 294-320). Holland, who transcribed the Cratfield
records, was himself the rector of Huntingfield-cum-Cookley from 1848
to 1891, and so witnessed the renovation of the neighboring church at
Cratfield. When he died, his work on the Cratfield records was edited
by his friend John Raven, Vicar of Fressingfield.

[4]Renewed interest in the Victorian interpretation of the Middle
Ages is suggested by recent expositions of Victorian stained glass and
the sessions on medievalism in nineteenth-century literature at the
International Congress on Medieval Studies in 1987. Because many of
the nineteenth-century vicars of East Anglian churches had been
influenced by the Anglo-Catholic movement, their renovations preserve

an admirable record of nineteenth-century liturgical understanding. A good example is the renovation at Aylsham (1839-67) made under the direction of Edmund Yates, who had been at Oriel College, Oxford. Much work remains to be done on the Victorian renovations of East Anglian churches.

[5]Some of the records are conveniently available in Holland's collection. However, the text, while convenient, must be used with caution since not all the records are exact transcriptions of the original records. Raven preferred not to use Holland's modern English transcriptions but the original spelling because of its "piquancy and quaintness" (*Cratfield Parish Papers*, p. 9) except where he could not locate the originals. In addition, only the records for 1490-1502 are complete in Holland's collection. Thus, the student must return to the original documents at the Suffolk Record Office in Ipswich (FC 62, series A-E), to whose archive staff I am particularly grateful for prompt and gracious help. In this paper I have provided page references to Holland only when the citations are difficult to locate; otherwise, the annual notation makes footnoting unnecessary.

[6]In the last decade there has appeared considerable literature about the nature of religious reform at the parish level, revisionists having argued that the English people by no means wholeheartedly supported the Reformation, that parish religion was flourishing and dynamic, and that the Reformation was ultimately accomplished because of a series of piecemeal political decisions whose religious ramifications were enforced at local levels. For a particularly useful collection of revisionist essays, see *The English Reformation Revised*, ed. Christopher Haigh (Cambridge: Cambridge Univ. Press, 1987). Revisionist interpretations, based as they are on local studies, provide a needed correction for the easy generalizations of earlier histories. My essay, however, presents rather different evidence from the parish level. While the early Cratfield records support the revisionist interpretation of parish religion that is "intensely dynamic" (Ronald Hutton, "The Local Impact of the Tudor Reformation," in Haigh, p. 116), the records from 1541 on suggest a parish eager for reform.

[7]Because *image* can refer to either statues or paintings, it is not possible to determine the exact nature of the images. In addition to the images inside the church, there must also have been statues in the twin ogee-arched niches on either side of the west door, probably of St. Mary and St. Edmund.

[8]Holland conjectures that a list of legacies in 1494 may have accounted for the considerable expenditure on the tabernacle (p. 24). F. E. Howard and F. H. Crossley suggest that surviving font covers provide a good idea of the artistic nature of tabernacle shrines (*English Church Woodwork* [London: T. Batsford, 1917], p. 357). A magnificent example of an East Anglian font cover, which retains its original color, can be seen at Salle (Norfolk).

[9]This statue and tabernacle must have stood in the north aisle, since this aisle alone retains evidence of an altar. Both the aumbry and piscina still remain. Such a position would have been the usual site for the shrine of a patronal saint. The extent of Marian devotion in the parish is also suggested by the clock bell, which was inscribed VIRGINIS EGREGIE, VOCOR CAMPANA MARIE ("I am called the bell of the glorious Virgin Mary") (H. Munro Cautley, *Suffolk Churches and their Treasures* [1937; rpt. Woodbridge, Suffolk: Boydell Press, 1982], p. 258). The west door is also decorated with crowned M's.

[10]It is difficult to date these fonts precisely. Costume details provide some evidence, but the figure sculpture has been badly damaged at Cratfield. However, such evidence as remains does not contradict a date of 1480. Traces of butterfly headdresses and the boat neckline of gowns suggest the fourth quarter of the fifteenth century. Similar styles can be seen on a 1482 brass at Iselham in Cambridge-shire; see C. Willett Cunnington and Phillis Cunnington, *Handbook of English Mediaeval Costume* (Boston: Plays, 1969), p. 162, fig. 76c. Elizabeth Woodville wears an identical headdress in the superb painting reproduced (facing p. 192) in Paul Murray Kendall, *Warwick the Kingmaker* (London: George Allen and Unwin, 1957). The painter was able to suggest the ethereal quality of the gauze fabric used to create the "butterfly" much more effectively than could any stonemason or brass engraver.

[11]*Cratfield Parish Papers*, pp. 41-47. A good example of stained cloth is illustrated in Christa C. Meyer-Thurman, *Raiment for the Lord's Service* (Chicago: Art Institute of Chicago, 1975), p. 136. We will never know exactly what happened to the lost church goods of the medieval church. One suspects that many a churchwarden profited from the perquisites of office, first chance to carry off what was discarded (certainly much of the textile wealth moved without record into private use), first chance to buy what was no longer needed. And who would point a finger at the helpful parishioner who offered to store statues or roods against a shift in official policy and, when the shift did not occur, used the wood for practical purposes?

[12]Foxe identified Norfolk and Suffolk as nurseries for Reformed religion and documented the martyrdoms of the early 1530's (*The Acts and Monuments of John Foxe* [rpt. New York: AMS Press, 1965], V, 41-44, and IV, 706-07). See also A. G. Dickens, *The English Reformation* (London: Fontana Books, 1967), pp. 56, 307, and Claire Cross, *Church and People 1450-1660* (London: Fontana, 1976), esp. pp. 77, 134. The Sudbury court book for the 1540's reveals local hostility to ceremonies, crosses, and the pyx (R. A. Houlbrooke, "Persecution of Heresy in the Diocese of Norwich under Henry VIII," *Norfolk Archaeology*, 35 [1970], 313). Such radical positions, which persisted through the Elizabethan reign, are particularly interesting, given the lukewarm evaluations historians have given to Norwich bishops Rugge (1536-50), Thirlby (1550-54), and Parkhurst (1560-75), who was even

criticized as naive and vacillating by his contemporaries. Such East Anglian radicalization supports the "populist" interpretation of the Reformation. The leaders may have been few, but they were vocal and powerful. See Ralph Houlbrooke, *Church Courts and the People during the English Reformation* (Oxford: Oxford Univ. Press, 1979), pp. 21-23. For the specific use of wills to document personal reformation, see Elaine M. Sheppard, "The Reformation and the Citizens of Norwich," *Norfolk Archaeology*, 38 (1981-83), 44-55. The extent of Marian persecution in Suffolk also indicates the nature of local commitment to the Reformation (Houlbrooke, *Church Courts*, p. 237).

[13]Houlbrooke, "Persecution of Heresy," p. 312. For comment on early iconoclastic incidents, see Aston, above, pp. 50-55.

[14]J. Charles Cox, *Churchwardens' Accounts from the Fourteenth Century to the Close of the Seventeenth Century* (London: Methuen, 1913), p. 181. There did, of course, exist a well-established precedent for selling church goods, but Cox's point is that such selling was rare compared with the sales precipitated by the Edwardian inventories. Sales could always be made for charitable purposes, but this was not the motive at Cratfield; for charitable sale, see Margaret Aston, "Gold and Images," in *The Church and Wealth*, Studies in Church History, 24 (Oxford: Basil Blackwell, 1987), p. 191. Neither was it a question of the items being "second-best," as were the pieces of service equipment sold at approximately the same time from six churches in Hutton's survey ("The Local Impact of the Reformation," p. 119).

[15]Hutton, pp. 117, 127.

[16]Thomas Wright, *Suppression of Monasteries*, Camden Soc., 26 (London, 1843), pp. 85, 144-45. Because there were family connections between Cratfield and Bury St. Edmunds, it is likely that news from Bury would have traveled easily to Cratfield. See A. J. Bedell, "Cratfield Church Font," *Proceedings of the Suffolk Archaeology Institute*, 15 (1915), 235-37.

[17]*Tudor Royal Proclamations*, ed. Paul L. Hughes and James F. Larkin (New Haven: Yale Univ. Press, 1964), I, 275-76.

[18]John Phillips, *The Reformation of Images: Destruction of Art in England, 1535-1660* (Berkeley: Univ. of California Press, 1973), p. 71n.

[19]The Guild records are complicated by terseness and a plethora of John Smiths.

[20]See Aston, above, pp. 64-69.

[21]*Letters and Papers, Foreign and Domestic, of the Reign of Henry VIII*, ed. James Gairdner (New York: Kraus Reprint, 1965), Hen. XII (I), 317, 512.

[22]Haigh, ed., *English Reformation Revised*, pp. 12-13.

[23]Henry Gee and William John Hardy, *Documents Illustrative of English Church History* (London: Macmillan, 1914), p. 277. In 1494 a parishioner was paid for "iii Image bereyng." Although this date is early, it is not unlikely that a procession with the Marian image continued to take place on the feast of the dedication of the church, and that such processions would have been within the living memory of the parishioners in the 1530's.

[24]Wright, *Suppression of Monasteries*, pp. 222, 226, 234. It is clear from London's letter to Sir Richard Rich that the coats, caps, and hair belonged to the statue of Our Lady of Caversham (p. 224). It is less clear in a later letter to Cromwell (pp. 233-34) to whom the coat and frontlets belonged, probably not to one of the heads of St. Ursula. For an excellent picture of the sort of bust designed to hold the remains of a saint's skull, one that might have been decked with hood and frontlet, see Aston, "Gold and Images," pp. 198-99. For the fate of the coat that belonged to the rood of Dovercourt, see Aston, above, p. 52.

[25]Holland, *Cratfield Parish Papers*, p. 57. Although Holland was unsure about the meaning of "bz," Ronald E. Zupko cites it as an optional abbreviation for bushel (*A Dictionary of Weights and Measures for the British Isles* [Philadelphia: American Philosophical Society, 1985], p. 56). The use of lime again highlights the difficulty of interpreting the records. In 1497, along with a labor charge to the glazier, there is an entry for "sowder and cyment." Yet when twenty quarrels were installed in 1608, there are entries for lead, solder, labor, but none for any cementing material. Churchwardens' accounts from other churches indicate the same inconsistencies; see, for example, Cox, *Churchwardens' Accounts*, p. 87. I am grateful to Ruth Bures, stained glass artist, and to Universal Studios, a firm specializing in the restoration of early stained glass, for help in interpreting the evidence of the accounts.

[26]Charles Wriothesley, *A Chronicle of England during the Reigns of the Tudors, from A.D. 1485 to 1559*, ed. William Douglas Hamilton, Camden Soc., n.s. 11 (London, 1875), pp. 86-87.

[27]For such whitewashing at Merton College, Oxford, see Davidson, above, p. 99. Painting-out of offending images was a conveniently inexpensive way of effacing images in glass. For such practice in succeeding years, see Aston, *England's Iconoclasts* (Oxford: Clarendon Press, 1988), I, 260-61. I am particularly grateful to Dr. Aston for providing me with page proofs from her book.

[28]Ibid., p. 122. The cost of removal was modest, a mere sixpence; the glazing and glazier's board, however, came to nineteen shillings. Mr. Bycker's work at Cratfield suggests that glaziers were regularly used for the orderly removal of painted glass. In the 1640's, for

example, a glazier named Russels took down painted glass at Toft Monks in Norfolk. When glaziers were so employed, it is likely that they also rearranged pieces of glass to destroy the image, thus producing many of the crazy-quilt effects still visible today.

[29]Ely Diocesan Records, in Camb. Univ. Lib., G/1/7, fol. 141[r]-141[v]. For a discussion, see Margaret Aston, *England's Iconoclasts*, pp. 238-39.

[30]Altars were damaged and even removed at shrines during the attack on relics and abused images in 1538. About his work at Grey Friars, Reading, Dr. London bragged that once he had "rydde all the fasschen of that church in parcleses, ymages, and awlters, it wolde mak a gudly towne hall," and Pollard complained of the length of time it would take to remove the altar at Winchester, reckoning at least two days (Wright, *Suppression of Monasteries*, pp. 219, 223). Even where no altars are cited, the commissioners were determined to clear the places where the shrines had stood. For example, Sir William Bassett wrote to Cromwell that he defaced "the tabernaculles and placis where they dyd stande" (ibid., p. 143). Such attacks, of course, were directed by officials of the central government. Still, the official pattern provided a model for private destruction.

[31]"Item, that such images as they [deans, archdeacons, parsons, vicars, and other ecclesiastical persons] know in any of their cures to be, or have been, so abused with pilgrimage or offerings of anything made thereunto, or shall be hereafter censed unto, they (and none other private persons) shall, for the avoiding of . . . idolatry, forthwith take down, or cause to be taken down, and destroy the same . . ." (*Tudor Royal Proclamations*, I, 394). Whatever the official iconoclasm of the 1530's, the language of the 1538 Injunctions is significantly different from the 1547 Injunctions since images were only to be "delayed" rather than "destroyed." See Aston, above, p. 88, n. 48.

[32]Hutton in his study of churchwardens' accounts cites the Cratfield purchase of a Bible as exceptionally late--in 1547 (p. 118). That purchase, however, was the Great Bible. The Bible purchased in 1540-41, because of its modest cost (6s 2d), was probably the Coverdale Bible, the possession of such a Bible exempting the parish from purchasing the more expensive one. It is unfortunate that the parish records for two years were collated. It would be useful to know whether the purchase antedated the Royal Proclamation of May 1541 that required possession of a Bible on pain of fine.

[33]I so interpret "makyng of the chalys"--that is, "remaking" (Holland, p. 73).

[34]Raven's edition of Holland's transcriptions is unclear concerning these undated sheets. The rood entries are listed twice, once under 1553 and once under 1557. Furthermore, Holland ascribes the sheet with pyx, covering, and candlesticks to 1547 (p. 76), but they must

belong to the list of Marian replacements, probably in 1555, since that year Bonner directed curates in his diocese to see that "your altars [are] set up" and chalices, vestments, and books procured (Edward Cardwell, ed., *Documentary Annals of the Reformed Church of England (1546-1717)* [Oxford: Oxford Univ. Press, 1844], I, 143).

[35]Ibid., p. 173: "Whether the churches be sufficiently garnished and adorned with all ornaments and books necessary; and whether they have a rood in their church of a decent stature, with Mary and John, and an image of the patron of the same church?" It is significant that the Cratfield records make no mention of the image of their patron saint being retrieved from the vicarage barn. For the crismatory date, see Suffolk Record Office FC 62/E4/2.

[36]Haigh calls the English iconoclasm "anaemic" compared to the violence of continental image-breaking (*English Reformation Revised*, p. 7), and Hutton concurs, describing it as "a very formal sort of iconoclasm" ("The Local Impact of the Tudor Reformation," p. 121). However, faced with the disfiguration of the seven-sacrament fonts, the viewer sees not the work of a disinterested craftsman paid to do a job but a hammer-wielding iconoclast. Furthermore, Parkhurst's Injunctions of 1561 imply extensive visible evidence of violent destruction in the churches of the Norwich diocese: "Item, that they see the places filled up in walles or ellswhere, where images stood, so as if there had been none there" (*The Victoria History of the County of Norfolk*, II, 263).

J. J. Scarisbrick has also argued that there was little popular iconoclasm except in London and a few towns; he bases his conclusion on churchwardens' records. Since men had to be paid to remove offending statues, roods, or altars, he concludes that the work was unpopular (*The Reformation and the English People* [Oxford: Basil Blackwell, 1985], pp. 88-89). At Cratfield, of course, there are no records of payment for the initial removal of images and altar; therefore, by extension of Scarisbrick's logic, he would argue that the removal was popular. He also equates the laconic quality of the records with duty rather than desire. However, it is, I believe, misleading to interpret laconic records as testimony of lukewarm attitudes because a financial account, often attested by a local notary, is not a suitable vehicle for popular or personal feeling. A good example is found in the accounts of John Filby for 1608. He records the costs involved in a court case involving himself and the minister over the issue of a pulpit cushion. Feelings must have run high, but they do not intrude on the account book. Nathaniel Gill, who used the parish register of Burgh-next-Aylsham in Norfolk to vent his feelings against the liturgical reforms of the Directory, is the exception rather than the rule; see E. T. Yates, "A Transcript of the Register of the Parish of Burgh," *Norfolk Archaeology*, 9 (1884), 37-57.

[37]Cautley, *Suffolk Churches*, p. 258.

[38]A. J. Bedell, "Cratfield Church Font," pp. 230-32.

[39]Thomas Becon, *The Catechism with Other Pieces*, ed. John Ayre (Cambridge: Cambridge Univ. Press, 1844), p. 65.

[40]*"These wordes before rehersed are to be saied, turning still to the Altar, without any eleuacion, or shewing the Sacrament to the people"* (*The First and Second Prayer-Books of King Edward the Sixth* [1910; rpt. London: J. M. Dent, 1920], p. 223).

[41]Article 41 from John Hooper's Visitation Book (*Later Writings* [Cambridge: Cambridge Univ. Press, 1852], pp. 127-28).

[42]Hooper similarly asks ministers whether they require communicants "to make their auricular confession unto the curate, as they did in the time of papistry" (ibid., p. 14).

[43]Jeremy Collier, *An Ecclesiastical History of Great Britain* (London, 1714), p. 120.

[44]Foxe, *Acts and Monuments*, VIII, 425.

[45]Houlbrooke notes that an alliance with "the godly gentry . . . had been the very cornerstone of Parkhurst's policy" (R. A. Houlbrooke, *The Letter Book of John Parkhurst* [Norfolk Record Society, 1974-75], p. 55). Because of the impossibility of identifying the key figures at Cratfield, I have throughout this paper taken refuge behind the evasive collective noun "the parish." Human nature being what it is, it is difficult to believe that the entire congregation was wholeheartedly in favor of anything. A modern instance, which also involves liturgical change, was the complaint that vicars had packed parish councils with members favorable to the Alternative Service Book. See, for example, Jane Ellison, "Vicars rigging parish councils on prayer book," *The Observer*, 12 April 1981.

[46]The elder Mr. Lany was a member of St. Margaret's parish, one well endowed with preachers, in a community committed to the ideal of magisterial commonwealth. For Ipswich as a model godly community, see Patrick Collinson, *The Religion of the Protestants* (Oxford: Clarendon Press, 1982), pp. 170-77. For the earlier Ipswich debate, which took place in 1427, see Foxe's account (*Acts and Monuments*, IV, 628-31). Foxe described Bilney as "a great preacher in Suffolk and Norfolk" (IV, 620). See Aston, above, pp. 54-55.
Evidence from the Sudbury archdeanery creates a picture of an equally strong Protestant enclave in the West with Bury St. Edmunds as its center (see, for example, Collinson, pp. 160-64). The records at Cratfield suggest that there was also a northeastern enclave of godly ministry, one supported, as in the West, by a Puritan gentry.

[47]Mr. Godbold was apparently a hefty man since he occurs again in

the records, being paid three shillings for "hys worke abowght the new bell" (1585).

[48]Henry Gee, *The Elizabethan Prayer-Book and Ornaments* (New York: Macmillan, 1902), p. 275.

[49]Houlbrooke, *Church Courts*, pp. 254-55. Verbal abuse of vestments was commonplace. The Marian martyr Rowland Taylor, a prominent preacher in Norwich, had referred to vestments as "apish toys and toying trumpery" (Foxe, *Acts and Monuments*, VI, 691). In one scuffle at St. Giles Cripplegate, the minister called the clerks in surplices wearers of "porters coats" (John Strype, *The Life and Acts of Matthew Parker* [Oxford: Clarendon Press, 1821], I, 302). One senses exasperation in Cecil's complaint with regard to the clergy: "Some say with a surplice; others without a surplice" (ibid., I, 424).

[50]Houlbrooke, *The Letter Book*, p. 85.

[51]Quoted by Collinson, *Religion of Protestants*, p. 259.

[52]Houlbrooke, *Church Court*, p. 243.

[53]Ibid., p. 247.

[54]Collinson also notes that the market-lecture had a much earlier tradition at Bury St. Edmunds *(Religion of Protestants*, pp. 136-40).

[55]There are consistent entries for charitable disbursements during the tenure of the two Elands. In addition to the usual local needs, in 1596 eight pence were "gathered for the ransum of serten men that ly in preson under the Turke"; and in 1635 the parish contributed one shilling to be disbursed by the lay impropriator, Mr. Lany, to two sailors cast ashore at Ipswich to enable them to return to their homes in the West. The long tenure of Francis and Gabriel Eland (Irland) warrants further study. The father in many ways fits the picture of the godly Suffolk minister as described by Collinson (*Religion of Protestants*, pp. 116-19). He certainly demonstrated the philoprogenitive propensities of the new Anglican clergyman of Elizabeth's reign, as the baptismal records of his children indicate.

[56]J. Charles Cox and Alfred Harvey, *English Church Furniture*, 2nd ed. (London: Methuen, 1908), pp. 17-20, and Cox, *Churchwardens' Accounts*, p. 105.

[57]*The Journal of William Dowsing*, ed. C. H. Evelyn White (Ipswich: Pawsey and Hayes, 1885), p. 47.

[58]Ibid., p. 24.

[59]Dowsing's editor concludes that font destruction "may be attribu-

ted to other hands than his" (ibid., p. 42).

[60]Alfred Suckling, *The History and Antiquities of the County of Suffolk* (London: John Weale, 1846-48), II, 214.

[61]The pertinent bundle of records is in the Suffolk Record Office, Ipswich, FC 62/E2/2.

[62]There seem to be traces of red paint on the back of the screen, but it is too close to the west wall to be examined. Canon Basil F. L. Clarke referred to it as "a poor, mutilated, varnished piece of screen" (manuscript notebook, p. 102). I am grateful to Janet Seeley of the Council for the Care of Churches for sending me a photocopy of Canon Clarke's notes.

[63]Howard and Crossley note that many benches were lost at the end of the seventeenth century because of the shift in fashion to box pews (*English Church Woodwork*, p. 310). Fashion is still a menace to pews, since the poppyhead pews at Heveningham were sold only recently. A parishioner told me during the summer of 1987 that they had stood along the back wall, but that when it was decided to use that area for coffee after the Sunday service, they were sold to make room for socializing. When I expressed dismay at their loss, she said, "But they were so awfully uncomfortable, dear."

[64]These pews were dated by Cecil B. Smith in a 1955 church inspection. He identified the volute benchends as "fairly plain seventeenth-century bench ends in the north and south aisles." He did not mention the earlier poppyhead pews.

[65]This is precisely the sort of preservation recommended by the Department of the Interior specifications for restoration of properties on the National Register of Historic Places. Exterior wood should never be stripped because such action destroys the *record* of earlier painting.

[66]Worstead church booklet.

[67]The Reverend Robert Barry, rector of North Tuddenham from 1851 to 1904, must be one of great antiquarian priests of the nineteenth century. For a further description of North Tuddenham, see Nikolaus Pevsner, *North-west and South Norfolk*, The Buildings of England (Harmondsworth: Penguin, 1962), and D. P. Mortlock and C. V. Roberts, *The Popular Guide to Norfolk Churches, No. 2: Norwich, Central and South Norfolk* (Cambridge: Acorn Editions, 1985).

[68]One of the churchwardens at Aylsham, for example, bought a discarded eighteenth-century altarpiece and then gave it to Marsham church. According to Aylsham church notes, the work was last seen in the stable of the Old Rectory at Marsham.

[69]Quoted from the high church journal *Norwich Spectator*, by Noel Spencer and Arnold Kent, *The Old Churches of Norwich* (Norwich: Jarrold Publications, 1970), p. 4.

Index

Abbot, George, *vice-chancellor of Oxford* 78
Actes des Apôtres, play (Bourges) 87
Adam 14, 102
Adrian, *Pope* 24
Agatho, *Pope* 5
Aldwick-le-Street, *near Doncaster* 154
Alcuin 9
Amersham, *Buckinghamshire* 155
Antichrist 120
Antwerp, *iconoclasm at* 80-81
Ap Rice, John 170
Arthur, King 77
Arthur, Thomas 54
Arundel, *Sussex, Holy Trinity Church at* 156
Aston, Margaret 29, 44, 82, 87, 95, 133, 189-90
Audley, Thomas, *Chancellor* 88
Aylsham, *Norfolk* 187, 195

Bacon, Roger 39
Bale, John, *reformer and playwright* 105
Banbury, *Oxfordshire* 76
Banbury High Cross 76
Bancroft, Richard, *Bishop of London* 78
Bankes, Richard, *of Coventry* 120
Barclay, Alexander 63, 68-69, 71, 88
Barfield, Owen 45
Barish, Jonas 33, 85
Barlow, William, *Bishop of St. David's* 72, 152, 154
Barry, Robert, *rector* 195
Bartholomew, *surgeon* 70
Bassett, Sir William 191
Bateman, John 168
Bearsted, Kent 159
Becket, St. Thomas 35, 88, 99-100, 107, 128-29, 169-70, 172; *guild of* 169-70; *images of* 99-100, 128-29, 169, 172, 174, fig. 25 (in painted glass); *pageants and plays of* 60, 107; *shrine of* 128, 145, fig. 23
Becon, Thomas 175
Bedell, A. J. 175, 180

197

INDEX

INDEX